Watercolour

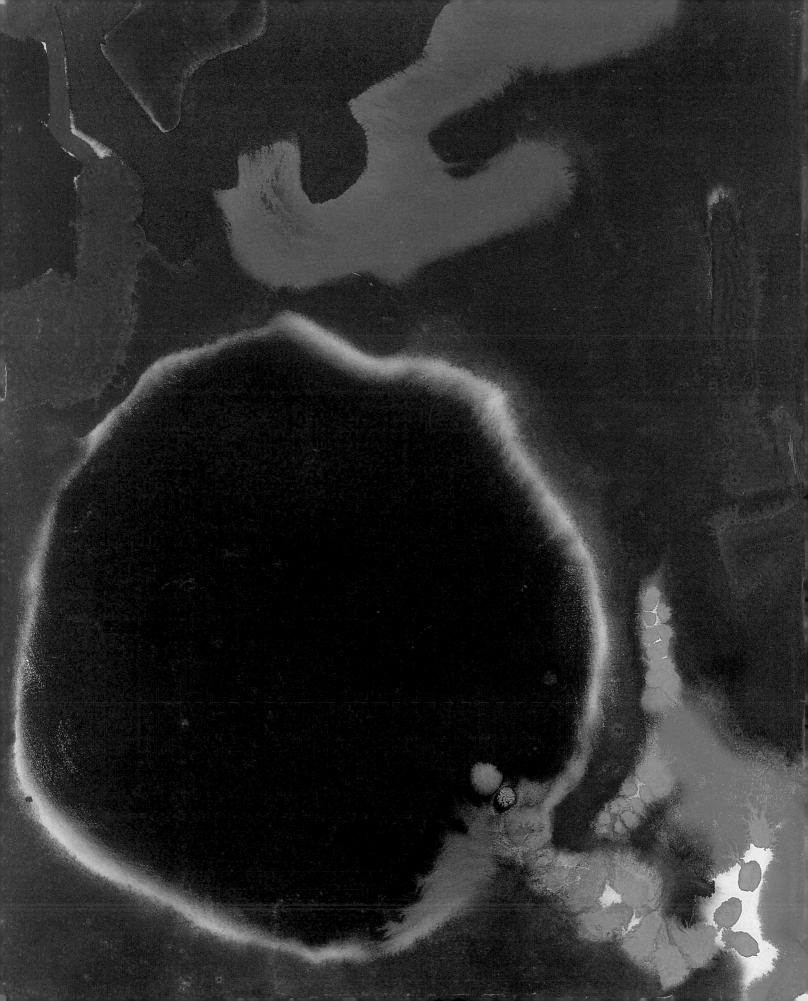

Watercolour

Edited by Alison Smith

WITH CONTRIBUTIONS BY
Thomas Ardill, Anna Austen, Tabitha Barber,
David Blayney Brown, Karen Hearn, Matthew Imms,
Nicola Moorby, Philippa Simpson, Katharine Stout

Tate Publishing

First published 2011 by order of the Tate Trustees
by Tate Publishing, a division of Tate Enterprises Ltd,
Millbank, London S W 1 P 4 R G
www.tate.org.uk/publishing

on the occasion of the exhibition
Watercolour

Tate Britain
16 February – 21 August 2011

This exhibition is part of the Great British Art Debate,
a partnership project between Tate Britain, Tyne & Wear Archives
& Museums, Norfolk Museums & Archaeology Service and
Museums Sheffield, supported by The National Lottery through
the Heritage Lottery Fund

A catalogue record for this book is available
from the British Library

ISBN 978 1 85437 913 9

Distributed in the United States and Canada by
Harry N. Abrams, Inc., New York

Library of Congress Control Number: 2010931939

Designed by LewisHallam
Colour reproduction by DL Imaging Ltd, London,
Printed in Italy by Conti Tipocolor, Florence

Front cover J.M.W. Turner, *The Blue Rigi, Sunrise* 1842 (detail, no.49)
Title graphic designed by The Studio of Fernando Gutiérrez
Back cover, top Anonymous artist, *Prose Life of St Cuthbert* c.1200
(detail, no.1): *back cover, bottom* Sandra Blow, *Vivace* 1988 (detail, no.144)
Frontispiece Patrick Heron, *January 9: 1983: II* 1983 (detail, no.140)

Measurements of artworks are given in centimetres, height before width

FSC
www.fsc.org
MIX
Paper from
responsible sources
FSC® C016114

Contents

Foreword

This exhibition, in its range, touches on many things. Of them all, perhaps the single most compelling is the relationship of drawing to painting as expressed, at different times and in different ways, by those who chose to make watercolours. This changing dynamic, in which one approach predominates over the other, and back again, is like a thread that runs through the exhibition and provides its underlying theme. Here we see how watercolour moves as it were between the pencil and the brush, between line and colour, between the transparent and the opaque.

Watercolour paints have always been remarkably portable. Inert, when dry, they are brought to life by the simplest of means. This simple recipe, colour + water, whilst almost mythical in its nature, has allowed watercolour paint to function as the most basic element of the reporter's repertoire, pre-figuring the invention of the camera. In this exhibition we see many examples – in depictions of exotic places, birds and plants, of extreme beauty and pain – of witnesses seeking to render credible accounts by drawing what they saw and then adding colour.

Yet whilst on the one hand watercolour was employed, much like a pencil, to record in careful detail, on the other it was used as a liquid medium, rendering the environment around us like an envelope of colour. This latter approach, combining as it does line and wash, the tangible and the intangible, has been particularly associated with Britain and its moist but temperate climes. This exhibition is one in a series of shows examining forms and moments particularly associated with British art that has been generated as part of the Great British Art Debate. This four-year project, supported by the National Lottery through the Heritage Lottery Fund, brings together four partners: Tate, Tyne & Wear Archives and Museums, Norfolk Museums and Archaeology Service, and Museums Sheffield. *Watercolour* draws on the collections of these partners and many other key regional collections with important holdings of watercolour paintings, especially those that represent the diverse geographies of our country.

Watercolour may have been easily accessible to any practitioner – from the child at play to the professional at work, from the amateur lady artist to the most ambitious male – but it has nonetheless been used in surprisingly diverse ways. Whereas some artists have sought to disengage watercolour from establishment practice, emphasising instead its potential for radical image-making, others have attempted to demonstrate how watercolour can take on oil painting and on the same terms. This exhibition makes no attempt to disguise these inconsistencies, showing instead how some artists sought to professionalise their medium, and also to make watercolours more like oils, in terms both of technique and of status, whilst others preferred to keep their distance and to use watercolour in more private ways.

In bringing together material from different periods – in this case from the medieval to the contemporary – this exhibition heralds an approach that we wish to consolidate at Tate Britain, which houses material from over five hundred years. Similarly, the way in which Alison Smith, as its chief curator, has been able to call on the expertise of other colleagues is indicative of the way we hope to develop curatorial integration. Anna Austen worked with her overseeing the exhibition, on which they collaborated with curators Thomas Ardill, Tabitha Barber, David Blayney Brown, Karen Hearn, Matthew Imms, Nicola Moorby, Philippa Simpson, and Katharine Stout. They have been helped by many colleagues, inside Tate Britain and well beyond; we are very much indebted to all those who have allowed us to borrow their works, and most particularly to the artists who have lent the project their support. In addition, we are extremely grateful to the Tate Patrons and those individuals and organisations that have lent financial support towards the exhibition as part of the dedicated Watercolour Exhibition Supporters Group. We also remember with respect and affection Henry Wemyss, who made a significant contribution to this field as Head of the British Watercolour department at Sotheby's.

Watercolour has perhaps always been a medium that hovers on the threshold between private and the public. At hand to record our own immediate experiences, whether real or imagined, present or past, it has also often been transported into the public realm, whether in the guise of documentary evidence or on pure artistic merit. Here we hope to present both sides of the medium – its introvert as well as its extrovert character – within the framework of a major public showing. In providing illustrations and entries representing most of the artists in the exhibition, this catalogue stands as its enduring companion.

PENELOPE CURTIS
Director, Tate Britain

Exhibition Support

Watercolour is part of the Great British Art Debate, a partnership project between Tate Britain, Tyne & Wear Archives & Museums, Norfolk Museums & Archaeology Service and Museums Sheffield, supported by the National Lottery through the Heritage Lottery Fund.

Additional support has generously been provided by The Watercolour Exhibition Supporters Group and the Tate Patrons.

The Watercolour Exhibition Supporters Group

British Pictures Department, Sotheby's London in memory of Henry Wemyss; Finnis Scott Foundation; Lord Leverhulme's Charitable Trust; Mark and Liza Loveday; Sir Christopher Mallaby; Janet Q. Treloar, Vice President of the Royal Watercolour Society ; Sir Samuel Whitbread; and those donors who wish to remain anonymous.

Acknowledgements

Watercolour has involved the goodwill and collaboration of many individuals and institutions. Within Tate Britain we would particularly like to thank the following for their valued contributions to different aspects of the exhibition: Gerry Alabone, Marie Bak Mortensen, Martin Barden, Jennifer Batchelor, Julia Beaumont-Jones, Kirstie Beaven, Anne Beckwith-Smith, Gillian Buttimer, Rachel Crome, Harriet Curnow, Penelope Curtis, Claire Eva, Ann Gallagher, Juleigh Gordon-Orr, Simon Grant, Selina Jones, Christine Kurpiel, Anne Lyles, Roanne Marner, Celeste Menich, Deborah Metherell, Martin Myrone, Judith Nesbitt, Judith Severne, Andy Shiel and the art handling team, Silaja Suntharalingam, Joyce Townsend, Piers Townshend, Ian Warrell, Andrew Wilson, Nikki Young and other colleagues in the marketing and media departments.

The exhibition was designed by Alan Farlie of RFK Architects with graphics by Philip Miles. Philip Lewis designed the catalogue and the marketing campaign creative was produced by Studio Fernando Gutiérrez.

We would also like to extend our gratitude to all those individuals and institutions who have kindly agreed to lend works to the exhibition. Among the many people who have offered advice and assisted the project in various ways, we would especially like to thank: Afroco, London; Colin Harrison, Ashmolean Museum, Oxford; David Austen; Sir Nicholas Bacon; Peter Barber; Emma Barker; Gillian Barlow; Tessa Sidey and Victoria Osborne at Birmingham Museums and Art Gallery; Karla Black; Elizabeth and Peter Brandt; Galerie Sandra Buergel, Berlin; Andrea Clarke, Tom Harper, Scott Mckendrick and Felicity Myrone at the British Library, London; Mary Ginsberg and Kim Sloan, British Museum, London; Alan Cristca, London; Doggerfisher, Edinburgh; Peer Doig; Nicola Durvasula; Tracey Emin; Donato Esposito; Jenny Franklin; Charlotte Schepke, Frith Street Gallery, London; Greengrassi, London; Christopher Gridley;

Andrea Harari; Ben Tufnell, Haunch of Venison, London; Pamela Robertson, Huntarian Museum, Glasgow; Bethan Huws; Jenny Wood and Sara Bevan Imperial War Museum, London; Callum Innes; Jitish Kallat; Sarah Richardson, Laing Art Gallery, Newcastle; David and Amanda Leathers; Christopher Le Brun; Todd Longstaffe-Gowan; Ian McKeever; Mary Mary Gallery, Glasgow; Victoria Miro, London; the late Mike Moody; Henry Moore Institute, Leeds; Felix Mottram; Judith Magee, Andrea Hart, Natural History Museum, London; Charles Newton; Andrew Moore, Norwich Castle Museum; Silke Otto-Knapp; Rachel Pedder-Smith; Richard Selby, Redfern Gallery, London; Anthony Reynolds Gallery, London; Annette Wickham, Rachel Hewitt, Royal Academy of Arts, London; Marilyn Ward, Royal Botanical Gardens, Kew; Martin Clayton and Jennifer Scott, Royal Collection, London; Paul Newland, Salliann Putman, Janet Treloar, Royal Watercolour Society, London; Gordon Rushmer; Rebecca Salter; Lucy Skaer; Dr Andrew Bamji, St Mary's Hospital, Sidcup; Helen Dorey, Sir John Soane's Museum, London; Julia Dudkiewicz, Society of Antiquaries, London; Antonia Spowers; Jane Stevenson; Sarah Taft; Neil Tait; Hayley Tompkins; Nicholas Tromans; Rosalind Mallord Turner; Hilary Underwood; Susan Owens, Stephen Calloway, Katie Coombs, Victoria & Albert Museum, London; Sophie Von Hellerman; Heather Birchall, Whitworth Art Gallery, Manchester; Timothy Wilcox; Paul Robinson, Winsor and Newton Archive; Uwe Wittwer; Ann Sylph, Zoological Society of London.

This exhibition has been made possible by the provision of insurance through the Government Indemnity Scheme. Tate Britain would like to thank the Department for Culture, Media and Sport and the Museums, Libraries and Archive Council for providing and arranging this indemnity.

ALISON SMITH

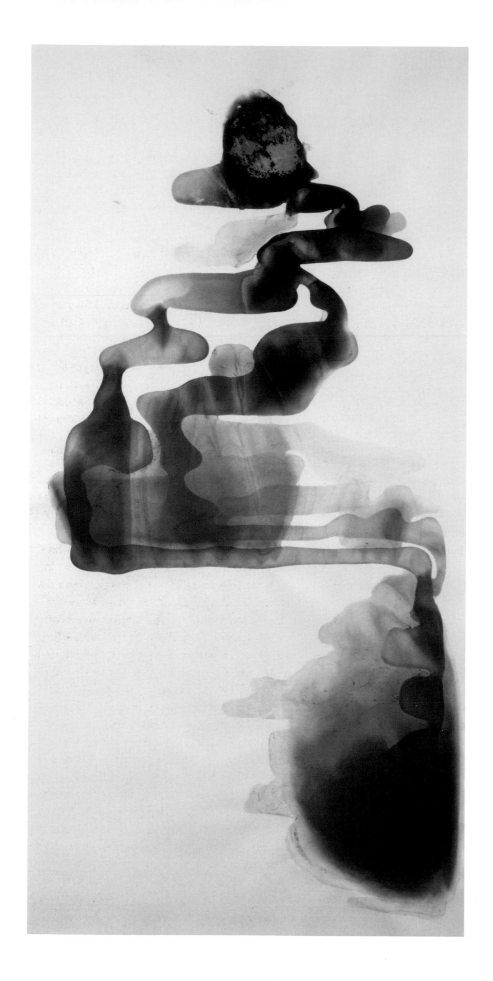

Introduction

Alison Smith

Watercolour is the most popular and accessible of all paint media, used widely by professionals and amateurs alike by virtue of being accessible, clean and cheap. Getting started is easy – just add water. Watercolour is also a highly versatile medium that can be used in a variety of ways, diluted in water so it spreads and is absorbed into the paper, or applied in a 'dry' manner with the brush dragged across the surface of the support until it runs out, leaving a broken trail of paint. Whether the end result is intended to be transparent or opaque, the essential character of watercolour is that it dries through evaporation. It is not viscous and slow-drying like oil. Thus any water-based medium can be termed watercolour, not only ink and gouache (also known as bodycolour), but acrylic and even more experimental materials like earth, examples of which are included in this exhibition to suggest an expansion of our understanding of the medium (fig.1). When paint is applied thinly, watercolour creates brilliant translucent effects with the white of the paper used to maximum advantage. Watercolour generally proceeds from light to dark, whereas the thickness of oil encourages artists to lay in lights on darks. Oil thereby permits a greater degree of illusionism even when compared to gouache which, being opaque, differs from watercolour in allowing greater flexibility in layering and texture (see p.23, below).

Watercolour may be easy for amateurs to begin with, but it is hard to master. It is an inherently intractable medium, hence our admiration for the myriad of ways in which artists have been able to manipulate pigment for astonishing effect, from the ethereal translucency of J.M.W. Turner's *The Blue Rigi, Sunrise* 1842 (no.49) to intensely detailed works of observation such as Walter Langley's *'But men must work and women must weep'* 1882 (no.77), where 'scratching out' (also known as dry removal) has been adroitly employed to render illuminated stray hairs on

the heads of the two women whose anxious presence dominates the image. Such bravura, virtuosic qualities have often been seen to distinguish masters of the medium from the efforts of amateurs attracted by its ease of application, as the foremost Victorian art critic John Ruskin noted dryly in an essay of 1883:

> Water-colour, under the ordinary sketcher's mismanagement, drops and dries pretty nearly to its own fancy, – slops over every outline, clots in every shade, seams itself with undesirable edges, speckles itself with inexplicable grit, and is never supposed capable of representing anything it is meant for, till most of it has been washed out.[1]

Ruskin, strictly speaking, was himself an amateur, in that he did not on the whole produce watercolours for sale or public exhibition. Nevertheless, he is regarded as a master of the medium due to the skill with which he combined precise detail with loose, vibrant washes of colour, qualities that respect the ways in which watercolour had been used over time both as a draughtsman's tool and as a means of painterly expression. It is often assumed that there is an authentic way to use watercolour, which is to go with the flow and honour the aqueous character of the vehicle itself (fig.2). In these 'truth to materials' terms, watercolour tends to be regarded as a one-shot technique that allows no margin for error or correction, the artist's virtuosity residing in methods such as the 'laying-in' of broad washes of colour so no join is visible to the naked eye, or the leaving of paper untouched or 'reserved' so as to register highlights.

Concomitant with this idea is the presumption that watercolour is best suited to representing ephemeral and contingent aspects of the visible world, notably landscape, the sea and picturesque old buildings, because such subjects offer endless potential for demonstrating the medium's capacity to evoke climatic effects such as light dappling through trees,

Fig.1
Andy Goldsworthy b.1956
Source of Scaur 1991–2
Watercolour on paper
235 × 121 cm
Victorian and Albert Museum,
London

mist enveloping ruins or storm clouds about to break. This 'immediate response to nature' idea, the way we tend to view watercolour through Romantic naturalism, which forms the conventional history of the subject in Britain, as represented by the abstract and expressive art of painters such as Francis Towne, Thomas Girtin, John Sell Cotman and Turner, can further be seen as a fundamentally Modernist understanding in asserting that the essence of a medium lends it a specific identity. In other words, that watercolour is at its purest when expressing its liquidity, not when attempting to emulate the properties of other media such as the viscosity of oil. Notions of transparency and fluidity not only sustain the ideal of direct expression and creative freedom so central to Romanticism and Modernism, but also the view that the integrity of the medium depends upon it being used in this pure way.

An important reason why more laboriously finished types of watercolour (such as those promoted by the Society of Painters in Water-Colours in the nineteenth century) do not reside comfortably within the standard narratives of modern art is because manual precision came to be regarded as a travesty of watercolour proper. However, the Modernist 'truth to materials' ideal of watercolour is too narrow, in that it does not encompass the whole history of the medium and the variety of purposes for which it has been employed. It is only one story in a grander narrative for which the contexts are, like the medium itself, amorphous, relating to a bewildering variety of practices that traverse the boundaries of fine art and craft. In fact watercolourists have been as much preoccupied with design and precise delineation as they have with freedom and spontaneity of expression.

This exhibition concerns the history of watercolour in Britain and the medium's association with British identity. Rather than charting a clear narrative that traces the development of the medium from its tentative beginnings as tinted drawing to painterly

Fig.2
Peter de Wint 1784–1849
Clee Hills, Shropshire c.1845
Watercolour on paper
38.1 × 52.7 cm
Private collection

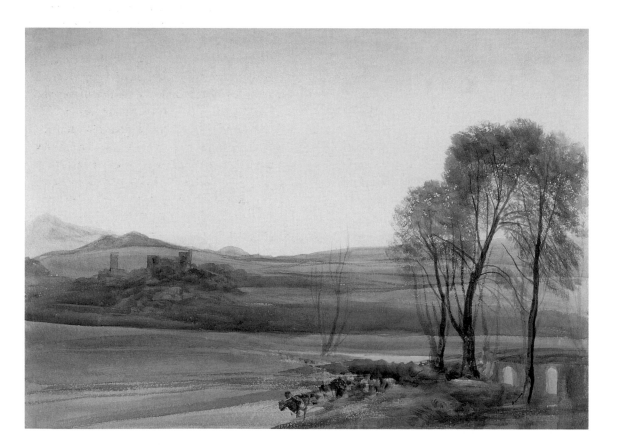

performance in the nineteenth century and beyond, it aims to embrace the diverse and fragmentary nature of the practice itself. The project investigates those qualities believed to be innate to watercolour, and how they have been used over time to sustain conflicting ideas about the medium and its relation to broader issues of social status, gender and national identity. At a time when watercolour itself might be seen to have been supplanted by new media and technology, it also considers why the simplicity of the medium still has such an irresistible pull for some artists working in a globalised contemporary art context, where many of the traditional functions of watercolour might be expected to be regarded as redundant and the identification with Britishness irrelevant.

Drawing or painting?

Watercolour traverses the boundaries of drawing and painting. Specific examples are often classified along with prints and drawings as 'work on paper', but in the course of its complex history watercolour has also aspired to be a public art form on a par with painting. Either way, the character of watercolour is inextricably bound up with questions of display. This is problematic for watercolour because the pigment lies exposed on the surface of the support rather than protected by oil and varnish. Some of the colours first employed by watercolourists proved particularly fugitive, indigo blue, for example, which when over-exposed fades to a dull brown or pink. Because the medium is vulnerable to light, not to mention tearing, works were kept hidden away in folios or albums during the eighteenth century. Display only became an issue with the development of exhibition culture in the nineteenth century, with the consequence that frames were sometimes fitted with green silk blinds to protect works when they were not being examined.

Today museums such as Tate limit the exposure of watercolours to an average of two years in four, recommending a lighting level of 80 lux maximum, and stipulating that for the rest of the time they should be stored in the dark in Solander boxes in acid-free mounts in a controlled air-conditioned environment. Anoxic framing, a preventive conservation measure that reduces or eliminates oxygen exposure, can be used to give greater display time without causing light damage for many watercolour materials. However, this process sometimes involves the use of bulky frames, which are neither practical nor aesthetically pleasing. The fragile nature of watercolour has thus given rise to the perception that it is a diffident, intimate medium, the preserve of specialist collectors and dealers, and more appropriate for private consumption than sensational public display, its unique appeal residing in the haptic thrill of holding the watercolour itself.

Until the later part of the nineteenth century, when the term 'watercolour' was more widely used to designate a particular type of work on paper, the medium was typically designated 'painting in watercolour', or 'stained' or 'tinted' drawing. One reason why it was considered essentially a type of drawing was because it was regarded as serving a practical role, not only being a pedagogic tool to train the eye and hand, but also being employed for a wide variety of utilitarian purposes such as the production of maps and surveys, architectural designs and botanical studies (see, for example, nos.7, 8, 22). Since it was used primarily for conveying information, colour was employed secondarily to articulate areas already constructed through linear means by drawing. An important early function of watercolour was for copy or reproduction in the form of prints, which were then stored in folios, reinforcing the private purpose of the medium. Because the watercolour design formed the initial stage of a process that involved a complex division of labour, it had to be legible in order to be translated by the engraver, which meant that aesthetic considerations were often subordinate to technical exigencies. Colour was more of an embellishment than an essential ingredient, as the main task of the engraver was to translate it into complex tonal equivalents. In 1770 Paul Sandby developed the aquatint process in etching, which was effective in imitating the appearance of watercolour washes, allowing for gradations of tone. This process was an instance of how watercolour began to dictate the appearance of intaglio prints, etching in particular, and how the two techniques became mutually influential, especially in the shared method of 'stopping out', which allowed for an alternate play of positive and negative areas. The invention of lithography in the later eighteenth century, and the development of tonal

processes associated with it such as tusche and litho tint, allowed for the further appropriation of watercolour effects in a method that was based on the principle of hydrophobia or antipathy to water.

The move towards painting rather than drawing in watercolour was propelled partly by technical advances, including the greater use of gouache with the introduction of Chinese or zinc white for watercolour painting during the 1830s, the production of stronger papers and the employment of more varied methods like stopping out, scraping, scumbling and sponging. These went hand in hand with the rise of the watercolour societies during the nineteenth century and the production of works for public exhibition, both of which saw a greater emphasis on aesthetics and the idea of the watercolour as a work of art in its own right. Exhibition culture inspired artists to vie with one another in the pyrotechnics of performance, Turner raising the stakes with the mysterious ways in which he would lay in washes on wet paper so forms would evolve from a chaotic jumble of marks. His showmanship set a precedent for later painters like A.W. Hunt (no.55), who regularly employed sponges to soften and blur outlines in conjunction with the ends of knives and brushes to striate texture, and Arthur Melville (no.81), who also worked into a wet surface, sponging out superfluous detail and then dropping in rich spots or blobs of colour.[2]

Other artists favoured what could be described as a counter-intuitive tendency to opacity. Some aspired to rise above the challenges presented by medium specificity in claiming the primacy of their own inner vision above allegiance to received ideas of how the medium should be used to represent and express the external world. William Blake's antiquarian interest in the Middle Ages inspired him to revive the use of watercolour in illuminating his own visionary texts. Professing not to care about exhibition culture, he challenged the conventional association of the medium with naturalism and the sketch, and developed his own recipe for watercolour, harnessing opacity to his mission of visualising the unseen. Blake's lead was picked up by Dante Gabriel Rossetti, Edward Burne-Jones and artists in their circle (fig.3), who returned to the idea of drawing with the medium and deliberately set out to make their watercolours look like oils and vice versa to create distinctly

Fig.3
Edward Burne-Jones
1833–1898
Clerk Saunders 1861
Watercolour on paper
69.9 × 41.8 cm
Tate. Presented by
Mrs Wilfred Hadley through
the Art Fund 1927

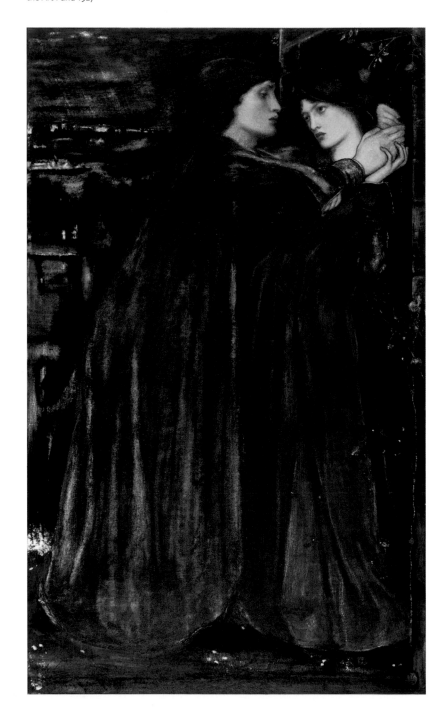

uncanny symbolist images. In contradicting the pliable and natural properties of watercolour with the addition of substances such as gum, glue and chalk, they aroused the indignation of both conservative critics and proto-Modernists such as James Abbott McNeill Whistler (fig.5). Hence the story of the frame-maker who tried to clean, and accidentally washed away, one of Burne-Jones's elaborate watercolours, believing it to be an oil painting. Whistler's reputed comment, 'Didn't I always say the man knew nothing about painting . . . They take his oils for water-colours and his water-colours for oils', provides insight into how the medium's potential for controversy resides more with issues of how paint is applied than what it is actually used to represent.[3]

While some nineteenth-century artists set out to eliminate differences between oil and watercolour in reviving medieval practices such as the illumination of manuscripts to create imaginative images, others insisted that the proper properties of watercolour rendered it ideal for illusionist purposes. They also appropriated earlier miniaturist techniques, building up the subject with small touches of the brush, but with the aim of depicting the external world, maintaining that only watercolour was capable of such detailed representation. The stipple method advanced by Turner was adapted for highly realist ends by William Henry Hunt (no.73) and John Frederick Lewis (no.54), both of whom employed gouache (bodycolour) and Chinese white for chromatic and mimetic purposes. As Ruskin declared: 'All disputes about the use of body-colour begin and end in the "to be or not to be" of accurate form. Not by any other means could Hunt have painted the bloom upon a peach, or Lewis a camel's eye.'[4] Contrary to instinct, the dotty stipple technique was ideal for mimesis in that it allowed for the creation of impressionist form through the application of minute touches of colour rather than by the artificial linking up of lines into a linear construction. Eventually this method became identified with Pointillism and in more recent times digital pixelation, now the most common optical means of registering illusionism. Nevertheless the return to looser painterly practices in the later nineteenth century, with the advent of Impressionism, resulted in a renewed emphasis on transparent washes as the right way to use the medium, encouraging a widespread appreciation

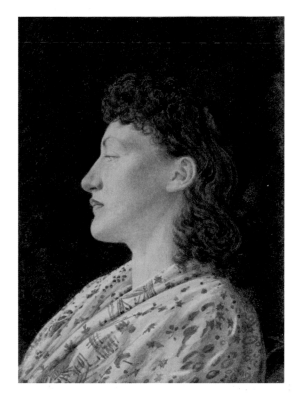

of the sketch as both a 'natural' mode of expression and an end in itself. By contrast the layering and complexity that distinguished both the realist art of Lewis and the symbolist work of Burne-Jones seemed static by comparison. This said, the idea that improvisation signified the essence of watercolour was just one way of appreciating a medium that had proved itself flexible enough to encompass drawing and painting in representing extremes of illusionism and abstraction.

Status

In the course of its complex history the status of watercolour has been contested across boundaries of class, gender and professional identity. From the time the Royal Academy (RA) was established as the most prestigious institution for promoting the fine arts in Britain, painters in watercolour developed what could be described as an inferiority complex when compared to artists working in other media. Their grievance was that their works often appeared poorly lit and badly displayed at public exhibition, besides which they were not granted the same privileges as painters in oil,

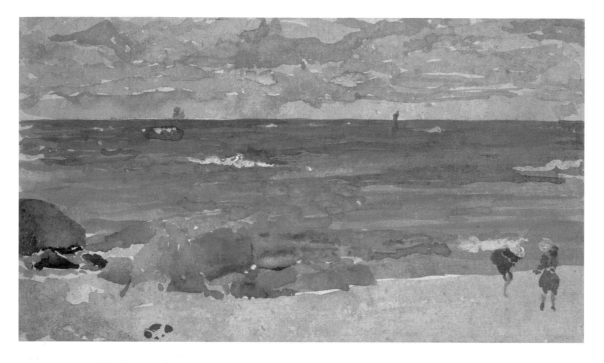

Fig.5
James Abbott McNeill Whistler
1834–1903
Beach Scene with Two Figures 1885–90
Watercolour and gouache on paper laid on card 12.5 × 21.3 cm
Birmingham Museums & Art Gallery

especially as they were not eligible for RA membership. These factors led to the establishment of the Society of Painters in Water-Colours in 1804 (SPWC) as a separate academy for artists working with the medium, reinforcing the segregation between the two practices. The widespread perception that watercolour involved artists replicating rather than inventing subjects further explains why it was conceptually separated from oil and accorded an inferior status.

Ordinary subjects or 'mere transcripts of the objects of natural history' were banned from Royal Academy exhibitions in the early years of the institution's existence, as they did not conform to Academic idealist theory.[5] However, such subjects suited watercolour, which further explains why painters in the medium found their reputation compromised by the Academy. The ambition to paint, rather than draw, with watercolour that set in during the nineteenth century was thus motivated by a concern to elevate the status of the profession and to claim for it an intellectual rather than a mere manual role. Exhibition culture not only encouraged artists to tackle history paintings but to harness style to the expression of individual personality, as did John Constable and

David Cox, for instance, the latter defending the 'rough' appearance of his mature watercolours as 'works of the mind'.[6]

Such aspirations have to be seen in the context that throughout the eighteenth century most watercolourists had to depend on hack-work for their livelihood: working for the publishing industry, as drawing masters, producing records of foreign scenes for grand tourists or diplomats in Britain's overseas colonies. Thomas Hearne thus travelled to the Leeward Islands in the Caribbean in 1771 as draughtsman to the new Governor General Sir Ralph Payne; while John Robert Cozens made two journeys to Italy, the first in 1776 with the connoisseur and collector Richard Payne Knight, the second with William Beckford in 1782. Botanical specialists were frequently employed on expeditions of discovery, such as Sydney Parkinson who joined the botanist Joseph Banks on Captain Cook's fated HMS *Endeavour*, dying of dysentery after completing hundreds of plant and animal studies (see no.25). By contrast the amateurs whom professional artists were obliged to instruct (typically clergymen and antiquarians as well as ladies) took to the medium as both a recreation and a useful

accomplishment, believing it to be relaxing, uncomplicated and untainted by pressures of commercial enterprise. However, the growth of exhibition culture and the development of more effective modes of transport in the nineteenth century gave artists the confidence to travel on their own terms, without having to be in the employ of a gentleman, especially as the new exhibition societies, the SPWC and the New Society of Painters in Water-Colours formed in 1831, provided selling space for the results. J.F. Lewis visited Spain in 1832–4 and in 1840–1 travelled via Italy, Greece and Turkey to Cairo, where he remained for the next ten years. Between 1854 and 1892 William Holman Hunt made four trips to the Holy Land with the aim of producing archaeologically accurate works for public exhibition. By the 1840s Richard Dadd must therefore have seemed to his contemporaries somewhat old-fashioned when he accompanied Sir Thomas Phillips as a paid travelling artist on a tour of the Middle East (no.52).

The emergence of the professional watercolourist in the early nineteenth century came in tandem with the rise of a distinct middle-class art-world culture and development of specialist professions. Not only were more people practising watercolour at this time, a shift encouraged by the commercial distribution of instruction manuals and a wider range of affordable materials, but many more were purchasing it, too, from exhibitions, dealers or direct from the artist. Watercolours were generally cheaper than oils, being modest in scale, and because they tended to be pleasing in terms of subject matter were considered ideal for a domestic environment. According to Martin Hardie, watercolours were typically hung three rows deep on a drawing-room wall, and Ruskin, whose *Elements of Drawing* of 1857 encouraged vast numbers of amateurs to take up the brush, did much to promulgate the democratic virtues of the new bourgeois aesthetic in his *Notes on Prout and Hunt* of 1879–80:

> It is especially to be remembered that drawings of this simple character were made for these same middle classes, exclusively; and even for the second order of the middle classes, more accurately expressed by the term *bourgeoisie*. The great people always bought Canaletto, not Prout, and Van Huysum, not Hunt. There was indeed no

quality in the bright little water-colours which could look no other than pert in ghostly corridors, and petty in halls of state; but they gave an unquestionable tone of liberal-mindedness to a suburban villa, and were the cheerfullest possible decorations for a moderate-sized breakfast-parlour opening on a nicely-mown lawn.[7]

The association between watercolour and the private sphere also cast the technique as an appropriate activity for women, the medium being regarded as delicate and non-odorous and therefore not too taxing on the feminine physique. This kind of thinking led some to demean watercolour as a trivial pursuit, with the consequence that the term 'professionalism' was increasingly employed to establish a boundary between male practitioners, dependent upon the medium for their livelihood, and amateur lady enthusiasts. Although watercolour was in fact an accepted area where women could promote themselves in public life, as evinced by the large numbers of female artists exhibiting from the 1840s, they were nevertheless barred from full membership of the Society of Painters in Water-Colours until 1889, the first full-time member being Helen Allingham, who was elected in 1890. At London's fashionable Grosvenor Gallery, women were expected to exhibit watercolours rather than oils, and they were assigned a separate space, which lent the watercolour room a gendered aspect.[8]

The connection between watercolour and the private sphere persisted throughout the twentieth century up to the present day, which may help explain why the medium still tends to be associated with amateur practice. There is a revealing passage in Evelyn Waugh's novel *Brideshead Revisited* (1945), in which the character Charles Ryder recalls that his father belonged to a generation that divided painters into the serious and the amateur according to whether they used oil or water.[9] The perceived lack of sophistication and the small scale of watercolour, together with the widely held attitude that it is a medium for dabbling in, may help explain why it became devalued in the twentieth century and still does not feature significantly in the curriculum of most art schools. Patrick Procktor (no.64) did not once glimpse a watercolour box when he was at the Slade School of Fine Art in the late 1950s.[10] Likewise Rebecca Salter

(fig.8) remembers the technique being dismissed as a somewhat effeminate pastime when she studied art at Bristol Polytechnic in the mid-1970s. There are of course exceptions, such as the Prince's Drawing School in Shoreditch, London, established by HRH the Prince of Wales in 2000 for the in-depth teaching of observational skills. But on the whole it would be true to say that today watercolour flourishes more on the margins than at the centre of vanguard artistic practice – among children, hobbyists and amateur groups comprised in the main of the retired and elderly. And what links these groups is the idea of watercolour as a means of connecting oneself with the immediate environment, together with the restorative, therapeutic benefits of this engagement.

The therapeutic watercolour

Watercolour's potential as a convalescing agent goes back to the eighteenth century, when it was recommended as an appropriate activity to help guide an invalid back to health and to divert patients from the trauma and tedium of their situation. Moreover, its generally non-toxic properties made it suitable for artists of delicate health. It was during the nineteenth century that watercolour started to be regularly prescribed as a gentle cognitive exercise for the mentally ill by physicians such as Dr William Browne, first superintendent of the Crichton Royal Institution in Dumfries (1838–57), under whose guidance patients were encouraged to engage in artistic practices to alleviate their condition. The watercolours produced by female patients in his care reflect exactly the subjects considered appropriate for respectable women in society. At Bethlem Hospital in London women were also encouraged to paint with watercolour for remedial purposes.[11]

One of the most prominent London physicians specialising in insanity was Dr Thomas Monro, visiting physician at Bethlem, then in Moorfields in the City of London, between 1787 and 1815, who treated J.R. Cozens between 1794 and his death in 1797. Cozens, who developed an undiagnosed mental illness, was renowned for developing a poetic, introspective kind of landscape painting and was an important influence on the romantic generation (no.37). His father, Alexander Cozens, had been significant in advancing

a method called 'blotting', which recommended the use of accidental inkblots for the suggestion of landscape motifs to aspiring amateurs (see nos.133, 134). Although Cozens's method was considered too subjective by some of the early historians of the medium, his ideas fed the growing interest in psychology and spiritualism that ensued during the nineteenth century, encouraging a number of, mainly amateur, artists to experiment with ink stains to stir the imagination. The French writer Victor Hugo, for instance, drew with ink in an automatic way to access the unconscious, using accidental blots to extrapolate recognisable forms (no.106). Some sixty years later, in 1921, the Swiss psychiatrist Hermann Rorschach developed a more clinical explanation of the blot technique, discovering in people's tendency to 'read' into the chance configurations made by inkblots their own deep anxieties and preoccupations. The notion that the immediacy and transparency of watercolour could function as a reflex of the unconscious, fuelled the Surrealist doctrine of psychic automatism, which encouraged artists to paint with ambiguous watery substances to release hidden desires and impulses. This practice can been see in the work of Ithell Colquhoun, who during the 1940s experimented with stained surfaces for purposes of divination and to explore ideas of metamorphic transformation (no.121).

These introspective uses of watercolour allowed the medium to float back to the centre of artistic practice. The modern art world has been fascinated with naive forms of expression and, during the twentieth century, art that had traditionally been marginalised was transported back into the mainstream by Modernism by virtue of its outsider status, with the result that the periphery took on its own aesthetic attraction. The growing interest in 'primitive' and child art at this time, as manifest in movements such as Art Brut and terms like Outsider art, saw artists tapping into the amateur or invalid strain in watercolour practice for aesthetic and psychological purposes. Edward Burra, who suffered from rheumatoid arthritis from an early age coupled with anaemia, found watercolour easier to manipulate in his crippled hands than oil (nos.58, 63, 93, 94). He was rare in painting exclusively with the medium during the twentieth century, producing strange, audacious works reminiscent of the Symbolists, which

eschew atmospheric effects in favour of clearly defined forms compressed in shallow claustrophobic environments. Bedridden with alcohol- induced peripheral neuritis in the early 1970s and unable to paint on a large scale, Roger Hilton used his one functioning arm to draw with children's poster paints. The crude childlike works he produced with this material provide testimony to his illness and addiction (see no.138). The artist Lucia Nogueira took to the medium when partially paralysed with cancer towards the end of her life, finding it easier to use than other methods. The intimate works she produced in pencil and watercolour almost seem to revert to an infantile stage of development, consisting of simple hieroglyphs often based on childhood storybook characters (no.123).

That such works traverse the boundaries of what might be termed therapy and artistic expression says much for the interior direction avant-garde water-colour practice came to takein sharp contradistinction to the illusionistic picturesque conventions associated with the genre in the past or, to put it another way, the marginal came to be recycled as a more public, even mainstream, form of confessional expressionism at this time. Several of the contemporary watercolours included in this exhibition could thus be seen to engage with an 'outsider' tradition in that they display a greater sense of affiliation with marginal and repressed traditions than with the golden age aesthetic, with some works evoking the naivety of children's drawings, featuring small motifs painted with barely articulated strokes of paint surrounded by large expanses of untouched paper. Describing Tracey Emin's *After My Abortion* watercolours, one commen-tator recently noted, 'Emin belongs to a tradition of outsider art ... her watercolours are anaemic to the point of invisibility'.[12] Whether the link back to amateur art or to the diagnostic use of watercolour in psycho-analysis, displayed in the drawings of artists like Emin and Sophie von Hellermann (nos.125, 132) is self-conscious or not, these works certainly resonate as such in the mind of the beholder, especially as they address themes associated with this kind of practice such as alienation, communication and the burden of memory.

A national tradition?

Watercolour has long been regarded as an innately British medium, the natural means of expression for an island race accustomed to a varied and unpre-dictable climate. Watercolour will freeze or bake on paper in extreme cold or heat, but it generally behaves in temperate conditions hence its association with English landscape in particular. The focus on watercolour landscape painting as a peculiarly British phenomenon gathered momentum during the nineteenth century, and was largely projected by the watercolour societies bent on establishing the reputation of their profession by demonstrating how it had evolved from humble beginnings as tinted drawing to a full-blown art form in the works produced by a succession of heroes. Their sculpted portraits still proudly adorn the façade of the Royal Institute of Painters in Water-Colours in Piccadilly, which opened at its new premises in 1883. According to the standard histories of watercolour published in the nineteenth century, the story began with Paul Sandby, whose topographical works paved the way for the poetic style of J.R. Cozens and Girtin, leading the British school to climax with the art of Turner, whose dazzling mark-making represented the culmination of British genius and originality.

The patriotic notion of 'triumph' that underscored this narrative also contained within it the idea that the delicacy and flexibility of the medium somehow encapsulated the essence of British character – its reserve, independence and tendency to view the world empirically rather than in obeisance to any abstract or ideological system. Writing in 1905, A.J. Finberg described watercolour as 'an intimate, personal, conversational' medium, the expression of 'a society in which the rights of individuals have been very largely insisted upon and the claims of authority and tradition somewhat ignored'. For Finberg watercolour did not demand a large audience but rather appealed to a community of individuals knitted together by ties of thoughts and sympathies held in common.[13] Further to this it should be emphasised that the concept of the amateur has been important for a certain idea of English decency and eccentricity, the idea being that a profession was vulgar, beneath a true gentleman. Watercolour is often seen to epitomise the individuality

and magnanimity of this ideal by virtue of its faux-amateur properties, despite the efforts of artists to professionalise the practice in the past.

The development of watercolour in Britain during the nineteenth century is often related to its independence from other traditions. It was considered to have blossomed and assumed a distinct identity as pure watercolour when Britain was cut off from the Continent during the Napoleonic Wars (1799–1815), and then flourished as a national art form when Britain emerged as a dominant world power. The first exhibition of the SPWC in 1805 has thus been regarded as a defining moment in the history of British art, signalling watercolour's claim to both fine art and professional status, as well as the idea that it was the invention of British artists.[14] This standard claim, with its clearly defined chronological perimeters, technical focus and canon of greats, is evolutionary in structure and tends to give way to a sense of decline in the twentieth century as fewer artists chose to make their reputation with the medium. There are moments of reprise, such as when watercolour was galvanised for the purpose of recording and protecting sites threatened by destruction or development in the Recording Britain and official war art-schemes of the 1940s, but the paucity of literature on the later history of the medium in contrast with the earlier period is testimony enough to its diminishing status. Those artists who do appear in surveys tend to be isolated figures estranged from a tradition, like Burra or David Jones (nos.119, 120), whose work can be viewed as a holistic vision of Britain where ancient myths revivify a sense of oneness with the past. In more recent times, when watercolour has been tarnished with the taint of amateurism and nostalgia by harking back to a conservative and unchanging ideal of the English landscape, the pastoral mode which gave English watercolour its distinct identity is no longer recognised as a genre through which any progressive artist would want to make their reputation.

The decline in the number of established artists working with traditional categories of watercolour in the present day has also contributed to the impression of an earlier supposed golden age, the period of roughly 1750–1850, both in contrast to other traditions and out of all proportion to what it actually achieved. Thus for some historians of the medium,

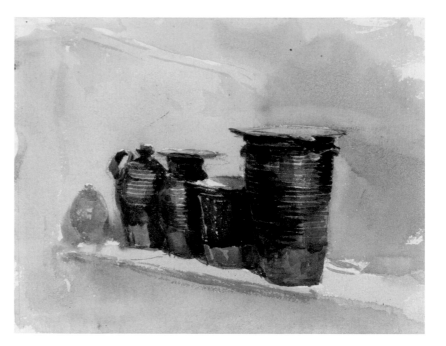

Fig.6
David Cox 1783–1859
Still Life
Watercolour on paper
17.1 × 21 cm
Tate. Bequeathed by
J.R. Holliday 1927

Impressionism was only a recovery of the freshness and lightness of touch that distinguished the work of Cox and Turner (figs.6, 14), and the classicism of Paul Cézanne a re-invention of the structural designs of Towne and Cotman.[15] Moreover, the triumphal tone of so much literature on watercolour has inadvertently worked to impose a barrier between early historic watercolour and its subsequent history, reinforcing the idea of a once glorious tradition that cannot be recovered or surpassed in the present. It is hardly surprising that, with perhaps the exception of Turner, the study and collecting of historic British watercolour has become a niche activity, alienated from the mainstream, the province of cultivated specialists rather than younger collectors for whom the 'brown' aesthetic of watercolour appears out of place in the cool minimalist space of a modern interior. And yet the idea of watercolour being a national art has never been convincingly watertight. Most historians of the medium have acknowledged that it originated in the work of itinerant artists such as Anthony van Dyck (no.4) and Wenceslaus Hollar (no.5). Even those writers like Finberg and Laurence Binyon who elevated the medium as the distinctive natural art of England were suspicious of the evolutionary model, arguing instead for an array of diverse artists who fragmented the

Fig.7
John Sell Cotman 1782–1842
On the Downs c.1835
Watercolour and gouache
on paper 23.5 × 39 cm
Private collection

practice rather than a linear history .[16] This view supports the widely held supposition that British art was premised on notions of individuality and difference from Continental schools, ideas that do not of course prove the medium's native status. The idea of a grand tradition of personalities that might yet be resuscitated in the present is very much alive, for example, in the watercolour art of Christopher Le Brun (no.122), which celebrates the 'strangeness' of the English Romantic tradition as exemplified by artists such as Samuel Palmer (nos.78, 102), Turner and Paul Nash (nos.92, 117, 118). For Le Brun the intimacy and directness of watercolour acts as a kind of lubrication on the memory, allowing for the easy transmission of images across time.[17]

At various moments artists and writers have challenged the hegemony of the English topographical tradition and the ideal of transparency in the history of watercolour, arguing that the roots of the medium go deeper into the past, back to medieval illumination where opaque paint was employed to strengthen the impact of gold. Blake, Rossetti and Burne-Jones all paid homage to this alternative tradition as the foundation for the densely worked figurative art they practised, as we have seen. Their lead was picked up by Neo-Romantics like John Piper (nos.61, 62), Nash and Jones, who likewise favoured the medium as the substance used by illuminators of ancient manuscripts. And although Jones could extol watercolour as the 'materia poetica' of Britain, he nevertheless recognised that it was important to other civilisations and cultures as well.[18] In fact the so-called intrinsic British character of the medium has not gone unchallenged, with specialists noting affinities with other, older traditions, notably Chinese and Japanese art. Binyon (Keeper both of the Department of Western Prints and Drawings and of Chinese Art at the British Museum) could thus relate the simplicity of colour and design in the work of Cotman to the landscape woodcuts of Hokusai, noting that the Englishness of the medium was simultaneously its global appeal. The Chinese

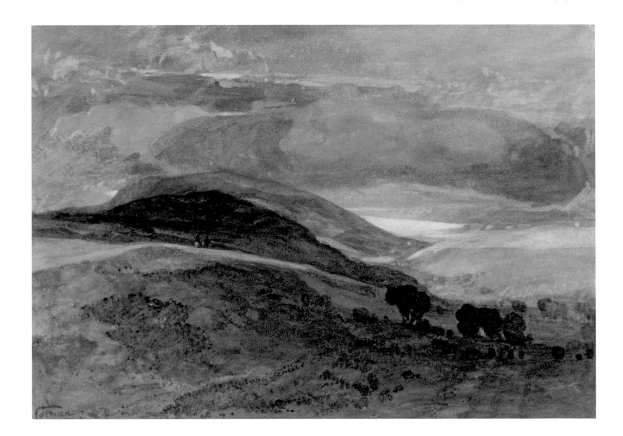

Fig.8
Rebecca Salter b.1955
untitled RR40 2009
Watercolour on paper
122 × 99 cm
Courtesy the artist and
Beardsmore Gallery, London

artist Chaing Yee similarly saw no real distinction between the two schools:

The more familiar I become with English water-colours, the more points of similarity I find between them and our paintings. The treatment in the black-and-white wash drawings of Cotman, Cozens, Constable and Cameron, make me believe there is really no boundary between English and Chinese art at all. Once Mr A.P. Oppé was kind enough to ask me to dine with him and to show me his lovely collection of drawings by Cotman and Cozens. Among them was a tiger by Cozens. Mr Oppé told me that the artist had found a tiger taking shape before his eyes. This is just the Chinese way of making a painting.[19]

The development of new approaches to the history of watercolour in Britain in recent years has done much to undermine the authority of the grand narra-tive projected in the past, by emphasising institutional history, amateur practice and different schools of watercolour above the notion of a succession of greats, revealing watercolour to be a subject fraught with schisms and uneven in its development.[20] The widespread awareness of issues relating to cultural diversity has also made the British appellation the subject of scrutiny. Historians and critics are now careful to nuance their approach to matters of national and regional identity, questioning, for example, the 'Scottishness' of Melville and the Glasgow school, or

the 'Welsh' character of David Cox's Betwys-y-Coed landscapes. With artists operating within a global network of contacts and influences, it is even possible to contend that the British designation has become redundant and no longer applicable to contemporary practice. But by the same token, signs of British identity have become available to anyone working within that global network. The Swiss artist Uwe Wittwer (no.98), whose watercolour technique has been informed by the pure monochrome method of Constable and Girtin, thus might be said to have more in common with the historic British school than a native-born painter like Rebecca Salter (fig.8) whose art takes its direction from a close study of the Japanese woodblock process. In an era when media heterogeneity has disturbed previous conceptions of purity, the distinctness of the medium is now at stake. Indeed, watercolour, now often considered to be a branch of drawing, has arguably returned to an earlier, more hybrid, stage of its existence, used in conjunc-tion with, and viewed alongside, works in other media. Looking beyond the modernist trajectory, there is arguably less of a hierarchy among materials today with artists working freely across media according to what they want to communicate. Watercolour, like Britishness, is part of a complex global visual culture, yet what it offers to that culture is precisely what has been inherited from the rich traditions explored in this exhibition.

NOTES

References to publications are given in full in the Bibliography, pp.200–1.

1 Ruskin 1903–12, vol.33, p.382.
2 See Moorby and Warrell 2010; on Hunt, Newall 1987, p.18; on Melville, Hardie 1968, vol.3, p.201.
3 Binyon 1946, p.163; Rothenstein 1935, p.114.
4 Ruskin, quoted in Hardie 1968, vol.3, p.107.
5 RA Council Minutes [n.d.], vol.6, p.207, quoted in Hutchison 1986, p.82.
6 Letter from the artist to his son, David Cox Jr., 18 April 1853, quoted in Solly 1873, pp.228–9.

7 Hardie 1968, vol.3, p.102; Ruskin 1903–12, vol.14, p.373.
8 Cherry 1993, p.66; Casteras and Denney 1996, p.3.
9 Evelyn Waugh, *Brideshead Revisited* (1945) Harmondsworth 2000, p.135.
10 John McEwan, Patrick Procktor obituary, *Independent*, 4 September 2003.
11 Park 2010, pp.xvi, 63.
12 Alastair Sooke, 'Tracey Emin: Dirty Sheets and All', *Daily Telegraph*, 5 August 2008.
13 Finberg 1905, p.2.
14 Introduction to the catalogue of the 1821 SPWC exhibition; see Bayard 1981, p.7.

15 Finberg 1905, p.182; Binyon 1946, p.165; Ayrton 1947, pp.106–8.
16 Finberg 1905, pp.5–11; Binyon 1946, p.10; Greg Smith, 'Watercolour: Purpose and Practice', in Fenwick and Smith 1997, pp.1–30.
17 Interview with author, 1 February 2010.
18 Blamires 1971, p.33.
19 Binyon 1946, pp.55–6; Yee 1943, pp.161–2. This drawing is now in Tate as part of the Oppé Collection.
20 See, for example, Johnson 1994; Sloan 2000; Smith 2002; Myrone 2010.

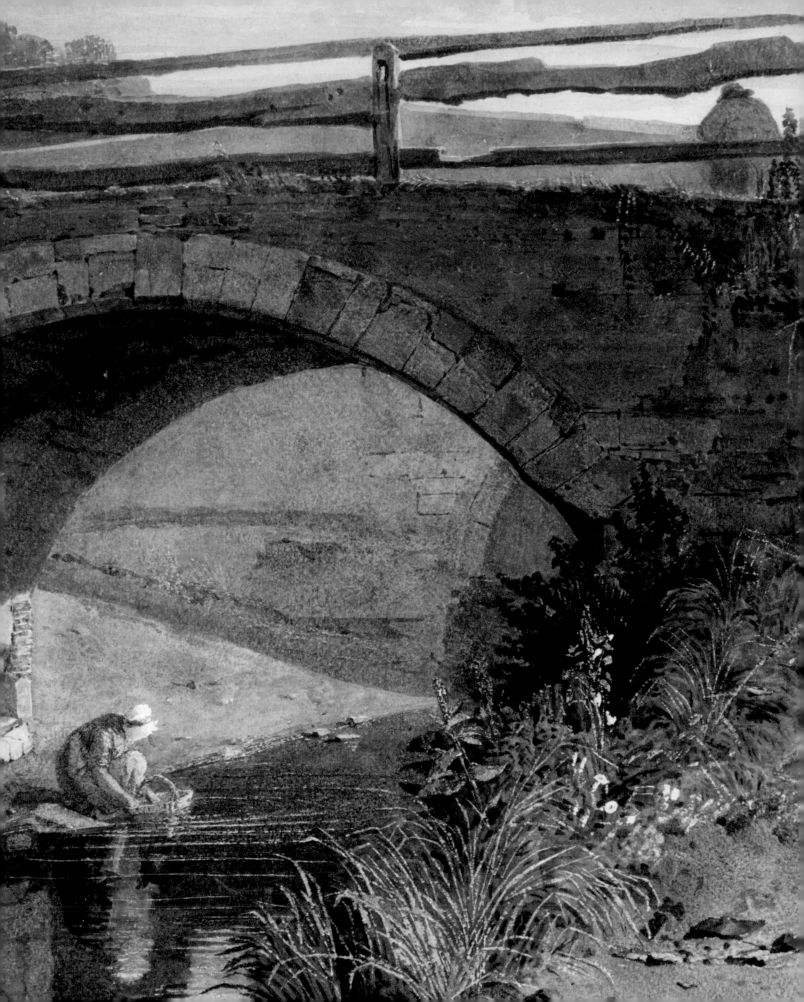

Water + colour: Exploring the Medium

Nicola Moorby

It is no coincidence that many collectors during the so-called 'golden age' of British watercolour (c.1750–1850) were also amateur practitioners with hands-on experience of working with the medium. This is because, unlike other types of painting, the key to truly appreciating watercolour is a basic understanding of how to use it. Like any visual art form, it has its own range of specialist tools and techniques, but unique to the discipline is the fundamental nature of the relationship between the properties of the paint and the ways in which it can be applied. Artistic ability aside, it is quite straightforward to draw a sketch, for example, without needing to understand the construction of a graphite pencil. Equally, on a very simple level, it is entirely possible to put oil on a canvas by simply squeezing some out of a tube and applying it with a brush. The paint will stay where it is placed, the colour will retain its hue and mistakes can be scraped off or covered up. By contrast, the 'water' component of 'watercolour' means that it is much trickier to use without some knowledge and anticipation of its physical characteristics. As anyone who has ever tried using it will know, the paint is prone to behave in ways that have nothing to do with the will of the artist. Wet colours (known as washes) have a habit of running in the wrong direction or bleeding into one another, of settling unevenly and of losing their intensity when dry. It is difficult to correct or hide mistakes, and virtually impossible to replicate effects in the exact same manner. Finally, the need to work from light to dark (rather than dark to light, as is more usual in oil painting) means that it is generally necessary to plan the various stages of a composition in advance, whilst also being able to respond to spontaneous, unpredictable occurrences.

Yet despite its technical challenges, watercolour remains one of the most accessible and widely used art forms, being relatively inexpensive, portable and easy to clean up. Children are most likely to be introduced to creative art with some sort of water-soluble paint, and outside the professional art world it is the medium most adults take up later in life. In fact the long-established tradition of amateur watercolour painting dates back to the late sixteenth century and its mass appeal remains undiminished today. Its qualities can be as exciting as they are frustrating, and it has a freshness and luminosity that is unmatched by any other material.

What is watercolour?

As its name suggests, watercolour paint is essentially comprised of extremely small particles of pigment (raw colour made from natural or man-made materials), which are diluted and dispersed with water. A crucial addition, however, is some kind of sticky binding agent such as a plant gum, which holds the colour together and makes it adhere to the paper or other surface support. Without this component (known as a colloid agent) the water would simply evaporate to leave a brittle, dry residue, which could be brushed away at the slightest touch. Finally, watercolours usually also contain various other additives such as glycerine, ox-gall, or honey, to alter the appearance and handling properties of the paint, for example, making it thicker, thinner or smoother to apply.[1] In its loosest sense, the definition can be applied to any painting material that is soluble in water, including tempera, gouache, poster or powder paints, inks and watercolour pencils. Most commonly, however, paints are made by mixing pigment with gum arabic (a water-soluble gum derived from the sap of acacia trees), and it is this type of watercolour that can be found in the paint boxes of professionals and amateurs alike all over the world.

Peter de Wint
Bridge over a Branch of the Wytham, Lincolnshire
(detail, fig.20)

A brief history of materials

For most artists the apparatus of watercolour painting has remained virtually unchanged over the last two hundred years. A standard set of equipment usually comprises paints, sable or 'camel' hair brushes (actually squirrel), palettes or mixing trays, paper and pots for water, as well some type of absorbent material to soak up excess liquid such as rags, sponges or tissue. Even the most basic chromatic range of six to eight colours can easily be expanded through tonal mixing on a palette or in shallow ceramic saucers. Modern advances in technology have led to a greater range of manufactured pigments, but the essential tools are the same. Indeed, whilst a nineteenth-century artist might be bewildered by virtually every other aspect of twenty-first-century life, he or she would be perfectly comfortable handling a contemporary paint box, and would even recognise many of the big names in watercolour merchandising, such as Reeves or Winsor & Newton for paints, and Whatman for paper.

Prior to the eighteenth century it had been necessary to grind and mix paints by hand, combining powdered pigment with water and gum arabic using a muller and a glass or stone plate (fig.11).[2] From the late eighteenth century onwards it became simpler and more convenient to buy them ready-made from specialist suppliers known as colourmen. Pre-prepared in the form of small cakes or pans, and often stamped with the mark of the manufacturer, these paints could be presented in an appealing wooden container with fitted compartments for brushes, ceramic or porcelain dishes and other bits and bobs (fig.10). During the British 'golden age', the emergence of watercolour as an independent art form, as well as its widespread popularity among non-professional men and women, created a huge market for all its practical paraphernalia, and the nineteenth century in particular witnessed the extensive commercialisation of the medium. Commodities came in all shapes and sizes

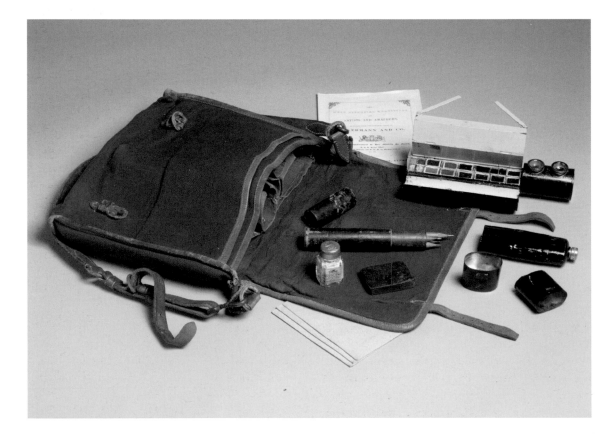

Fig.9
Winsor & Newton
painting satchel owned by
Queen Victoria
Canvas and leather
Royal Academy of Arts,
London

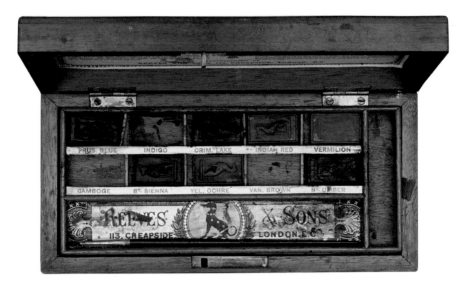

Fig.10
Reeves watercolour blocks
and box, 1860s
Tate Conservation Archive

Fig.11
Natural ultramarine being
ground in gum arabic,
using a small muller on
a glass plate

and at prices to suit all purses, from cheap and compact metal starter kits, to deluxe decorative boxes and furniture for the luxury home. One of the best-selling products was a shilling colourbox in japanned tin. Introduced in 1853, its manufacturer Rogers sold eleven million in less than twenty years.[3] Also popular was portable equipment for working in the field. For the most famous amateur watercolourist of the day, Queen Victoria, Winsor & Newton produced a functional canvas satchel complete with pencils, paints, paper and a tubular metal paint box with attachments for holding water (fig.9). This kind of apparatus would probably have been used outside in conjunction with a small wooden easel, an umbrella and a hand-held palette such as those used by John Singer Sargent's sister, Emily, in *Miss Eliza Wedgwood and Miss Sargent Sketching* 1908 (fig.23).

Aside from paints, the most crucial component in the art of watercolour is paper. Due to the inherent transparency of watercolour wash, the support plays an active role in the final appearance of a picture as well as affecting the behaviour of the wet paint as it is applied. A paper that is too absorbent, like blotting paper, soaks colour into the fibres rather than allowing it to sit on the surface. The best papers for watercolour therefore are generally 'sized', meaning that they have been treated with a substance (such as gelatine) that makes them less absorbent and therefore better suited to holding paint. The surface of a sized

sheet can take a significantly greater amount of wear and tear than one that has not been sized, giving the artist greater freedom for manipulating and reworking washes. In addition, extensive pre-soaking, as well as wiping, scraping or rubbing, dilutes or eliminates the size, changing the way the watercolour interacts with the paper surface.

The most revolutionary development in paper manufacture for watercolour was the invention during the second half of the eighteenth century of 'wove' paper. Prior to this time all paper was 'laid', meaning that it was made by pressing pulp on to a mould of parallel rectilinear wires so that a ribbed, grid-like pattern was impressed into the sheets. Even when the paper was covered with watercolour these lines tended

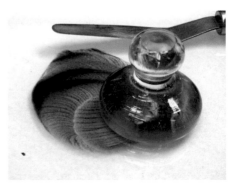

to remain clearly visible, as in Samuel Scott's study of a lady (fig.12). During the 1750s, the Kent papermaker James Whatman senior, substituted the grid with a wire mesh of fine weave, which left no discernible mark upon the finished product.[4] This new 'wove' paper was ideal for receiving transparent washes and, by the end of the century, it had come into general use. Thomas Gainsborough (1727–88) summed up the widespread approval of the artistic community when he described it as 'so completely what I have long been in search of'.[5]

The implications for painting with watercolour are different depending on whether the paper is thick, thin, rough, smooth, white or coloured, hand- or machine-made, and each artist chooses according to their individual requirements. Thomas Girtin, for example, favoured the smooth consistency and mellow tone of 'cartridge' paper.[6] By contrast, David Cox preferred very thick coarse wove sheets, which suited his tendency to work with a large brush saturated with wet paint.[7] The texture of the paper is clearly visible in his study of jars on a shelf, where the uniform

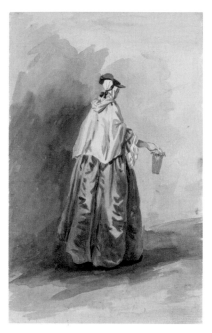

Fig.12
Samuel Scott C.1702–1772
*A Lady in Full Dress,
Seen from Behind*
Pencil and watercolour
on paper 24.3 × 15.3 cm
Tate. Purchased as part of
the Oppé Collection with
assistance from the National
Lottery through the
Heritage Lottery Fund 1996

Detail showing the lines
visible in the laid paper

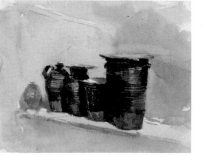

Fig.13
David Cox 1783–1859
Still Life
(see fig.6 for larger illustration)

Detail of the paper texture

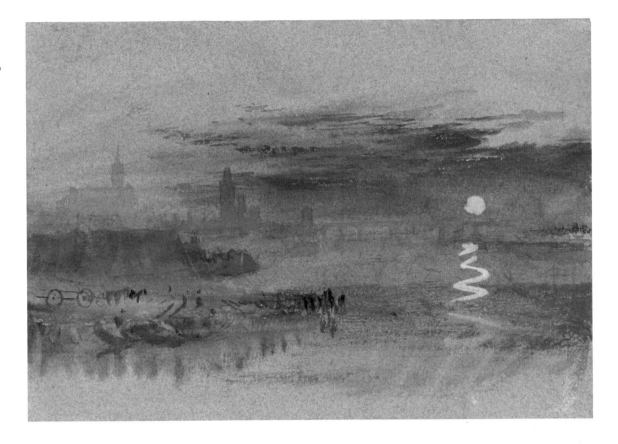

Fig.14
Joseph Mallord William Turner 1775–1851
The Scarlet Sunset c.1830–40
Watercolour and gouache on paper 13.4 × 18.9 cm
Tate. Accepted by the nation as part of the Turner Bequest 1856

appearance of the wash has been modified by the high points and hollows in the rough, granular surface (fig.13). One of the most experimental watercolourists was J.M.W. Turner, who used an immense array of papers, both British and Continental, according to his changing needs.[8] He is perhaps best remembered for his unusual adoption of blue paper, which provided an excellent background for the application of gouache (also known as bodycolour), a type of watercolour made opaque by the addition of white pigment. Turner made effective use of gouache in small-scale, vibrantly coloured landscapes such as *The Scarlet Sunset* c.1830–40 (fig.14), most noticeably in the dense patches of red in the sky, the dramatic yellow sun and the calligraphic flourish of its reflected light.

Purists regard the use of opaque gouache as a corruption of watercolour practice, seeing it as a betrayal of its characteristic transparency. However, it is symptomatic of the exceptional flexibility of the medium. Watercolour lends itself to physical modification and there is an attendant tradition of material experimentation. Many painters past and present have adopted a hands-on approach to changing, customising or enhancing the ingredients. The eighteenth-century watercolourist, Paul Sandby, for example, was famous for adding different substances to his paints, such as gin to accelerate the drying process, or the burnt scrapings from his breakfast roll to create a particular shade of black.[9] Similarly the French writer Victor Hugo (no.106) painted countless ink and watercolour studies incorporating unorthodox matter such as soot, dust, blood and coffee.[10] During the 1950s and 1960s, practitioners began to take up the new medium of acrylic, which can be diluted and used to resemble watercolours (although unlike other water-soluble paints they become water-resistant when dry; see no.144). Artists today continue to stretch our understanding through non-traditional approaches. Anish Kapoor, for example, has made 'drawings' combining pigment with other materials which can be seen as 'sounding boards' for his sculptural practice (fig.15).[11] Andy Goldsworthy, meanwhile, has created a

series of paintings using a snowball stained with natural dyes from elderberries, slate and earth.[12] In *Source of Scaur* 1991–2 (fig.1), the fluid, melting snow has mingled with pulverised red stone from the river bed of Scaur Water in Scotland to leave evocative pools and trails. Rebecca Salter uses mixed media on various supports such as linen, aluminium and gesso panel as well as paper, and works by rubbing and manipulating the paint with chopsticks and other unconventional utensils (fig.8).

Watercolour techniques: traditions and innovations

Aside from changes in materials, watercolour has undergone several shifts over the centuries in the way it has been used, and artists have gradually developed a range of processes designed to harness and exploit the unique characteristics of the medium. Sometimes these changes have been prompted by manufacturing innovations, and at other times by aesthetic tastes and sensibilities. In general, however, the evolution of watercolour has been compelled by its two most distinctive qualities, its liquidity (or wateriness) and its transparency (the way that light is reflected from the paper beneath). Almost since its emergence, an abundance of literature has been devoted to demystifying its terminologies and techniques, and huge numbers of books are still published every year designed to instruct and encourage the average painter.

The forerunner of the practical watercolour manual was a small treatise written around 1627 by Edward Norgate, entitled *Miniatura, or the Art of Limning*.[13] Derived from the Latin 'luminare', to give light, and the Middle English 'limnen', to illuminate, the word 'limning' was an early term for painting in watercolour and reflects the use of intense, densely applied colour for the decoration of handwritten medieval illuminated manuscripts (nos.2, 3). At this point the type of paint employed was often fast-drying tempera (pigment traditionally mixed with egg yolk), to create glowing, jewel-like images enhanced with gold or silver leaf. By the sixteenth and early seventeenth centuries, the definition had extended to the production of portrait miniatures, small likenesses painted on smooth animal skin, known as vellum (see fig.21, and nos.12–15, 17, 18). The technique was highly involved

and laborious.[14] First the translucent vellum was pasted to a thin piece of card (often a playing card) to produce a firm, white background, before being burnished with an animal tooth to create a smooth surface. The artist would then have to prepare his paints by grinding raw pigments to a fine powder and mixing them with water and gum. Norgate advocated the use of mussel or mother-of-pearl shells as containers for the different colours. The first stage of the portrait was created by painting a flesh tone for the skin known as the 'carnation', before adding the outline and details of the face with tiny brushstrokes. As is clear from Isaac Oliver's unfinished portrait of *Prince Charles* c.1615–16 (fig.16), the costume and background were then built up with thinner washes followed by denser dabs and dots of paint to create areas of solid, rich colour. During the eighteenth century, thin slices of ivory replaced vellum as the preferred material for miniature painting (see no.16). The surface of the ivory had to be roughened or de-greased to make it more absorbent, and there was a corresponding change in paints, which were now prepared with a higher proportion of gum arabic to make them stickier.

The concentrated, opaque paint of the portrait miniature was quite different to the type of watercolour employed within another genre, the eighteenth

Fig.15
Anish Kapoor b.1954
Untitled 1990
Earth, PVA and gouache
on paper 56.2 × 76.1 cm
Tate. Presented by
the artist 1991

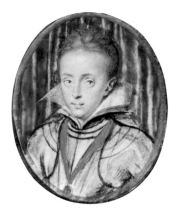

century 'stained' or 'tinted' drawing, introduced to
England a century earlier by the Bohemian artist,
Wenceslaus Hollar (see no.5). A classic description
of this type of painting was provided by the naturalist,
Gilbert White, who outlined the working methods of
Samuel Hieronymous Grimm. According to White,
the artist

> first of all sketches his [land]scapes with a lead-
> pencil; then he pens them all over, as he calls it,
> with indian ink rubbing out the superfluous pencil-
> strokes, then he gives a charming shading with a
> brush dipped in indian ink; and at last he throws
> a light tinge of water-colours over the whole.[15]

The main compositional base of a tinted picture was
the underlying wash of monochrome ink, known as
'dead colouring', and any subsequent washes of water-
colour were very thin, subtle and subdued. They
simply formed touches of local colour, but added no
spatial modelling or suggestion of atmosphere, as, for
example, in the green hue of the grass or the faint hint
of icy blue on the surface of the glacier, in Grimm's
The Glacier of Simmenthal 1774 (fig.17). Tinted drawings
were commonly stored in portfolios but displayed
within a bespoke setting known as a washline mount.[16]

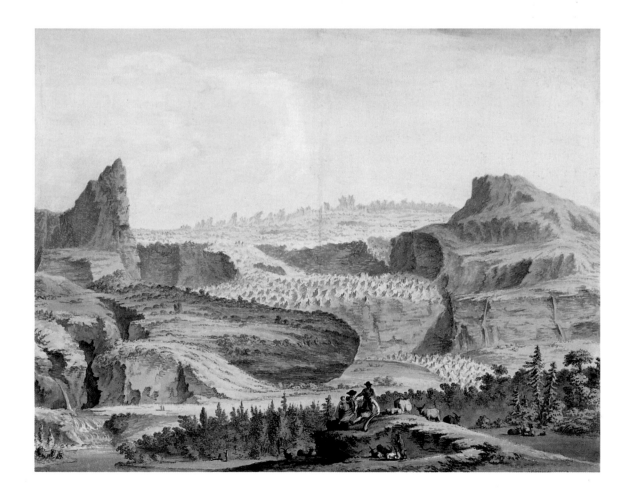

Fig.18
An example of wet-in-wet technique

Fig.19
An example of dry-brush technique

These cardboard or paper frames picked out one or two tones from the painting and repeated them as handpainted watercolour borders, supposed to enhance the presentation of the image.

Watercolour really came into its own as a powerful aesthetic medium during the late eighteenth and early nineteenth centuries, when artists such as John Robert Cozens, Girtin and Turner abandoned the strictures of the tinted drawing and began to depict form and atmosphere with pure washes of colour, directly applied on to the paper. This was a time of intensive innovation, and one of the reasons this period is known as the golden age of British watercolour is because it witnessed the flowering of the medium's innate potential, uncovering a myriad of ways to introduce texture, interest, atmosphere and effects (see fig.2). The resulting range of techniques are those still widely employed today, for example, 'wet-in-wet'

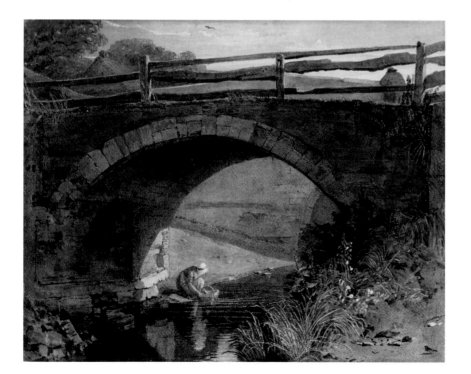

Fig.20
Peter de Wint 1784–1849
Bridge over a Branch of the Wytham, Lincolnshire
Watercolour and pencil on paper 41.6 × 51.4 cm
Tate. Bequeathed by John Henderson 1879

(wet wash on pre-soaked paper), or 'dry-brush' (less-diluted paint applied to dry paper) (figs.18, 19). Other emerging processes included strategies for creating highlights or passages of white, which in watercolour can be preserved or removed, but never simply painted on (unless in the form of opaque gouache). The elegant stone arches above the doorway in John Sell Cotman's unfinished study of Rievaulx Abbey, for example, have been created by 'reserving the whites', that is, simply leaving the natural colour of the paper untouched (fig.22). Cotman also appears to have employed a technique known as 'lifting-out' (using a dry brush or rag to soak up and remove wet paint) in order to depict the pale shoots of foliage beneath. By contrast, the spiky grasses and sparkling ripples in *Bridge over a Branch of the Wytham, Lincolnshire* by Peter de Wint reveals an alternative method, that of 'scratching-out' (fig.20). The artist has scraped through the painted surface with a knife or other sharp tool in order to reveal the white of the paper beneath.

During the late nineteenth and early twentieth centuries, the gamut of techniques was represented by two very different styles of painting.[17] On the one hand artists adopted a meticulous and textured application of thicker watercolour and gouache to create the dense, rich Victorian images typified by the Pre-Raphaelites (no.103) or George Price Boyce's portrait of a young girl (fig.4). These sorts of works were closer in appearance to oil painting and were partly facilitated by the introduction of moist paints in collapsible screw-cap tubes, which aided a drier application of full-strength colours.[18] A different approach was preferred by artists such as James Abbott McNeill Whistler or John Singer Sargent, who painted with loose, transparent and liquid washes and left areas of paper bare and exposed as an integral part of the composition (figs.5, 23).

These polarised positions represent the extent to which watercolour had matured as a versatile and eclectic art form, one that would continue to progress into the twentieth century and beyond. Indeed we have now reached the point where virtually 'anything goes' (see no.142). Some artists continue to work with the established, and by now conventional, techniques, while others have formed means of reinvigorating, extending or even challenging the tradition using different systems and modern media. This exhibition demonstrates the extraordinary evolution of the medium from its roots to the present day, and, hopefully might even inspire future artists to take it ever further.

NOTES

1 Modern paints also contain fungicides to prevent the growth of mould or bacteria. For advice on materials I am very grateful to Joyce Townsend, Senior Conservation Scientist, Tate.

2 See for example Joyce Townsend, 'A Brief History of Watercolour Paints', in Moorby and Warrell 2010.

3 Mallalieu 1985, p.32.

4 For a more detailed discussion of paper and its manufacture see Cohn 1977, pp.16–26; Bower 1990, pp.17–38. See also Harris and Wilcox 2006.

5 Letter from Gainsborough to his publisher, Dodsley, November 1767, quoted in Mallalieu 1985, p.37.

6 See Smith 2002, p.96, and particularly Peter Bower, 'Tone, Texture and Strength: Girtin's Use of Paper', pp.138–9.

7 Egerton 1986, p.14.

8 See Bower 1990 and Bower 1999.

9 See John Bonehill and Sarah Skinner, 'Grand Secrets': Sandby's Materials and Techniques', in Bonehill and Daniels 2010, p.65.

10 Rodari et al. 1998, p.31.

11 See Jeremy Lewison, 'On the Edge of Meaning: The Drawings of Anish Kapoor', in Lewison 2005, p.182.

12 Ronald Parkinson, *British Watercolours at the Victoria and Albert Museum*, London 1998, p.191.

13 Norgate, *Miniatura, or the Art of Limning*, ed. Jeffrey M. Muller and Jim Murrell, New Haven and London 1997.

14 For a detailed description of materials and techniques see the V&A's online resource (www.vam.ac.uk/collections/paintings/miniatures/materials_techniques/index.html).

15 Quoted in Egerton 1986, p.11.

16 For a general discussion of historical mounting and framing practices, see Joyce H. Townsend, Robin Hamlyn and John Anderson, 'The Presentation of Blake's Paintings', in Townsend 2003, pp.162–74.

17 For a detailed survey see Newall 1987.

18 Introduced by Winsor & Newton in the mid-nineteenth century (see www.winsornewton.com/resource-centre/dating-your-paintings--materials). See also Hardie 1966, vol.1, p.21, and Lyles and Hamlyn 1997, p.28.

Watercolour: Practice to Profession

David Blayney Brown

The emergence of the professional watercolourist and a network of teachers, societies, exhibitions, collectors and markets, both competitive and supportive, is part of the narrative of art in nineteenth-century Britain. Less widely appreciated are the many, sometimes marginal activities that promoted the use of water-colour before it became recognised as an art in its own right. 'Jewellers, Gold-smiths, Silver-smiths … Watch-makers and Clock-makers … Stone-cutters … Cosmographers, Geographers and Surveyors … Architects … and Cabinet makers' were only some of the trades and sciences to which one early 'Teacher of the Art of Drawing', John Dunstall, planned to offer his skills including watercolour (no.6).[1] In 1760, an 'Old Officer', Francis Grose, recommended it to young ones – *'particularly Subalterns '* – for planning fortifications or as 'Amusement'.[2]

For the artist Edward Norgate, watercolour in portraits, landscape and 'history' in miniature, such as was painted by Isaac and Peter Oliver (no.14), was a 'gentle' art and a luxury for the court (fig.21). A distinguished painter like Anthony van Dyck might use watercolour occasionally (no.4), as Albrecht Dürer had a century earlier. But other pioneers were consistent only in putting it to the support of another profession or study that required drawing and illustration. This remained true of men like George Edwards, ornithologist and Librarian of the Royal College of Physicians, who 'added' a 'general idea of drawing and paintings in water colours' to his *Natural History of Uncommon Birds and Animals* (1743–51). Such men were experts in their own spheres and gravitated towards London's learned societies. That painting in watercolour might itself generate their status, relationships or income, would not have occurred to them.

'Artist' and 'amateur' can be fluid descriptions when applied to watercolourists. Whilst artists like John Sell Cotman (fig.22) were to be found, albeit sometimes reluctantly, in country houses throughout the land, instructing young ladies in an accomplishment to enjoy 'before marriage and between confinements' (as could still be written in the 1960s!),[3] leisured and professional practitioners were sometimes only differentiated by money. Private means allowed Francis Place to pursue his vocation as artist and antiquary, along with fellow-members of his local learned society, the York Virtuosi. Sir George Beaumont became an honorary professional, seeking the company of his painter-peers and exhibiting with them. A pupil of Alexander Cozens at Eton, Beaumont, like the Earl of Aylesford, was taught watercolour at Oxford by the influential John 'Baptist' Malchair, himself an amateur by virtue of his main job as band-master in the city's Music Room. Among Malchair's pupils and friends were William Crotch, the young Professor of Music, and Oldfield Bowles whose Peter Martyr Society (named after a picture by Titian) embraced amateurs and professionals. William Turner of Oxford enjoyed similar influence in the following century. By then, instruction manuals promoted the styles, methods and fame of artists like David Cox beyond their immediate circle.

If a patron or pupil (and they were often the same) favoured watercolour, topography was the subject in demand and a reliable source of income. The collecting classes liked views of their country seats and places of interest nearby, took up archaeology, antiquarianism or the aesthetics of landscape with their debates about the 'Sublime' and 'Picturesque', and wrote or sponsored publications with engraved illustrations, designed first in watercolours by Thomas Hearne, Edward Dayes, Michael Angelo Rooker or Thomas Girtin. Even a career as distinguished as Turner's began with work of this kind for patrons and publishers; nor was Turner too proud to continue with it as his fame grew.

Topography need not mean a round of estates, castles and cathedrals or the picturesque tours

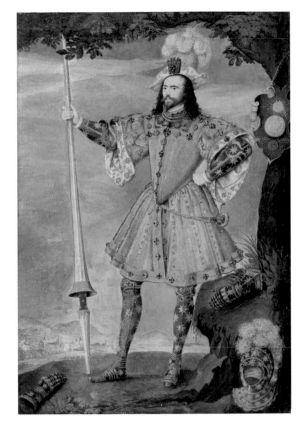

Fig.21
Nicholas Hilliard
c.1547–1619
George Clifford, Earl of Cumberland c.1590
Watercolour on vellum, on panel
25.8 × 17.6 cm
National Maritime Museum, Greenwich, London. Caird Collection

endemic by the late eighteenth century. Paul Sandby started out in the Ordnance Office in the Tower and served as draughtsman on a survey of the Highlands after the Jacobite rebellion of 1745. As the nation extended its international reach, watercolour was put to the service of exploration, map-making and research, and thus of trade and empire. John White recorded Virginia and Florida while accompanying the Elizabethan adventurers to America. Wenceslaus Hollar joined the art-loving Earl of Arundel on an embassy to Ferdinand II in 1636 and was sent on official missions to Morocco in 1669 and Tangier in 1683 (no.5). William Alexander accompanied Lord Macartney's embassy to China in 1792 (no.38). Captain Cook took a brace of artists on his Pacific voyages, including the botanical artist Sydney Parkinson (no.25) and the landscapist John Webber, engaged by the Admiralty, Cook stated, 'for the express purpose of supplying the unavoidable imperfections of written accounts, by . . . drawings of the most memorable scenes of our transactions'.[4]

If watercolourists had once often been foreigners in England, now they were as likely to be Englishmen abroad, usually (unless wealthy independent travellers) as draughtsmen or drawing masters in service – to grand tourists, or learned bodies like the Societies of Antiquaries or Dilettanti that sponsored research in Italy, Greece and Asia Minor. Letters written by Jonathan Skelton from Rome in 1758 to the patron who had sent him there shed some of the brightest light we have on such a relationship.[5] Skelton's employer stayed at home, the artist providing him with a vicarious grand tour, but John Robert Cozens's patrons Richard Payne Knight and William Beckford accompanied him to Italy in 1776 and 1782. The pernickety Turner was not tempted by the terms offered by Lord Elgin to document the antiquities of Athens. Instead, a consortium of wealthier noblemen financed his first visit to France and Switzerland in 1802. With a friend of theirs as 'paymaster', transport and a French-speaking guide, Turner never travelled so comfortably again.

A patron, commission or project had long been essential to watercolourists without private means or another profession. Their work was destined for a collector's portfolio, or some learned or official archive. Hardly ever were watercolours hung on walls or thought of as pictures, and if they reached a wider audience it was usually in the form of a print. Patronage and employment were no guarantee of a public or a reputation, and a Skelton or Francis Towne could vanish from memory until caches of their work reappeared. The social and professional organisations for artists that developed in eighteenth-century London – the Society of Artists, the Free Society and the Royal Academy – were dominated by oil painters and, while open to watercolourists, showed them no favours in their exhibitions. By 1791 the Academy was the only outlet left, and treated watercolour as if it were still the preserve of drawing masters and topographers.

It was inevitable that watercolourists, who were in fact now more numerous, better connected and manifesting remarkable technical advances, conceptual range and ambition, should build their own networks for mutual encouragement, instruction and exhibiting. The evening 'Academy' formed in the 1790s at his London home in Adelphi Terrace by Thomas Monro, the art-loving doctor who cared for the ailing J.R. Cozens, attracted the young Turner and Girtin to copy watercolours in their host's collection in return

for a meal of cheese and porter. Girtin was a leading light in the Brothers, a sketching club founded in 1799, which included other important figures like Cotman. Meetings were devoted to subjects chosen from history, poetry or literature, in a deliberate challenge to the Academy's humbler estimation of watercolour's status and function. From 1830, the Clipstone Street or Artists' Society, and later its associated Langham Sketching Club, provided models for watercolourists of historic and poetic figures. George Price Boyce was elected in its last days in 1851; entrance a guinea, a quarter's subscription £1 9s. 6d. and sardines (his first ever) for supper.

Dedicated watercolour exhibitions began in 1805, after the Society of Painters in Water-Colours was founded in a London coffee-house the previous year. Another New Society of Painters in Miniature and Water-Colours was formed in a tavern in 1807, changing its name to the Associated Artists in Water-Colours for its own first exhibition in 1808. Their shows were instant hits, launching the 'exhibition watercolour' and giving artists much-needed profile. But the boom turned briefly to bust before the market stabilised. Neither society was truly inclusive or repre-sentative, with a strong emphasis on landscape and the 'Old' Society retreating into conservatism. Its first loan retrospective of work by the recent generation, as early as 1823, while including distinguished non-members or Royal Academicians like Turner, also signalled its wish to exhibit its own history long before J.L. Roget wrote his massive official one. From Roget's pages still rises the whiff of disdain for progressive newcomers like Edward Burne-Jones, so grudgingly admitted in 1864 that two members of the committee refused to shake his hand and his work was deliberately 'skied' (see no.76).

The 'Old' Society was hardly predisposed towards artists of the Pre-Raphaelite generation, and it was the Associated Artists who in 1883 incorporated the more sympathetic Dudley Gallery. Burne-Jones had been advised to seek election to the 'Old' Society by John Ruskin, so as to gain a wider audience after the Hogarth Club, formed by Pre-Raphaelites themselves, was terminated. However, neither Ruskin nor the art dealer Ernest Gambart could persuade Dante Gabriel Rossetti, who 'would not on any account become ticketed as a water-colour painter wholly, or even

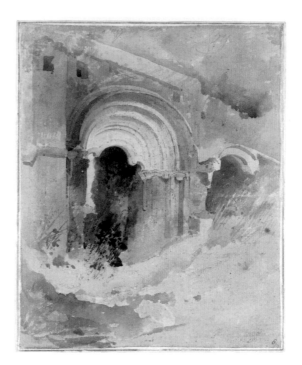

Fig.22
John Sell Cotman 1782–1842
Doorway of the Refectory,
Rievaulx Abbey 1803
Watercolour and pencil
on paper 31.9 × 25.5 cm
Tate. Purchased as part
of the Oppé Collection
with assistance from the
National Lottery through the
Heritage Lottery Fund 1996

chiefly'.[6] Rossetti made another point, that the original style of his works should have 'claims which may counter-balance their greater publicity' – as if familiarity would reduce their mystique. His views probably echoed those of Turner, who had demon-strated characteristic exceptionalism by continuing to show his watercolours at the Royal Academy or, from 1804, at his own gallery.

The watercolourists' adoption of the Royal Academy's hierarchical, male culture, albeit with the best intentions, tended to disadvantage or exclude non-members, women and amateurs. The drive for professionalism bred all sorts of prejudice, as when the Society of Female Artists barred amateur water-colourists. Oil painters were either out or unwelcome. But hard economics, the failure of watercolour prices to rise to parity with oil paintings, exerted their own constraints. In 1858, the 'Old' Society's President, John Frederick Lewis, resigned, complaining he had been earning 'by water-colour art £500 a year ... when I know that as an oil painter I could with less labour get my thousand'.[7] The 400 guineas achieved by Thomas Heaphy for a single work at the height of the exhibition watercolour boom in 1809 was the excep-tion to a less startling rule and even Turner's prices were rarely large, compared to equivalent values today.

It was the philanthropic John Julius Angerstein who offered him 40 guineas, more than Turner would have asked himself, for a watercolour in the 1799 Academy. In 1848, the record for a Turner watercolour was 100 guineas, paid by John James Ruskin.

Turner never depended on sales from public exhibitions and was more than capable of being his own publicist, and salesman, too, lugging a series of Rhine views up to Walter Fawkes in Yorkshire in 1817 or, in the 1840s, instructing his dealer Thomas Griffith to market watercolours of Switzerland on the basis of prepared 'samples'. His wealth came not from sums paid for original work but from a spread of income from engraved reproduction, whether single plates, illustrations to Byron, Walter Scott or the new keepsake annuals and his clever, ruthless grasp of what we might today call copyright or intellectual property, as when he loaned watercolours to publishers for repeat fees. Not just extraordinary for its output, his career was an object-lesson in display, marketing and public relations at a transitional period when the art dealer, commercial exhibition or one-man show was only just emerging.

The role of the collector-enthusiast was no less crucial in building Turner's reputation and income, and more public than eighteenth-century patronage had been. In Ruskin, the amateur and arbiter of elite taste had morphed into the interpreter and critic whose sphere of influence was vastly enlarged. The collector Benjamin Godfrey Windus opened his house in Tottenham, north London, lined with Turner watercolours, to visitors. Fawkes's exhibitions of his watercolours by Turner and contemporaries in his Grosvenor Place house in 1819 and 1820 were milestones in exhibition history, and he was singled out in the catalogue of the 'Old' Society's exhibition in 1821 for his influence promoting the art. The London houses of Thomas Hope and John Soane, with watercolours among their treasures, were effectively museums, and John Sheepshanks's collection of watercolours by modern artists became the foundation for today's national collection, in the Victoria and Albert Museum.

Most exhibitions of Turner watercolours in his lifetime consisted of works made for engraving, and he hardly lived to see another important plank added to the structure supporting artists. Commercial galleries showing new work arrived later in the century, their exhibitions becoming fixtures in the London season, and staff like Marcus Huish of the Fine Art Society or David Croal Thomson of the Goupil Gallery being important opinion formers; both men edited the *Art Journal* while Huish produced *The Year's Art*, a comprehensive list of the latest artists' societies, exhibitions, membership and events. Then far more than now, watercolour could be found in the vanguard, whether Burne-Jones's monumental *Days of Creation* that helped launch Coutts Lindsay's luxurious Grosvenor Gallery in 1877, or in John Singer Sargent's first London solo show at the Carfax Gallery in 1903.

NOTES

1 Dunstall, *Art of Delineation*, BM. Add. NS.5244; Hardie 1968, vol.3, App.1 revised by Ian Fleming-Williams, p.213.
2 Grose, *Cautions and Advices to Officers of the Army, Particularly Subalterns*, London 1760; Hardie 1968, vol.3, App.2 revised by Fleming-Williams, p.251.
3 Hardie 1968, vol.3, App.2 revised by Fleming-Williams, p.246.
4 James Cook, cited by William Hauptman, *John Webber 1751–1793: Landschaftsmaler und Südseefahrer / Pacific Voyager and Landscape Artist*, exh. cat., Kunstmuseum Bern and Whitworth Art Gallery, University of Manchester 1996, p.133.
5 Brinsley Ford (ed.), 'The Letters of Jonathan Skelton Written from Rome and Tivoli in 1758', *Walpole Society*, vol.36, 1960, pp.23–82.
6 Rossetti to Gambart, 28 April 1864; in Hardie 1968, vol.3, p.119.
7 Ibid., p.53.

Fig.23
John Singer Sargent
1856–1925
Miss Eliza Wedgwood and Miss Sargent Sketching 1908
Watercolour and gouache on paper 50.2 × 35.6 cm
Tate. Bequeathed by William Newall 1922
(overleaf)

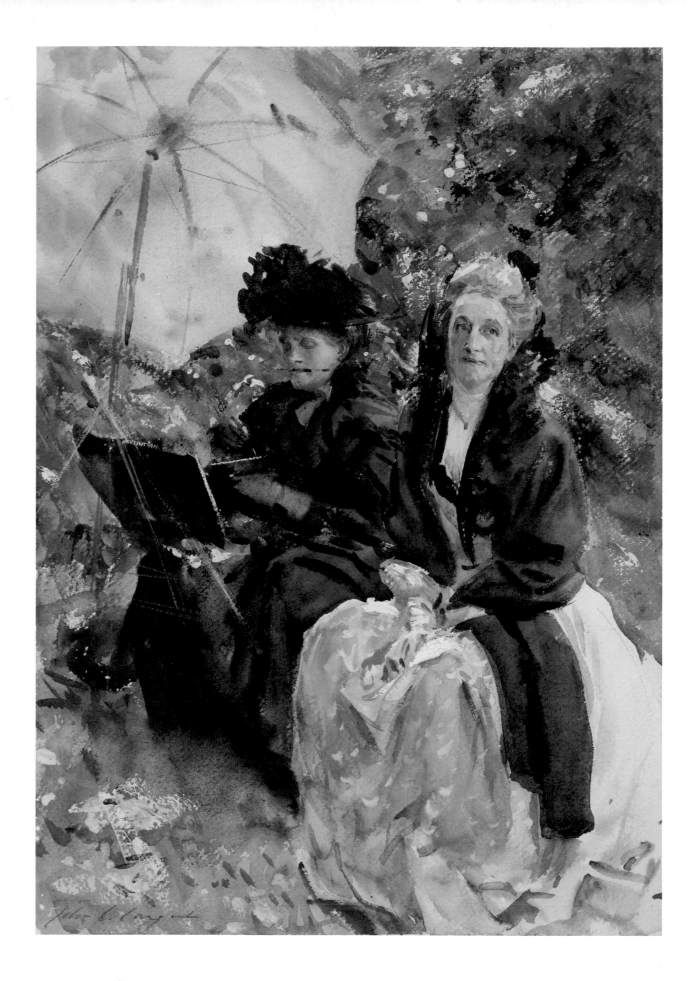

Catalogue

Authorship of catalogue entries
is indicated by initials

TA Thomas Ardill
AA Anna Austen
TB Tabitha Barber
DBB David Blayney Brown
KH Karen Hearn
MI Matthew Imms
NM Nicola Moorby
PS Philippa Simpson
AS Alison Smith
KS Katharine Stout

Bibliographic references are cited
by author and date of publication.
For full entries, see pp.200–1.

Intimate Knowledge

Anna Austen

A late nineteenth-century commentator on watercolour wrote:

> When we endeavour to trace the ancestry of the water-colour art of today … previous to the period of stained or tinted drawings which were the precursors of the earliest English water-colour paintings … we are beset by so many contradictions that we are compelled to abandon any theory of a continuous tradition or descent (Redgrave 1892, p.6).

Prior to the golden age of British watercolour painting of the late eighteenth and early nineteenth centuries, the medium had been used in Britain for hundreds of years: for the illumination of religious and later secular manuscripts; to add colour and ornament to maps and plans; in the production of portrait miniatures; to decorate costume designs; and in the painting of early topographical and landscape views. While a continuous narrative of the development of watercolour in Britain during this early period cannot be achieved, what is discovered through an examination of the history of the medium is the great variety of its deployment. The works brought together in this section attempt to explore the diverse uses of the medium from the Middle Ages to the beginning of the eighteenth century, the point at which traditional histories of British watercolour practice usually begin.

The first published treatise on painting to be available in English was translated from the Italian by Richard Haydocke (published 1598). In it he succinctly described the various uses of tempera painting at that time.

> In Distempour the colours are grounds with water and bounde with glew, sise, or gummes of diverse sortes … Of Distemper I note three kindes: In Sise, used by our common painters upon cloath, walles, etc. In Washing, with gummed colours, but tempered very thinne and bodilesse used in mappes, printed stories, &c. And in Limning where the colours are likewise mixed with gummes, but laied with a thicke body and substance: wherein much arte and neateness is required (Lomazzo 1598, pp.125–6).

In this treatise, three distinct uses of tempera are identified, based on the methods of its application and the purpose of the resulting work. Importantly, the writer also places tempera artists in a hierarchy according to the three uses. Those who used 'Distempour' for painting murals or scenery upon walls and cloth were the lowliest of artisans, followed by those who washed maps and books in transparent colour. The most skilful and esteemed practitioners were the 'Limners' (illuminators).

The technical differences in the period prior to 1600 between the washed application of tempera on maps and plans and the highly skilled techniques of the manuscript illuminators and the portrait miniaturists must be considered with regard to the very different circumstances of their production and also their use and purpose. The predominant function of maps and plans was the recording and relaying of information relating to land ownership – whether an entire kingdom (*Angliae Figura* 1534–46), or a landowner's estate (John Darby's *Estate Map of Smallburgh, Norfolk* 1582). While the colouring and decoration of these works was of some importance – not only for practical reasons such as a means of demarcation, but also as an indicator of status – design was customarily secondary to function. The opposite must be said for the art of medieval illuminators and portrait miniaturists, where exquisite attention to colour and detail was of

a greater significance. Early Christian manuscripts, whether used for liturgical purposes, private devotion or religious instruction, were decorated in a manner appropriate to the glorification of God and the status of the owner. The addition of gold leaf was thought to be essential, as was the use of pigments made from precious materials such as the extremely expensive mineral lapis lazuli, which created the uniquely intense blue, ultramarine. Thus, the limners were understood to be 'the most skilful and esteemed practitioners' of tempera (Lomazzo 1598, p.126).

It is generally agreed that the techniques of the Tudor and Stuart miniaturists were adopted directly from those of the manuscript illuminators. The early miniaturists who worked in Britain were rarely native; the most successful of them came from the Low Countries in what had been the centre of manuscript illumination. The art form insisted upon a very particular technique and required much expertise, not merely in the accurate delineation of the subject but also in the technical knowledge required to prepare the vellum ground (stretched and dried animal skin) and pigments.

Watercolour has always proved useful as a quick means to produce inexpensive but colourful, accurate and detailed sketches and designs. In the seventeenth century artists such as Inigo Jones employed the medium to execute beautiful costume designs for Court masques. Watercolour drawings such as the *Costume design for the 'Lords' Masque'* 1613 show Jones working with watercolour in a loose manner, using the medium to develop his designs from simple pen and ink sketches into elaborate, brightly coloured, imaginative fancies. Working in this manner enabled him to provide his patrons with a rapid and attractive visualisation of his ideas.

The seventeenth century saw further foreign artists settling in England to work for various wealthy patrons, bringing with them new modes of watercolour practice already in use on the Continent. During his extended stay in England as painter to Charles I, Anthony van Dyck produced a number of watercolours depicting the English landscape in a highly naturalistic manner, unprecedented in England. But rather than influencing a new mode of watercolour practice in Britain, van Dyck's poetic interpretation of landscape painting would not be practised by British artists until the late eighteenth century. By contrast, some British artists were producing landscape views on vellum in the antiquated tempera technique of the medieval illuminators, a style of painting still being encouraged by British tracts on art, for example in William Sanderson's *Graphice* written in 1658.

The landscape watercolour practice in Britain was originated in part by the work of émigré artists such as Wenceslaus Hollar. During his time in England, Hollar produced a large output of delicate topographical views of England, and of British colonies such as Tangier. Although he was predominantly an etcher, Hollar must also be recognised through his watercolour drawings as a natural landscapist who appreciated the subtle nuances of composition and light, and used watercolour to enhance his subjects, rather than merely to add colour. He had a number of British followers, in particular the Yorkshire artist Francis Place , who continued and developed his topographical approach to landscape into the eighteenth century.

The practice of watercolour painting in Britain from the Middle Ages until the end of the seventeenth century was not consistent in its techniques, or in its aims and purposes. It depended largely on visiting Continental artists, and had no clear narrative of development. But although the history of watercolour practice in this period is essentially piecemeal, there are many beautiful and highly accomplished works that together demonstrate the great richness of artistic output over the centuries.

1

Anonymous artist
Prose Life of St Cuthbert c.1200

Tempera and gold on vellum 13.5 × 10 cm
The British Library, London

2

**Anonymous artists, possibly
Alexander Bening** c.1444–1519
Hours of William Lord Hastings c.1480

Tempera and gold on vellum 16.5 × 12.5 cm
The British Library, London

Like the famous *Lindisfarne Gospels*, c.698 (British Library), this illuminated manuscript of a biography by the monk and scholar known as the Venerable Bede, was made in honour of St Cuthbert (c.634–87), the most important saint in the north of England. It was executed in Durham in the late twelfth century, probably for the monastic community and perhaps at the behest of Bishop Hugh de Puiset (Marner 2000, pp.9, 53).

The text is illuminated with forty-six miniatures in tempera and gold on vellum, which illustrate episodes from Cuthbert's life, especially his miracles. One impressive double-page spread consists of two connected miniatures. On the left is Cuthbert and on the right are two monks praying for the safety of ships in a gale. Linking both images is the sea, which extends across the two pages. This detail, however, does not belong to either miniature; instead it floats above them, suggesting that, rather than depicting the actual sea, it represents a vision that is the subject of Cuthbert's and the monks' prayers. TA

Books of Hours were popular manuscripts for private ownership and personal devotion. Consisting of the Hours of the Virgin and other religious texts, they were read at set times of the day, and were often lavishly illuminated with miniatures, decorative initials and borders.

Although it was written in Latin like all Books of Hours, the Hastings Hours has the 'Sarum' (Salisbury) version of the text, indicating that it was intended for a British reader, who, judging by the presence of his coat of arms, was probably William Lord Hastings (c.1431–83). The Baron had strong links with the court of Burgundy, and ordered this manuscript from a Flemish workshop where it was written, illuminated and bound by a team of specialist craftsmen of the Ghent–Bruges school. The principal artist is thought to have been Alexander Bening, who may have been responsible for both the miniatures and borders (Turner 1983, pp.8, 121–2).

Of the thirty-nine miniatures (most of which survive), gilded and painted in tempera on vellum, eight illustrate the life of the Virgin. The Holy Family appear in naturalistic scenes with figures wearing fifteenth-century Flemish dress in distinctly northern European landscapes. The borders are among the earliest examples to be entirely filled with illusionistic flowers, insects and birds (Backhouse 1996, p.19) anticipating the development of botanical illustration as a separate genre in the following century. TA

1

2

3

Master of the Prayer Books of c.1500
active c.1500
Roman de la Rose c.1490–1500

Tempera on vellum 39.5 × 29 cm
The British Library, London

Made in Bruges for a prominent member of the Burgundian ducal court around the same period as the Hastings Hours (no.2), this is an example of a lavishly illuminated secular manuscript. It contains the popular allegorical poem the 'Roman de la Rose', a thirteenth-century tale of chivalric love by Guillaume de Lorris and Jean de Meun, and is decorated by four full-page illuminations and eighty-eight miniatures set within the text.

The artist is known as the Master of the Prayer Books of c.1500, and worked on Books of Hours as well as contributing illuminations for a book of the poems of Charles, Duke of Orléans for Henry VII (British Library, Royal MS 16 F.ii; Backhouse 1997, p.215). The manuscript first came to England in 1726, when it was bought by the bibliophile, collector and patron of the arts, Edward Harley. In 1753 it was acquired by the nation as a founding item of the British Museum.

Illustrations to the poem, such as the *Tower of Jealousy* (folio 39), depict late fifteenth-century courtly life and fashion, but also have a fantastical aspect, often showing several narrative moments within a single image and manipulating scale and perspective for dramatic effect. The miniatures are set within borders of carefully observed flowers, birds, snails and butterflies. During the nineteenth century the Roman de la Rose made a deep impression on Burne-Jones, who adapted several of its motifs in his paintings. Although the watercolours of Rossetti and Burne-Jones (no.103) do not closely resemble medieval miniatures, they were clearly influenced by the stage-like constructions and piled-up effects of the latter (Treuherz 1984, pp.167–8). TA

4

Anthony van Dyck 1599–1641

A Coastal Landscape with Trees and Ships c.1635–41

Pen and ink, watercolour and gouache on paper
18.9 × 26.6 cm
The Trustees of the Barber Institute of Fine Arts,
University of Birmingham

Anthony van Dyck, who was Antwerp born and
trained, painted some of the earliest watercolour
landscapes to be executed in Britain. This complex
example probably dates from his later years in
England, between spring 1635 and his death there in
late 1641. The roofs at the centre and the sails in the
right-hand distance demonstrate van Dyck's fluency
and easy mastery of the technique. The location
depicted has not been identified, but it is likely to
have been painted in summer as the trees are shown
in leaf. KH

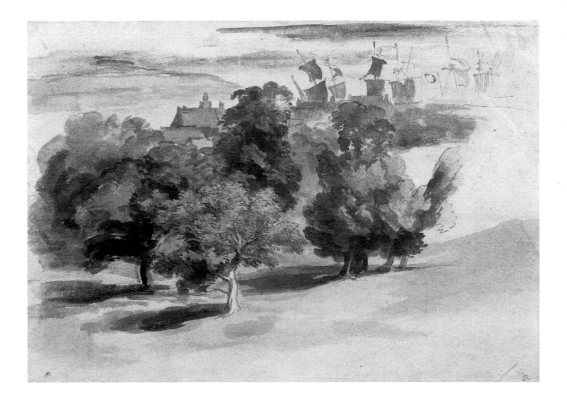

5

Wenceslaus Hollar 1607–1677

View from Peterborough Tower, Tangier Castle c.1669

Pen and ink with watercolour on paper 28.1 × 102.2 cm
The British Museum, London

In 1669, Prague-born Wenceslaus Hollar accompanied a British expedition to Tangier, part of the dowry that accompanied Charles II's Portuguese bride, Catherine of Braganza. Hollar was paid £100 to produce around thirty topographical drawings of the area, some of which he later published as etchings. The forts and settlements in Tangier were given incongruous English place names, for example Peterborough Tower and Whitby Bay, recorded by Hollar in these drawings. When the English left Tangier in 1683–4 due to local pressures, all these settlements were completely destroyed, and Hollar's drawings thus provide a unique record of this short-lived colony. Hollar expertly adapted the practice of creating military topographic prospects by combining the panorama with a naturalistic landscape view. In these finished drawings, he added a watercolour wash over the pen and ink outline sketch, a technique later taken up by subsequent British topographers. AA

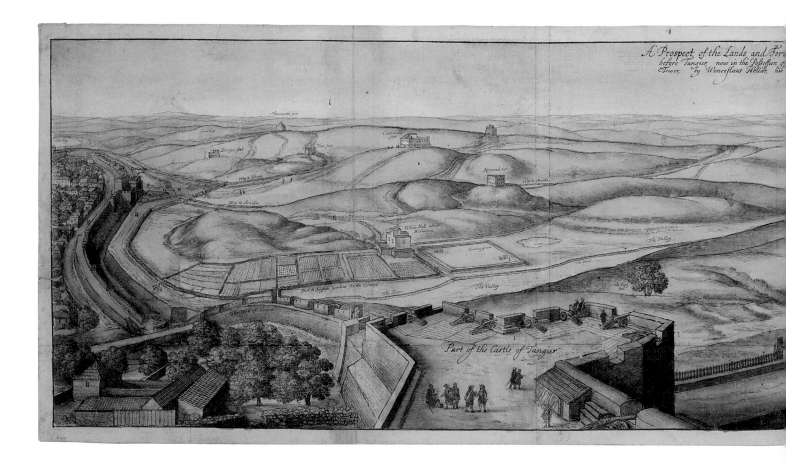

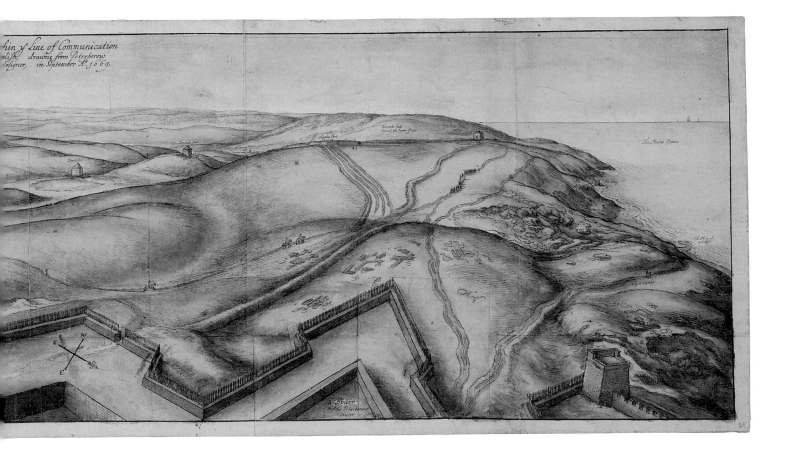

hin ye Line of Communication
... drawne from Peterborow
...signer, in September A. 1664.

The Maine Ocean

45

6

John Dunstall active 1663–d.1693

A Pollard Oak near West Hampnett Place, Chichester c.1660

Watercolour and gouache on vellum 13.4 × 16 cm
The British Museum, London

John Dunstall painted this view of West Hampnett Place in the 1660s, at the same time as he was etching various views in the Chichester region (Sloan 2000, p.23). Dunstall focuses his attention on the great oak tree in the foreground, and slightly repositions the mill and stream to incorporate a distant view of Chichester Cathedral (Stainton and White 1987, p.121). West Hampnett Place was a late sixteenth-century red-brick house, which was destroyed by fire in 1930.

Dunstall painted this rather naive scene in opaque watercolour on vellum, the same technique used by the medieval manuscript illuminators. Rather outmoded for its time, especially when we consider that van Dyck was creating wonderfully free watercolours a few decades earlier (see no.4), this antiquated technique was still being promoted for landscape painting as late as 1658 by William Sanderson in his treatise *Graphice*. Dunstall also produced a number of manuals on drawing, and is known to have been an early teacher of watercolour. AA

7

Anonymous illuminator

Angliae Figura 1534–46

Ink and watercolour on vellum 63.5 × 42 cm
The British Library, London

The *Angliae Figura* is a colourful and attractive map of the British Isles intended for public display in a gallery alongside portraits and history paintings. Thought to have been designed by the scholar and Bishop Maurice Griffith and made in a workshop by a scribe and two artists, it may have been a New Year's present for Henry VIII, given in an attempt to win favour.

As well as containing the most up-to-date cartographic information with a scale, lines of longitude and latitude and symbols for man-made and geological features, the map was elegantly decorated with a fashionable 'cartouche' text panel inspired by the watercolour designs of Hans Holbein (c.1497/8–1543). It also reflects the recent Act of Union (1535–6); England and Wales are painted the same colour, and the King's sovereignty over the whole of Britain is implied by the crown that surmounts the text panel (Barber 2009).

Early maps on vellum were executed with the same materials as manuscript illuminations: ink for the outlines and labels, and watercolour or tempera for coloured areas. TA

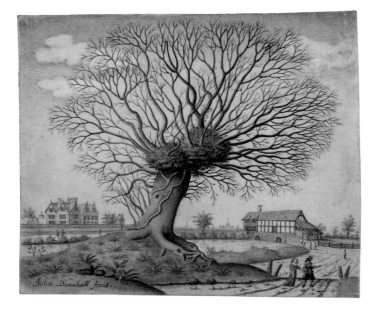

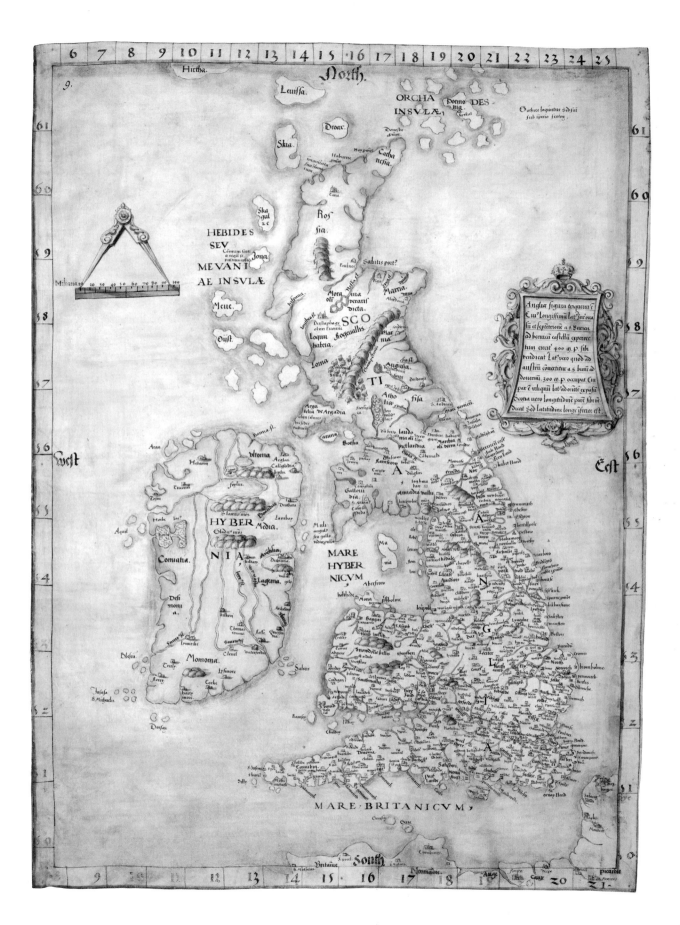

MARE·BRITANICVM,

John Darby active 1582–d.1609
Estate Map of Smallburgh, Norfolk 1582

Ink and tempera on parchment 104 × 177 cm
The British Library, London

Bernard de Gomme 1620–1685
Plan of Plymouth 1672

Ink and watercolour on vellum 92 × 101.5 cm
The National Maritime Museum, Greenwich, London

This impressive map, produced in 1582, records the estate of Smallburgh in Norfolk, then owned by Sir Philip Parker. It is a particularly early example of an estate map drawn to a consistent scale, a technique that would continue to be used until the present day. The map was made by the surveyor John Darby, and accurately depicts the size of Parker's various fields, meadows and pasture land, as well as their proximity to each other. The assorted land uses are ingeniously coloured in different shades of green, enabling the landowner to interpret his estate immediately.

Drawn on vellum and coloured in tempera, the techniques employed are similar to those used by manuscript illuminators. Due to the elaborate nature of the map, its colouring, pictorial detail and impressive size, it would have been intended to hang on the wall in Parker's house in Suffolk. However, its unfinished state and freshness today leads us to believe that it was never displayed in this way. AA

This work depicts the proposed fortifications of Plymouth by Bernard de Gomme, Surveyor General of the Ordnance to Charles II. The drawing is split into two sections, the lower part being a bird's-eye view of the layout of the new fort and part of the existing town, and the upper part a panoramic interpretation of how the town would look once the Royal Citadel had been completed.

The plan serves as an interesting example of the transition between military drawing and topographical landscape within one work. De Gomme was working in England at a similar time as another fellow émigré, Wenceslaus Hollar (no.5), whose topographical work in Tangier depicting forts (built by de Gomme) served a very different purpose, but had its artistic origins in military designs such as this. Whilst de Gomme used the antiquated practice of painting on vellum in a very precise manner, Hollar used watercolour on paper in a much more fluid style. De Gomme was a surveyor rather than an artist, yet he delicately depicted ships and added vibrant colour across the work, turning an otherwise functional plan into an attractive work of art. AA

8

9

10

Possibly by Jacob Halder active in England

1557–1607

Almain Armourer's Album c.1586–90

Pen and ink, and watercolour on paper, two sheets 42.5 × 28.8 cm
Victoria and Albert Museum, London

This one of thirty armour designs, collectively known
as the Almain Armourer's Album, possibly drawn
by the German designer Jacob Halder for wealthy
English courtiers. The album served as a pattern
book for future patrons, who were thus able to
admire the variety of decorative detail available at
the Royal Armoury for those who could afford the
large sum of £500 per suit. These preliminary
designs are splendidly coloured and include detailed
drawings of the separate elements of the armour, as
well as a striking visualisation of the full suit.

The Royal Armoury was founded by Henry VIII
in 1515 in Greenwich, south-east London, and
operated until about 1637. It was set up by eleven
'Almains' (Dutch and Germans) and became known
as the Royal Almain Armoury. AA

11

Inigo Jones 1573–1652

*Costume design for the 'Lords' Masque':
A Fiery Spirit (A Torchbearer)* 1613

Pen and ink, and watercolour on paper 29.5 × 16 cm
The Trustees of the Devonshire Settlement

The London-born Inigo Jones was the leading
British architect of his time, and also the principal
designer of Italian-influenced sets and costumes for
the lavish court entertainments, called 'masques'.
The Lords' Masque celebrated the marriage of
James I's daughter Elizabeth to Frederick V, Elector
Palatine, in 1613. While most of Jones's surviving
costume designs are in pen and ink, a handful
include watercolour. This *Fiery Spirit* is among the
most celebrated: perfectly balanced and assured,
it demonstrates Jones's remarkably free use of
the medium. KH

10

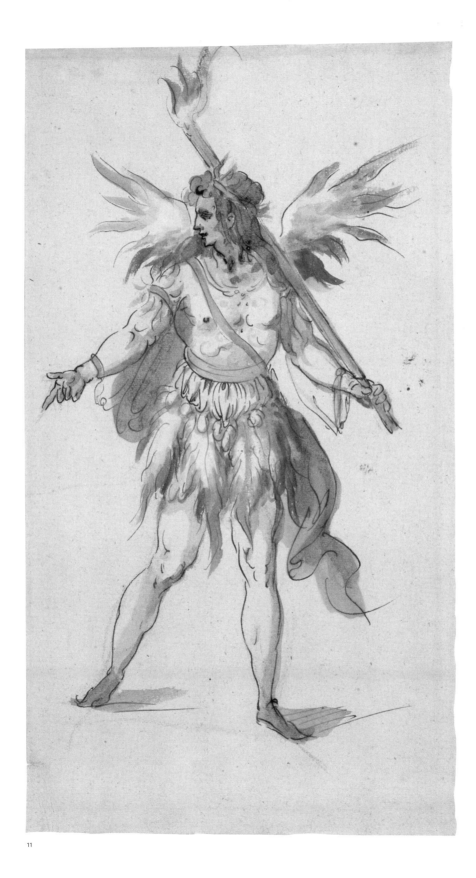

11

12–15

12

Nicholas Hilliard c.1547–1619

Elizabeth I c.1587

Watercolour on vellum laid on thin paper
3.8 × 3.3 cm
The Royal Collection

14

Isaac Oliver c.1560–1617

*Unknown Melancholy Man
(known as 'The Prodigal Son')* c.1595

Watercolour on vellum 7.2 × 5.3 cm
Private collection

13

Nicholas Hilliard c.1547–1619

*Charles Blount, later 1st Earl of
Devonshire* 1587

Watercolour on vellum 4.3 × 3.5 cm
Private collection

15

Isaac Oliver c.1560–1617

Elizabeth Harding, Mrs Oliver c.1610–15

Watercolour on vellum on playing card
5.3 × 4.3 cm
Private collection

Although likenesses *had* appeared within medieval manuscripts, small-scale portraits first appeared as discrete items in the mid-1520s when, at the French court, the Netherlandish artist Jean Clouet, and at the English court another Netherlander, Lucas Horenbout (c.1490/5–1544), both produced tiny half-length images of members of the French and English Royal families respectively. Horenbout probably taught this process later to the German Hans Holbein the Younger in London. All three artists painted with water-bound pigments on vellum stuck to paper card, as did the Exeter-born Nicholas Hilliard, whose miniatures incorporate elements also seen in the large-scale portraits of the period. Wording is included within the image, and the sitter's status and wealth are shown through the minutely detailed depiction of rich fabrics and jewellery. A miniature is, however, a more intimate and private image, and Hilliard's conveyed a greater comparative naturalism than many larger-scale Tudor portraits (nos.12, 13).

Hilliard's most important sitter was Elizabeth I (no.12), whom he first portrayed in 1572. At least fifteen surviving miniatures of her are associated with him. In about 1600, in his unpublished treatise on the 'Arte of Limning', Hilliard described how, when she first sat to him, she commended a linear,

unshadowed approach. In his treatise, Hilliard constructed the portrait-miniaturist as a gentleman, practising a commensurately clean and disciplined process.

Most early English miniatures were of court, often Royal, sitters, although a few of middle-class individuals also survive. Reflecting its luxury status, a miniature was often incorporated into a piece of jewellery such as a pendant, or framed in precious materials (no.13).

From the 1590s onwards, Hilliard's French-born former pupil Isaac Oliver became his rival. Oliver worked in a stippled, shadowed manner, closer to contemporary Continental portrait methods (nos.14, 15). The English-born John Hoskins, who worked for Charles I, not only painted original miniature images but also copied on a tiny scale paintings by the leading court artist Anthony van Dyck (no.17).

Hoskins trained his nephew Samuel Cooper, who opened a workshop in London in 1642, just as the Civil War broke out. In spite of the political situation, Cooper's career flourished. He could convey a strong sense of naturalism, apparently catching a sitter almost in the act of turning and speaking (no.18). Cooper worked not only for Parliamentarians, including Oliver Cromwell, but

12

13

14

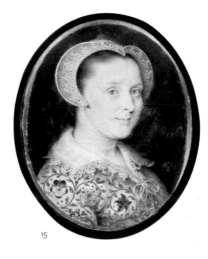

15

16

Samuel Finney 1718–1798

Unfinished rectangle of ivory with painted head of an older gentleman c.1748

Watercolour on ivory 4.7 × 4.5 cm
Victoria and Albert Museum, London.
Given by Shirley Crabb on behalf of her
grandmother Mabel Dod

17

John Hoskins c.1590–1664/5

after Anthony van Dyck 1599–1641
*Lady Mary Villiers, Duchess of Lennox
and Richmond* c.1637/8

Watercolour on vellum 11.7 × 9.8 cm
Private collection

19

John Smart 1741/2–1811

A Gentleman of the Tayler Family 1787

Watercolour on ivory 4.1 × 3.3 cm
on a bracelet fitment
Victoria and Albert Museum, London.
Alan Evans bequest, given by the National Gallery

18

Samuel Cooper 1608–1672

Sir Thomas Smith 1667

Watercolour on vellum 6.8 × 5.7 cm
Private collection

20

Unknown

An Eye Miniature c.1790–1810

Watercolour on ivory, in a case set with pearls
1.2 × 2.2 cm (frame)
Victoria and Albert Museum, London

also for Royalists, and post-Restoration Charles II appointed him 'King's limner'. Cooper's reputation extended across Europe.

From about 1707, British miniaturists adopted ivory as a support. Although harder to paint on, it gave a more translucent effect. Samuel Finney had trained as an attorney, and learnt painting as an amateur (no.16). His memoirs and letters reveal how he constructed his career as a professional miniaturist. Following the founding of the Royal Academy in 1768, miniaturists exhibited there at annual public exhibitions. Professionally trained, the successful John Smart was celebrated for his strong draughtsmanship and bright colouring. From 1785 to 1795, he worked in India, exploiting the lucrative market for portraiture there (no.19). Between 1790 and 1810 there was a fashion for miniatures that depicted just one of a sitter's eyes (no.20). During the 1840s, photographic studios opened, and surprisingly quickly made many of the miniature-painters redundant. KH

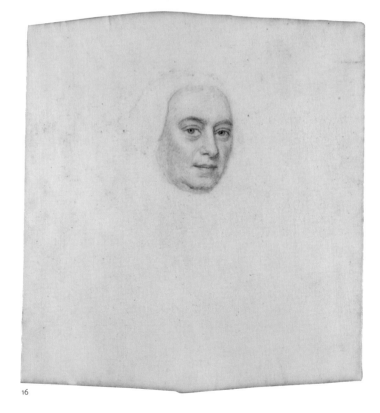

16

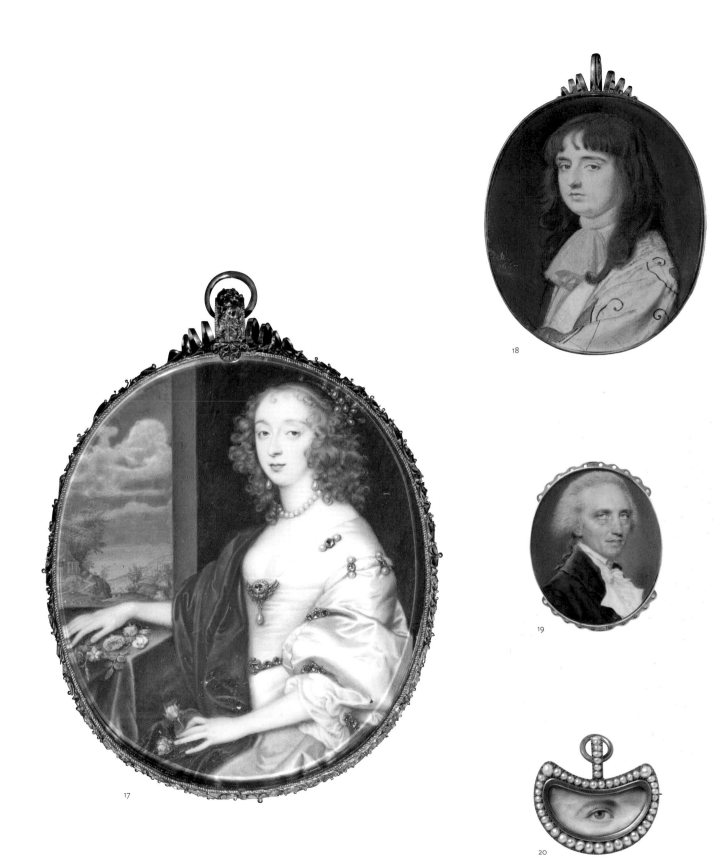

17

18

19

20

The Natural World

Tabitha Barber

John Ruskin had a profound admiration for the work of natural history illustrators, characterised by close observation and meticulous depiction of detail, but he increasingly resisted the rise of scientific naturalism. He rejected the 'microscopic malice of botanists', and their emphasis on dissection and classification, which he believed to be at the expense of poetry and beauty (Smith 2009, pp.166–8). This symbiotic relationship between natural history illustration and science partly explains its near absence from art historical discussion. Even the greatest natural history artists, such as the botanical illustrators Georg Dionysius Ehret and Franz Bauer, are not usually considered alongside the water-colourists of mainstream art history. Natural history illustration has been considered a genre apart, sitting somewhere between art and science, and its practitioners as mere copyists in the service of science whose work is a utilitarian aid in the task of taxonomic classification and identification. Natural history illustrators in fact occupied an essential and privileged place in the sixteenth century's resurgent interest in naturalism, and the early modern culture of rational enquiry, which placed increasing emphasis on exact observation and careful delineation. In the seventeenth and eighteenth centuries, when travel, trade and voyages of discovery were pushing the boundaries of the known world, which stimulated an astonishing influx of new species to Western Europe, illustrators were key to making new knowledge visible both to scientists and to a curious and amazed public. Natural history illustration cannot be divorced from scientific purpose, as its critical role is to visually elucidate and impart scientific knowledge. But illustrators occupied, and still do, the complex dual role of artist and naturalist, producing works of aesthetic beauty that also combine precise delineation and observational skill with scientific accuracy.

In 1676, in *Flora: Seu, De Florum Cultura*, the botanist John Rea lamented the crudely executed, stylised and botanically inaccurate woodcuts used to illustrate herbals and other botanical literature. 'Such Artless things being good for nothing,' he wrote, 'serving neither for Ornament or Information'. Rea was writing at a time when rational scrutiny and close observation was increasingly emphasised as an aid to the advancement of natural and scientific knowledge. His desire for accurate portrayals, observed directly from nature, to assist in the emergent science of identification and classification, was a logical requirement. One response to the wealth of new specimens arriving in Europe from all quarters of the globe – including the southern Mediterranean, North Africa, the Cape of Good Hope, India, the Americas, China, Indonesia and Japan, an extraordinary demonstration of the trade in plants and seeds between Europe and its colonies – was the florilegium, or pictorial flower book. Such books, in printed or manuscript form, were visual reflections of the collections amassed by botanists, nurserymen and wealthy virtuosi, intent on discovering and gathering together all of God's creation. The flowers depicted included the newest, rarest and choicest specimens from their gardens and exotic hothouses, but also the common and mundane as well as fashionable and expensive florist's flowers, or cultivars, such as carnations and tulips.

While florilegia celebrated the wonder of discovery and possession, their focus was essentially pictorial rather than scientific. But botanical illustrations were also crucial tools in

the process of identification, a challenging task in an age of discovery before the emergence of a universal taxonomic system. Images were circulated among the elite and specialist circles concerned with botany. In 1706, for example, the great aristocratic collector Mary Somerset, Duchess of Beaufort, who had enlisted her household servant Daniel Franckom as artist, sent Sir Hans Sloane a drawing of an aloe raised from an unnamed imported seed in the hope that the 'Bottanicks about town' could identify it. The development of natural history illustration, and its increasing professionalisation, necessarily mirrors the evolution of science, with its different preoccupations and technological advances, such as microscopy, over the ages. Carl Linnaeus's new classification system for plants, based on the sexual characteristics of flowers and largely adopted by the mid-eighteenth century, had a profound impact on botanical illustration. Rather than the whole plant, flowers, or the flower and fruit, became the focus. Carefully delineated floral dissections and magnifications – essential for classification purposes – became a staple requirement. Ehret was closely associated with the dissemination of the Linnaean system. He drew the famous *Tabela*, or table, illustrating the different classes of the sexual system that Linnaeus had identified (Natural History Museum, London). His work also demonstrates the shift from the particular – a detailed depiction of a specific specimen, with its individual flaws and blemishes – to the ideal type specimen, based on a particular plant but manipulated and regulated to display its essential characteristics and all information necessary for precise identification.

Linnaeus claimed that 'Ehret did in the beginning absolutely not want to paint the stamina, pistilla, and other small parts, as he argued they would spoil the drawing' (Magee 2009, p.119). But natural history illustration, whether botanical, ornithological, zoological or other, has the dissemination of knowledge as its vital function. Even by the eighteenth century there was a profound difference to be made between a beautiful design and, for example, botanical art associated with female polite culture, and a professional work created to aid scientific understanding. The latter, which by the nineteenth century were being produced by many professional women artists, combined artistic beauty with technical precision and scientific accuracy. A genre that has its roots in manuscript illumination, natural history illustration is a living, continuing tradition, with strict codes of practice that have evolved over the centuries. Such illustrations have as their underlying principle the necessity to serve as a useful source of scientific information, but nevertheless many illustrators were among the finest and most technically gifted watercolourists of their age.

21

Jacques le Moyne de Morgues 1533–1588

Figs (Ficus carica) c.1585

Watercolour and gouache on paper 21.5 × 13.9 cm
The British Museum, London

One of the foremost botanical artists of the sixteenth century, and a key figure in the production of early florilegia, le Moyne is thought to have been trained in Dieppe, a centre of cartography and manuscript illumination. In 1564 he was the official cartographer on an ill-fated expedition to establish a Huguenot settlement in Florida; and by 1580 he had fled France and was living in London as a religious refugee (Hulton 1977; Sloan 2007). Le Moyne's exquisitely executed botanical art combines the techniques of manuscript illumination with finely detailed naturalism. Borrowed from the former, seen in illuminated scatter borders (see no.2), is his refined technique, suited to the rendering of minute detail, the rich gold backgrounds he uses in some of his works, flowers and insects that cast shadows against the paper, and his supremely elegant compositions contained within painted borders, over which leaves occasionally escape. Although he worked on paper, it was sometimes burnished with a stone to create a smooth, vellum-like quality. This page is from a florilegium prefaced with a sonnet dedicated to Lady Mary Sidney and dated 1585. Le Moyne seems to have had a stock of designs that he reproduced with subtle variations. Although some are taken from manuscript or printed sources, the majority, whether common plants such as larkspur and borage, or cultivated blooms, such as carnations, or fruit, are clearly observed from life and include the blemishes or dying leaves of particular plants.
TB

22

Alexander Marshal c.1620–1682

Tulips (Tulipa gesneriana) before 1682

Watercolour and gouache on paper 45.7 × 33.2 cm
The Royal Collection

Alexander Marshal's 159-page florilegium, with portraits of more than six hundred plants, as well as birds, snakes, moths, beetles and other insects, holds an important place in the history of botanical illustration in Britain as the only known florilegium executed by a native-born artist in the seventeenth century (Leith-Ross 2000). Marshal had no formal training as an artist but studied the work of miniaturists as well as still-life works by Flemish artists such as Jan Brueghel and Joris Hoefnagel, as well as Dürer. This page is from Marshal's own personal florilegium, to which he continued to add throughout his life. Executed on paper, rather than expensive vellum that he had used for the the florilegium of the 'choicest' plants in the Lambeth garden of John Tradescant the Younger (1640s, no longer extant), it includes detailed and botanically accurate portraits of common plants such as vetch and bindweed, as well as rare and exotic introductions encountered in the gardens of virtuosi collectors such as Tradescant and Henry Compton, Bishop of London. As with most florilegia, the plants are arranged seasonally, beginning with spring, with a large concentration on fashionable cultivars. Marshal names these tulips as 'Agatte Robin' (top), 'yeleo Croune' (bottom left) and 'penelope' (bottom right). TB

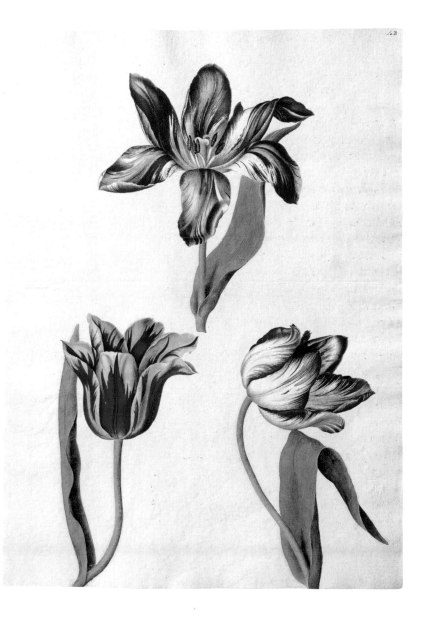

23

Mark Catesby 1682–1749

A Blue Grosbeak (Passerina caerulea) and
Sweet Bay (Magnolia virginiana) c.1728–9

Watercolour and gouache on paper 37.5 × 23.4 cm
The Royal Collection

This bold design of a grosbeak perched amongst
Magnolia virginiana, or sweet bay, is one of 263
original watercolour designs for Catesby's magnifi-
cent publication, with full-page plates, *The Natural
History of Carolina, Florida and the Bahama Islands*,
published in parts between 1729 and 1747. It was the
first publication on its subject, and introduced to a
curious world the plants, birds, fish and reptiles of
the New World (Meyers and McBurney 1997; Meyers
and Pritchard 1998). An amateur artist and naturalist,
on his first trip to Virginia (1712–19) Catesby had
stayed with his relative Elizabeth Cocke and her
husband in Williamsburg, but also collected dried
specimens and seeds for the apothecary Samuel
Dale and the Hoxton nurseryman Thomas Fairchild.
His second trip, to Carolina (1722–6), was funded
by a group of subscribers, including Sir Hans Sloane,
and supported by the Royal Society. He made his
studies from life and firmly believed that natural
history illustrations were more efficient at conveying
essential information, such as character, habit and
vibrant colour, than textual description. TB

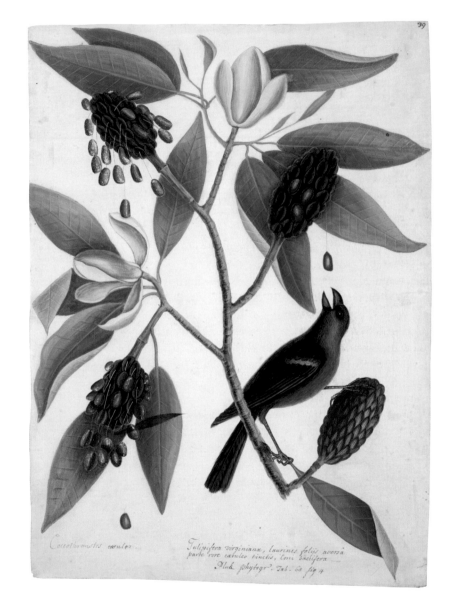

24

Georg Dionysius Ehret 1708–1770

Asphodel (Asphodeline lutea) with Two Butterflies 1747

Watercolour and gouache on vellum 53 × 36.9 cm
The British Museum, London

Georg Dionysius Ehret was the most respected botanical illustrator of his age. Originally from Heidelberg, he settled in England in 1736. He had professional links with the Chelsea Physic Garden, and was sought by leading botanists and collectors to record their rare plants. His contacts were international. The Nuremberg physician and botanist Christopher Jacob Trew was one of his most important patrons, and a great many of Ehret's finest works were produced for Trew's *Plantae Selectae* (1750–73). Ehret's sophisticated works satisfied both his serious botanical patrons, who favoured taxonomic natural history, as well as the world of fashion and design. Until his visit to Paris in 1734–5 Ehret had worked on paper but he was heavily influenced by the *vélins du roi*, the exquisite botanical works on vellum, with butterflies and insects and gilded borders, first produced by Nicolas Robert (1614–85) at the Jardin du Roi (now the Jardin des Plantes) (Saunders 1995, p.10). Inspired by their rich, luminous quality, thenceforward Ehret's finished works for elite patrons were executed on vellum. This painting clearly demonstrates French influence, and Ehret's inscription 'Hort. Reg. Paris' implies that the plant was supplied by Bernard de Jussien, the professor of botany at the Jardin du Roi.

Ehret's name is closely associated with that of Carl Linnaeus, whose new classification system for plants, based on their sexual characteristics, revolutionised botanical illustration. Ehret was the first artist to adhere to the Linnaean system, concentrating on depicting the flower (here the flower spear) and its sexual organs for the purpose of identification. Ehret had excellent botanical knowledge and dissected his specimens before painting them to understand their structure. TB

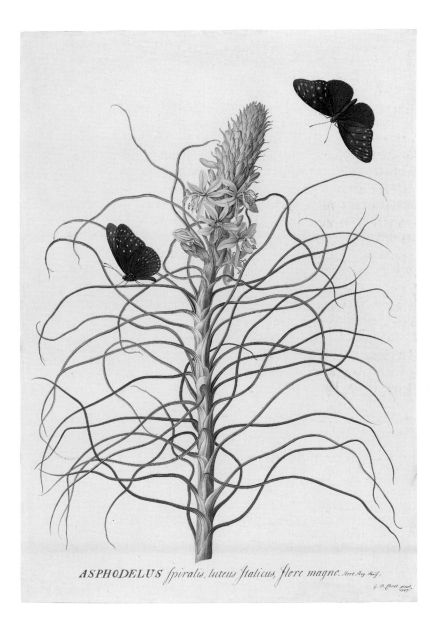

ASPHODELUS spiralis, luteus Italicus, flore magno. Hort. Reg. Parif.

G. D. Ehret pinx.
1747.

25a, 25b

Sydney Parkinson c.1745–1771

New Zealand Honeysuckle (Knightia excelsa) 1770

25a: Watercolour and gouache on paper 52 × 35.3 cm
25b: Gabriel Smith 1724–c.1783 after Sydney Parkinson
Copperplate engraving (1771–84) 48.7 × 32 cm
The Natural History Museum, London

Parkinson was engaged by Sir Joseph Banks as the botanical draughtsman on board the HMS *Endeavour*, on Captain James Cook's first voyage to the South Seas of 1768–71. Banks headed the natural history contingent, which included the naturalist, and former pupil of Carl Linnaeus, Daniel Solander, and the topographical artist Alexander Buchan. The *Endeavour* voyage was the first devoted entirely to scientific discovery. As well as observing the transit of Venus across the sun at Tahiti, the first circumnavigation of New Zealand was made and the east coast of Australia mapped. More than one thousand animal specimens were collected and more than thirty thousand plants specimens, of which approximately fourteen hundred were species unknown to science. Parkinson's illustrations are of the utmost scientific importance as a record of these discoveries. His vivid diary made on the trip records the difficult circumstances of their creation, in cramped, rolling conditions and, in Tahiti, with insects that ate his pigments. Early on in the voyage Parkinson was able to keep up with the pace of discoveries, and produced finished watercolours. But Buchan had died in Tahiti, which placed a heavier burden on Parkinson and, by the time the *Endeavour* had reached Australia, the volume of specimens arriving on board, especially at Botany Bay, had become overwhelming and Parkinson turned to brief sketches, with only the principal parts fully painted. *Knightia excelsa* or New Zealand honeysuckle (rewarewa in Māori),

one of the most distinctive New Zealand trees, was encountered at Tolaga Bay, New Zealand, in late October 1769, where Parkinson found the air filled with 'a most grateful and fragrant perfume'. It was seen again in early November at 'Opoorage', or Mercury Bay on the Coromandel Peninsula (so-called because it was here that the transit of Mercury was observed). A new species, Parkinson inscribed his finished watercolour 'Brabejum sparsum', the name that predates its official taxonomic classification.

Parkinson contracted malaria and dysentery in Java on the return voyage and died at sea on 26 January 1771. Back in England Banks planned a 14-volume publication of the botanical discoveries. As well as 269 completed watercolours, Parkinson had left 679 incomplete sketches. Banks employed five artists, including Frederick Miller and Frederick Polydore Nodder, to create finished watercolours, based on Parkinson's incomplete sketches, the brief notes made by Banks and Solander and the dried herbarium specimens. Eighteen engravers were engaged to cut copper plates but the project never progressed beyond trial proofs and was put aside in 1784. A total of 100 sets of *Banks' Florilegium*, each with 743 plates, was finally published in 1980–90 by Alecto Historical Editions, in association with the British Museum, using the original copper plates.
T B

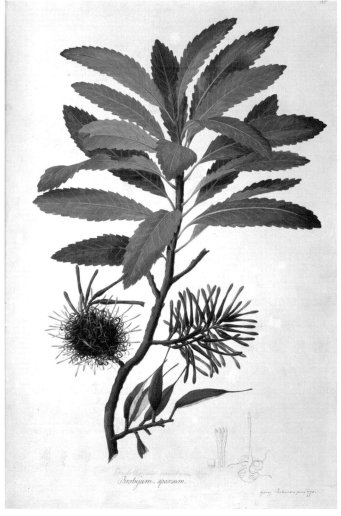

25a

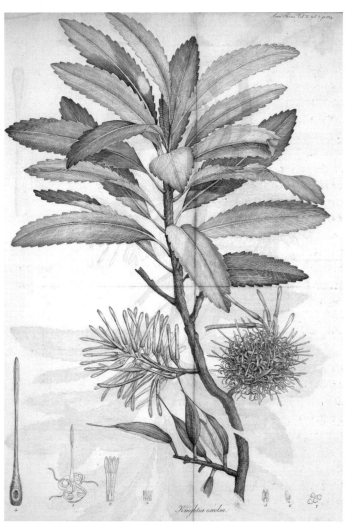

25b

26

Sarah Stone 1760–1844

Shells and Coral c. late 1770s–1780s

Watercolour on paper 39.5 × 54.3 cm
Whitworth Art Gallery, The University of Manchester

Sarah Stone was an accomplished amateur natural history artist, particularly known for her ornithological paintings, for example the naval surgeon and amateur naturalist John White's Australian birds (Jackson 1998). She is most closely associated, however, with Sir Ashton Lever, who employed her to make more than a thousand illustrations of the collection at the vast Leverian Museum. First established at his family seat, Alkrington Hall, Manchester, in 1771, in 1775 Lever moved the museum to London, where it opened to the public as the Holophusicon in Leicester House. By the 1780s it housed more than 26,000 items. Natural history was its focus, but it also included important ethnographic material from the Pacific, donated by Captain James Cook. Stone's watercolours provide a vivid record of the contents of the museum, which included 'Corals, Corallines, Sea Plants, Sea Weeds and Spunges', for which Lever made public appeals (King 1996, p.176). In 1781 Stone showed watercolours of birds and shells at the Royal Academy (ibid. p.174), and in 1784 Lever mounted an exhibition of her work prior to the museum's sale. TB

27

Franz Bauer 1758–1840
Monkshead Orchid (Catasetum macrocarpum)
before 1796

Watercolour on paper 48.7 × 31.9 cm
The Natural History Museum, London

Together with his brother Ferdinand, the Austrian Franz Bauer is considered one of the outstanding artists of natural history illustration. His work is characterised by an astonishing economy and precision of line as well as a purity of watercolour wash, but Bauer was also a remarkably talented microscopist. He is particularly known for his scientifically accurate painted images of dissected and magnified plant parts, especially the microscopic features of pollen and, his personal fascination, the floral mechanisms of Orchidaceae (Stewart and Stearn 1993). This work, showing the whole plant with dissections and magnifications alongside it, is from his series of watercolours for *Delineations of Exotick Plants cultivated in the Royal Garden at Kew … the Botanical characters displayed according to the Linnean System*, published from 1796. On a visit to England in 1788, to view the library and herbarium of Sir Joseph Banks, Bauer had been persuaded to take up the unofficial post of 'Botanick painter to His Majesty', and became in effect the first botanical artist at Kew, a position he held until his death. His combination of artistic skill with accurate and critical observation has, for some, never been matched. TB

Anonymous

Lion-haired Macaque (Macaca silenus) c.1820s

Watercolour on paper 46.6 × 59 cm
The Natural History Museum, London

This bold watercolour by an unknown Chinese artist was painted in Canton (modern-day Guangzhou) for the British East India Company employee John Reeves. In 1812 Reeves was appointed Assistant Tea Inspector for the Canton factory. He was not a naturalist himself but had an intense interest in natural history, and through a network of local contacts was able to send a regular supply of natural history specimens back to scientists and institutions in Britain, such as Sir Joseph Banks and the Royal Horticultural Society (Bailey 2009). Europeans were restricted to the Port of Canton and to Macau, but Reeves employed local Chinese artists to depict the native, and also non-native plants, insects, reptiles, birds and fish that were imported and traded at the thriving international port. Rather than being satisfied with the stylised and ornamental tradition of Chinese export art, Reeves oversaw the production of the illustrations he commissioned to ensure that they conformed to the standards of European natural history illustration, and imparted information useful to scientists (Magee 2009, pp.146–9). TB

William MacGillivray 1796–1852

Osprey (Pandion haliaetus) 1831–41

Watercolour and pencil on paper 56.2 × 68.3 cm
The Natural History Museum, London

MacGillivray was a leading ornithologist and natural historian who became professor of natural history at Marischal College, Aberdeen. His pioneering teaching methods championed research in the field. 'Let us betake ourselves to the fields and woods', he urged, rather than studying dead specimens indoors. This meticulous watercolour painting of an osprey was intended as an illustration for his five-volume *History of British Birds* (1838–52), but the plates were never published. His knowledge of the bird's natural habitat and behaviour lends it a particular naturalism, and the osprey's defining characteristic – the ability to grasp prey such as slippery fish with two claws at the front and two at the back (in MacGillivray's words 'its peculiar adaption to fishing') – is clearly presented. A lifelong friendship and working collaboration with the celebrated ornithogical artist John James Audubon (MacGillivray provided text for Audubon's *Birds of America*) had a clear influence on MacGillivray's own work. Like Audubon, his birds are shown life-size, in their natural habitats and in action. MacGillivray was also a skilled artist of fish but has left a blank template here, presumably awaiting a specimen to observe from life. TB

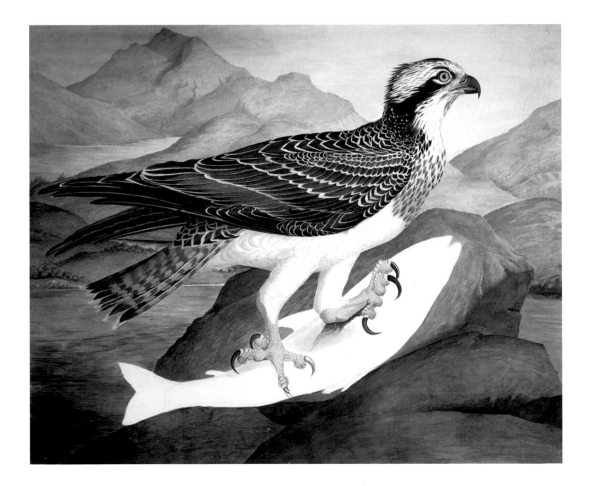

30

John Ruskin 1819–1900

Spray of Withered Oak Leaves 1879

Watercolour and gouache on paper 12.8 × 17.1 cm
Museums Sheffield (Collection of the Guild of St George)

31

Arthur Harry Church 1865–1937

*Mourning Widow
(Geranium phaeum)* 1909

Watercolour and gouache on board 23.5 × 35 cm
The Natural History Museum, London

John Ruskin was not interested in scientific botany but in the intrinsic beauty and essence of natural objects. He had undertaken focused botanical study in the 1840s and 1850s and certainly valued the close observation of nature, but his aim was significantly different from that of the professional natural history illustrator. In *Elements of Drawing* (1857) and *On Leaf Beauty* (1860), he described the significant effort it took to capture the composition, form and colour of a leaf (this study took him two hours) but he was not concerned with accurate structure, writing that 'the form of a complete leaf is never seen; but a marvellous and quaint confusion … wholly indefinable and inextricable, part by part, by any amount of patience'. In common with natural history illustrators Ruskin was concerned with intricate detail. But here his concern is with the beauty of the dead, crumpled leaf rather than relaying its proper structure, and with the specific specimen rather than the ideal. TB

One of the finest botanists of the twentieth century, Church taught botany at the University of Oxford for more than thirty-five years. He was principally concerned with floral morphology and mechanism, and his astonishing watercolours of magnified flower dissections and internal structure were made to demonstrate his research (Mabberley 2000). Intended to illustrate his multi-volume *Floral Types of Mechanism* (in fact only one volume was published, in 1908), this work is annotated with its precise date, 23 May 1909. Church's revolutionary drawings are held as some of the finest botanical illustrations of the last century, although he considered them a by-product of his science. Painted with an exacting clarity and fluidity, their technical excellence is matched by an astonishing sense of design which evokes that of Art Nouveau. Precision of the tiniest detail, such as ovules, was achieved by the application of Chinese white, which was shaved with a razor when dry to create a smooth surface, over which tonal wash was added. TB

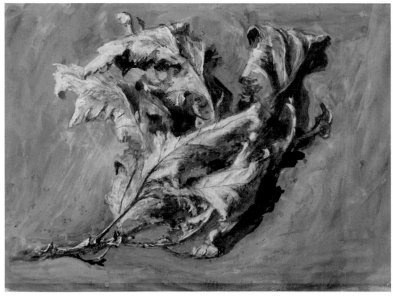

30

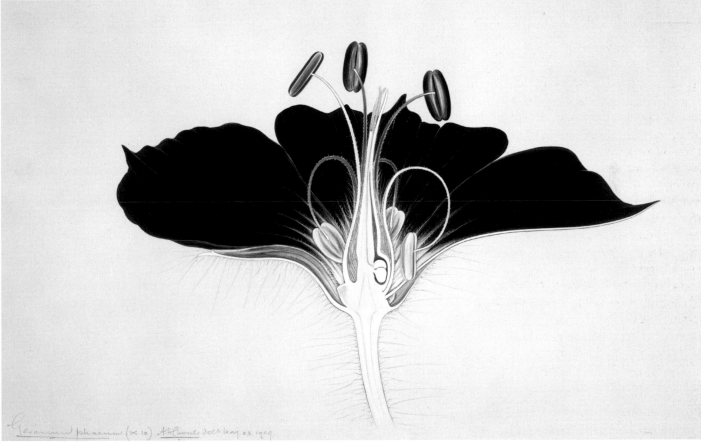

Geranium phaeum (× 10) AH Church del. May 23. 1909

31

32

Margaret Mee 1909–1988
Aechmea rodriguesiana 1977

Pencil, watercolour and gouache on paper 66.1 × 48.3 cm
Courtesy of the Director and Board of Trustees,
Royal Botanic Gardens, Kew

Trained at Camberwell School of Art in London
under Victor Pasmore, Mee became a highly
respected botanical illustrator most particularly
associated with her expeditions of discovery in
Brazilian Amazonia (Morrison 1988; Stiff 1996).
One of Mee's passions was the magnificent plants
of the Bromeliaceae family (the bromeliads, which
include the pineapple). In the Rio Negro region
she discovered new species of the genus *Neoregelia*,
some of which, for example *Neoregelia margaretae*,
bear her name. She was concerned that her work
should be a record not only of individual species
but also of the vanishing world of the rainforest. Her
best-known works combine accurate representations
of individual plants with extraordinary environmental
backdrops, a significant departure from the tradition
of showing individual specimens isolated against a
blank page. *Aechmea rodriguesiana* was seen on a trip
up the Rio Maraú. Her local guide, Bento, swam to
the tree and 'tipped out spiders and scorpions with
the point of the knife and hacked at the hard woody
root'. The plant is an epiphyte, and Mee illustrates
this interdependence on other organisms as well as
its rainforest habitat. TB

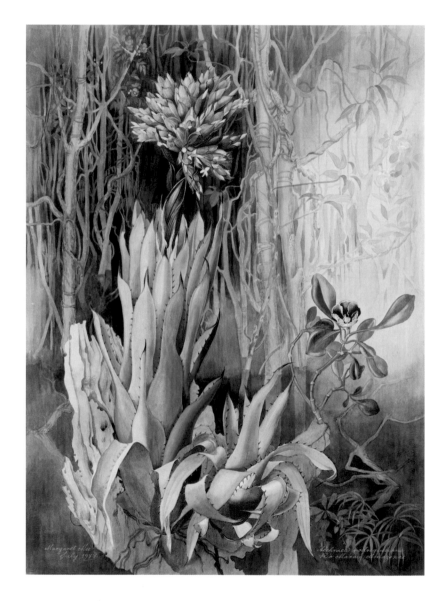

33

Rachel Pedder-Smith b.1975

Bean Painting: Specimens from the Leguminosae Family 2004

Watercolour on paper 56 × 75.5 cm
Courtesy of the Director and Board of Trustees,
Royal Botanic Gardens, Kew

Rachel Pedder-Smith trained at London's Royal College of Art, and is currently completing a PhD there, exploring museum collections of natural history as an inspiration for contemporary artists. *Bean Painting* was inspired by the herbarium collections at the Royal Botanic Gardens, Kew. Scattered across the page, the dried specimens are treated as objects of interest in their own right, each with its own history and provenance, and not just items for scientific research. Her PhD examines this theme more fully. Through illustrating one specimen from every flowering plant family, spread across seven large pages, the herbarium sheet is presented as an art form in its own right. The meticulous depictions of dried specimens, including their textures and identifying characters, turns the goal of natural history illustration on its head – herbarium reference specimens are generally used as information for the creation of portraits of live plants. TB

Travel and Topography

Matthew Imms

As the official artist on an expedition to America in 1585, John White made watercolours, but landscape was incidental to his portrayals of the native peoples and fauna in a conventionalised Renaissance style (British Museum). By the middle of the seventeenth century, when van Dyck (no.4) had depicted the English countryside in watercolour, the painter Edward Norgate (1580s–1650) observed that landscape was 'an Art soe new in England' that the term had been adapted from the Dutch 'landschap' (Binyon 1946, pp.5–6).

Early views in watercolour functioned primarily as documentary records, aesthetic considerations and the use of colour being secondary; such works were often referred to as 'tinted drawings', not on a par with oil paintings. Lecturing at the Royal Academy in 1810, Henry Fuseli described topography, when limited to 'the tame delineation of a given spot', as 'the last branch of uninteresting subjects' (Wornum 1848, p.449). However, by the late eighteenth century, as they developed bolder, more adventurous techniques, watercolourists had begun to compete with painters in oils in the arena of the public exhibition, with increasingly rich, complex works for which the 'given spot' was only the starting point.

Although he had various forerunners such as Francis Place (1647–1728), Paul Sandby might conveniently be regarded as the 'father' of mature topographical watercolour painting in Britain. His practice arose from the need for clarity and accuracy in his early work as a military draughtsman in Scotland. Peopling his carefully studied architectural and landscape settings from around Britain with contemporary figures engaged in appropriate activities, he provided an enduring pattern. Views of great ecclesiastical and military buildings, ruins and country houses were imbued with a patriotic sense of history and tradition.

A growing number of accomplished 'amateurs' such as Sir George Beaumont and Lady Gordon had the leisure to visit and study art collections and exhibitions, and take lessons from artists such as the young Turner and Girtin. They and their professional contemporaries interpreted the sites they visited in Picturesque terms, characterised by a certain degree of varied outline and texture, as conveyed in treatises and guidebooks by William Gilpin, Sir Uvedale Price and others. The concept of the 'Beautiful', embodied in serene lowland landscapes in the tradition of Claude Lorrain (1604/5–82), was long established, but there was a growing appreciation of the 'Sublime', explored by Edmund Burke in his *Philosophical Enquiry …* (1756), with artistic precedents including Salvator Rosa (1615–73) and the Swiss landscapist Louis Ducros (1748–1810), whose dramatic watercolours in British ownership were known to Turner and his contemporaries (Solkin 2009, pp.104, 106).

Turner and Girtin were equally adept in these various modes, rivalling oil painting in ambition; Turner's concurrent practice in oils informed his watercolours, and vice versa. The Sublime, embodied in mountainous landscapes in dramatic weather conditions with undercurrents of immense natural forces, has come to be seen as a prime characteristic of the Romantic period. Francis Towne, working in a relatively small format, evoked an impression of great scale by filling the sheet with simplified, elemental forms. The sense of the individual facing Nature continued to resonate with Neo-Romantics such as Eric Ravilious and Edward Burra, whose high horizons simultaneously generate pictorial space and loom over the viewer.

The heyday of the European grand tour, focusing on the artistic glories of Italy but with novel attention to the Alpine scenery en route, provided artists such as J.R. Cozens with the patronage necessary to undertake prolonged journeys beyond Britain. With imperial expansion and worldwide trading connections, artists began to travel further afield, as far as India and even China. In the Mediterranean and Middle East, the Victorian Orientalists operated from mixed motives, ethnographic curiosity about exotic cultures and their settings perhaps being compounded with elements of voyeurism in J.F. Lewis's extensive work in Egypt. The precision and psychological intensity already evident in the work of William Holman Hunt and Richard Dadd was concentrated further by unaccustomed heat and light; ironically, Dadd's mental illness may have been triggered by sunstroke during his time in Egypt (Allderidge 1974, p.21). Other artists, such as John Sell Cotman, David Cox and Richard Parkes Bonington, had been content with homelier subjects in Britain and the near Continent, reflected in a looser, spontaneous style in response to familiar, everyday life.

To some, the very word 'watercolour' may evoke an image of the artist sitting on a folding stool at some convenient viewpoint with portable equipment and a jar of water to hand, working directly from the subject. The manufacture of soluble cakes of pigment in the late eighteenth century along with small, portable boxes to house them and the later development of tubes of semi-liquid colours all facilitated mobility. But a finished watercolour, as opposed to a sketch setting down keynotes of colour and form for later development, is historically as likely to have been a studio production as a landscape painted in oils would be. This was the general case with Turner, whose practice moved from large, elaborately detailed pencil studies with watercolour towards an intellectualised process of rapid line notations in small sketchbooks whereby, according to the son of a friend, 'he could make 15 or 16 pencil sketches to one coloured' (Finberg 1961, p.262).

Conditions may not always facilitate painting, due to extremes of climate or weather. In the North African desert in 1941, Edward Bawden, used to the softer atmosphere of England, found difficulty adapting both to the heat which rapidly dried out his paints and the brightness: 'It does seem almost impossible to find means to represent the intensity of the light' (McLean 1989, p.13). His war artist colleague Thomas Hennell (1903–45) had problems working at the other extreme in Iceland, resorting to using urine as his watercolour vehicle (MacLeod 1988, p.77).

Easily portable watercolour equipment may nevertheless assist the artist in making works serving as a diary, or as an aid to a thought process while travelling. John Piper used his sketchbooks in this way, often incorporating photographs and handwritten texts from observation or published guides. Since Victorian times, artists have sometimes resorted to the camera, cutting out the need for extensive preliminary work before the motif. Burra picked up local postcards on his foreign travels, using them to fuel his imagination once back in the studio.

The revolutionary succession of stylistic developments over the last century would seem necessarily to have affected topography less dramatically than other aspects of watercolour. There has still been scope for subtle formal experiment through selection and simplification, as demonstrated by Charles Rennie Mackintosh and – in an era of constant travel and ever-increasing visual overload from television and electronic media – for intense, direct engagement with a small corner of the world, seen for example in Patrick Procktor's *Kôm Ombo, Dawn*.

34

Paul Sandby c.1730–1809

*Part of the Banqueting Hall of
the Royal Palace at Eltham*

Watercolour, pencil and pen and ink on paper 25.4 × 36.8 cm
Tate. Presented by William Sandby 1901

Although once a sumptuous Royal residence much
favoured by monarchs until the sixteenth century,
Paul Sandby's depiction of the Banqueting Hall at
Eltham shows the state of dilapidation the building
had fallen into by the eighteenth century. While
what remains of the hall today abuts an elaborate
Art Deco residence, at the time of Sandby's visit
the building was being used as a farmer's barn.

Sandby greatly developed the topographical
tradition from a simple stained drawing – as
introduced to Britain by émigré artists such as
Wenceslaus Hollar (no.5) – into a more technically
skilled manner of painting. This work displays his
subtlety in delineating in watercolour the differing
textures of brick, stone, wood and foliage. Sandby
imbued his scenes with a sense of historical
integrity, combined with a contemporary human
interest. Here, the inclusion of a centrally placed
grouping of figures adds a lively quality to the
scene despite the general air of neglect. AA

35

Thomas Hearne 1744–1817

Edinburgh Castle from Arthur's Seat 1778

Pen and ink, watercolour and gouache on paper 35.6 × 50.8 cm
Tate. Presented by Frederick John Nettlefold 1947

In 1778, when this work was completed, Thomas
Hearne was occupied in producing topographical
watercolours of Britain in preparation for his
publication *The Antiquities of Great Britain* (1786
and 1806). As the watercolours were intended for
engraving, Hearne adopted a linear approach to
watercolour, ensuring an easy transference to the
printed medium, and although this scene was not
included in the publication, he has employed a
similar technique here. *Edinburgh Castle* also reveals
a close link to the earlier influence of Hollar (no.5),
but draws upon recent developments, achieving a
greater sense of atmosphere and depth of view
point. This is reinforced through figures at various
points within the composition to draw the eye.

Hearne began his career as the official artist to
the Governor General of the Leeward Islands in the
Caribbean, today part of the West Indies. The well-
travelled artist would later prove an inspiration to
the next generation of artists, including Turner and
Girtin, who would copy works by Hearne in the
collection of his great admirer, Dr Thomas Monro.
AA

34

35

36

Francis Towne 1739–1816

The Source of the Arveyron 1781

Pen and ink and watercolour on paper 31 × 21.2 cm
Tate. Purchased as part of the Oppé Collection with assistance
from the National Lottery through the Heritage Lottery Fund 1996

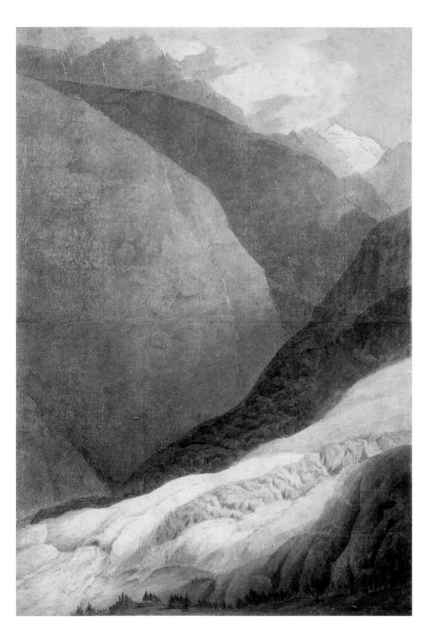

This composition is painted on a double-page spread extracted from the sketchbook Towne used on the spot. Using four pages of the same book, Towne made another vertical composition of twice the surface area, showing more of the mountain and ice (Victoria and Albert Museum, London). He travelled to Italy in 1780, working in Rome alongside John 'Warwick' Smith and visiting Thomas Jones in Naples before returning to England the following year across the Alps.

Towne was an Exeter painter and drawing-master who exhibited oils in London, where he achieved little success despite staging a large one-man exhibition of watercolours in 1805. He was rediscovered by the collector and scholar Paul Oppé and others early in the twentieth century, when his open, simplified forms and coolly atmospheric colouring were at last appreciated and considered far ahead of their time, influencing Eric Ravilious (no.59) and his generation. MI

37

John Robert Cozens 1752–1797

Lake of Albano and Castel Gandolfo c.1783–8

Watercolour on paper 48.9 × 67.9 cm
Tate. Presented by A.E. Anderson in memory of his brother Frank
through The Art Fund 1928

Lake Albano, filling an old volcanic crater south of Rome, is overlooked by the Pope's summer residence. Cozens was the son of the artist and theorist Alexander Cozens (nos.133–4), who developed a 'blot' technique to generate compositions. John Robert inherited a feeling for large, simplified masses, infusing his topographical views with a delicacy of colour and a sense of melancholy.

In the era of the grand tour, Cozens made a pioneering 1776 visit to the Alps with the connoisseur Richard Payne Knight, and sketched the lake while staying in Italy until 1779. He was there again in 1782–3, supported by the collector William Beckford of Fonthill, who commissioned this watercolour. One of at least six versions, it was later owned by Thomas Hearne (no.35). Copying Cozens's works in the collection of Dr Thomas Monro, the young Turner (no.40) and Girtin (no.41) were greatly influenced by what John Constable called his 'poetry'. MI

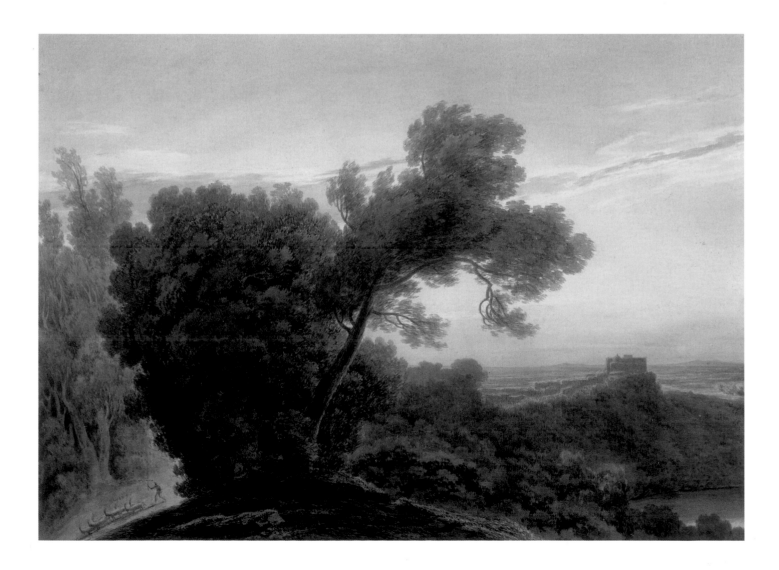

38

William Alexander (1767–1816)
'The Fou-yen of Canton' c.1793

Pencil and watercolour on paper 20.9 × 16.6 cm
The Ashmolean Museum, Oxford. Purchased (Hope Collection
Fund), 1942

Portraits and depictions of costume and customs,
as well as topography, were recorded by artists
employed to accompany diplomatic, trade or
military missions. Alexander spent two years, from
1792 to 1794, in China as official 'draughtsman' to
an embassy to the Emperor Ch'ien-lung, led by
Lord Macartney. In his diary, Lord Macartney
noted his reception by the Viceroy, and the Fu-yuan,
or Governor, of Canton on 19 December 1793.
Subsequent visits were exchanged, and this water-
colour might show the Governor as Macartney's
guest. An inscription on the back of the mount
records that the sitter is depicted 'when sitting at
Table with the Ambassador', and the table is laid
with European cutlery and wine. Alexander's fresh,
clear washes illuminate the Governor's silk gown,
fur cap and necklace. Later, Alexander published
The Costume of China with his own illustrations
(1805) and illustrated an account of the Macartney
embassy (1797). DBB

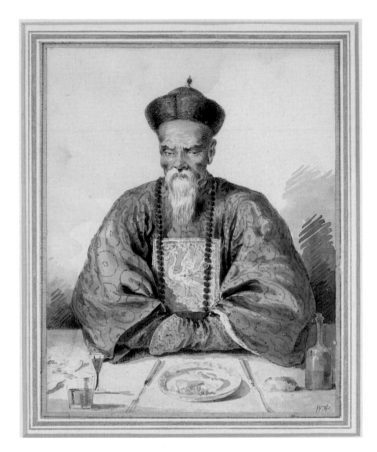

39

Michael Angelo Rooker 1746–1801

The Abbot's Kitchen, Glastonbury c.1795

Watercolour and pen and ink on paper 35.6 × 45.1 cm
Tate. Presented by The Art Fund (Herbert Powell Bequest) 1967

The abbot's kitchen at Glastonbury Abbey is one of the best-preserved medieval kitchens in Europe. While externally its appearance has changed relatively little over the centuries, internally it is very different. Rather than depict the building from the outside against a picturesque backdrop, Rooker chose to paint the interior, exposing the reality of its deterioration: when Rooker visited in the 1790s the kitchen was being used as a cow shed.

Rooker had been taught by Paul Sandby (no.34) and was among the first artists to enter the newly established Royal Academy Schools in 1769. Although he had aspired to be an oil painter, by the 1780s he had essentially abandoned this ambition and had turned to drawing and watercolour. He undertook regular walking tours across England and Wales and produced topographical watercolours in the Sandby tradition. Rooker was a meticulous draughtsman, inspired by scenes of picturesque antiquity that he depicted with great finesse and subtlety of colour and composition. AA

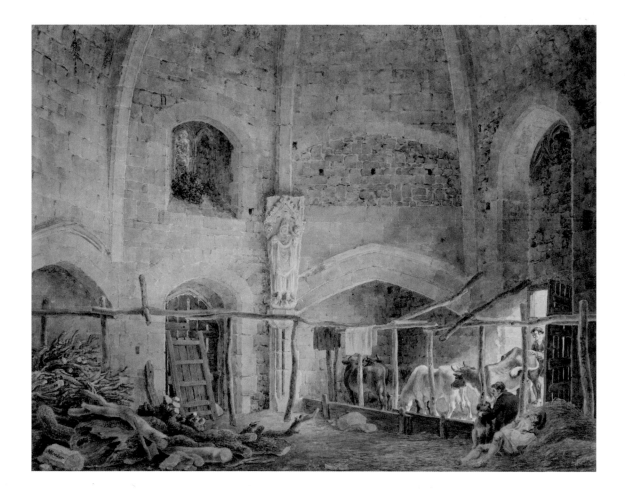

Joseph Mallord William Turner 1775–1851

*Fountains Abbey: Huby's Tower from the
South Part of the Chapel of Nine Altars* 1797

Pencil and watercolour on paper 36.8 × 26.2 cm,
in the *Tweed and Lakes* sketchbook 1797
Tate. Accepted by the nation as part of the Turner Bequest 1856

Thomas Girtin 1775–1802

Bamburgh Castle, Northumberland c.1797–9

Watercolour, gouache and pencil on paper 54.9 × 45.1 cm
Tate. Presented by A.E. Anderson in memory of his brother Frank
through The Art Fund 1928

Turner made three detailed drawings around this Yorkshire site, already popular with tourists, on his North of England tour of 1797. He used this and another heavy, leather-bound, brass-clasped sketchbook for intricate studies of townscapes, mountains, castles and ruins, a few of which are finished in watercolour to varying degrees, possibly to entice patrons to commission finished versions. His later sketchbooks were generally smaller, with the drawings, usually in pencil alone for speed, kept private.

Though it is impossible to be sure, the sense of immediacy here suggests that the colour was applied at the scene. Many leaves of Turner's sketchbooks were extracted for prolonged exhibition in the nineteenth century. The centre of this page is slightly darkened, surrounded by the tell-tale trace of an acidic mount, and the colours are likely to have faded a little, demonstrating some of the key issues affecting the display of watercolours. MI

Girtin visited Bamburgh on his 1796 tour of the North of England, where he recorded many of the sites drawn by his friend and rival Turner the following year (see no.40). He focused on an unfamiliar corner of the castle, since much restored, piling the vertical sheet high with its monumental, eroded bulk, which seems almost to be actively merging into its rocky coastal setting.

The composition is extended a little to the left with additional paper, and the colours are slightly mismatched. The low horizon of the sea emphasises the towering height, as do the seagulls, touched in with white gouache. The eye is also drawn to a white cow and its companion in a rather precarious position near the centre of the composition. Scudding clouds and bursts of sunlight place this view at the 'Sublime' extreme of Girtin's work, compared with his serene *White House at Chelsea* (no.42). MI

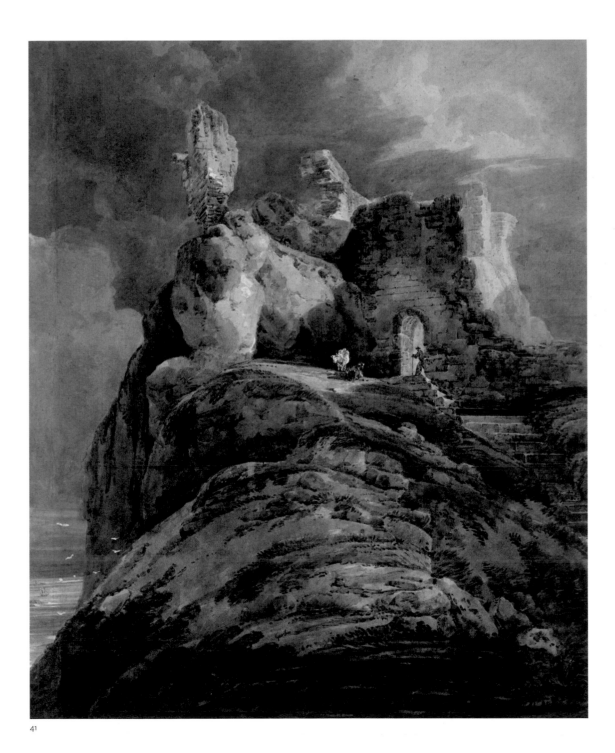

41

42

Thomas Girtin 1775–1802

The White House at Chelsea 1800

Watercolour on paper 29.8 × 51.4 cm
Tate. Bequeathed by Mrs Ada Montefiore 1933

Chelsea Old Church appears across Battersea Bridge towards the right, while the house is actually on the opposite bank of the Thames along Chelsea Reach, later the site of Battersea Park; tower blocks now terminate the view westwards. This is one of the most famous of English watercolours, partly because it was venerated by Turner. Turner's occasional introduction of a white, reflected motif in his own work may have been a tribute to his short-lived contemporary and friend (no.49).

The White House was not publicly exhibited until the 1820s, when it was praised for its 'simple means'. The bare, off-white paper of the gable-end is further touched with yellow, so the perceived 'whiteness' of the house is actually by contrast with its blue-grey surroundings. The solemn silhouettes may have been inspired by Rembrandt's *Mill* 1645–8 (National Gallery of Art, Washington, D.C.), which Girtin knew, but his work was generally less introspective (no.41). MI

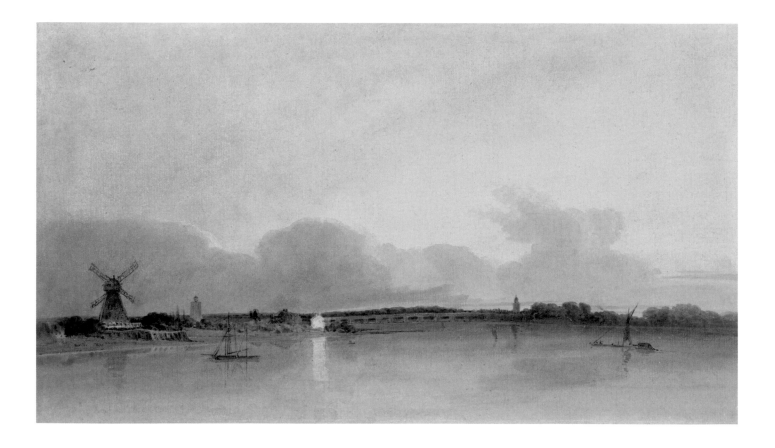

43

Lady Gordon
(née Julia Isabella Levina Bennet) 1775–1867

Cottage at Wigmore, Kent 1803

Watercolour and pencil on paper 24.3 × 31.5 cm
Tate. Purchased as part of the Oppé Collection with assistance
from the National Lottery through the Heritage Lottery Fund 1996

Julia Bennet was an amateur artist who was taught by Turner and Girtin, two of the leading watercolour artists of the late eighteenth and early nineteenth centuries. Many artists were compelled to teach young ladies to draw due to the need for a steady income although, as Turner writes to a friend, he was only paid five shillings a lesson. An important element of teaching was in the copying of a master's work (also the practice of professional artists). Bennet is known to have copied works by Girtin, indeed she inscribes one of her watercolours 'after Girtin, a very good drawing master'.

This watercolour of a cottage in Wigmore, near Maidstone in Kent, demonstrates Girtin's influence on Bennet evident in the type of paper selected, her choice of subject matter and her handling of paint.
AA

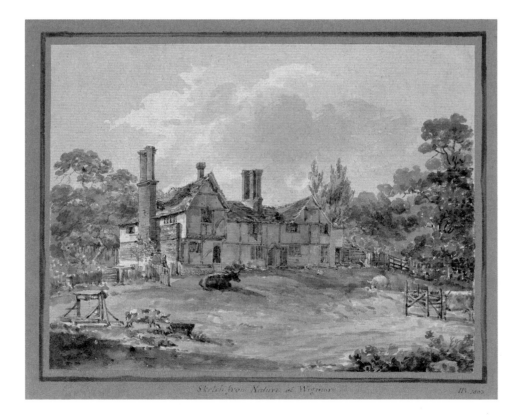

Colonel Robert Smith 1787–1873

A Bungalow at the Powder Manufactury,
Ichapore, Barrakpore, West Bengal 1806

Watercolour on paper 27.5 × 40.5 cm
Private collection

Like all his army-officer contemporaries, Smith learnt to draw and use watercolour, in his own case as a cadet at the East India Company's military college. He painted all his life, but never exhibited, suggesting his motive for doing so was professional or, later on, for his own amusement. He went to India in 1805, where he joined the Bengal Engineers. He rose to the rank of Colonel and served as Garrison Engineer in Delhi, from 1822–30. Made within a year of Smith's arrival on the subcontinent, when he was only nineteen, this watercolour depicts the River Ganges and buildings around the East India Company's important gunpowder factory at Ichapore (also known as Ichapur/Ishapore). This had opened in 1791 on a site originally developed by the Dutch Ostend Company from 1712. Smith's style is topographically precise, as he would have been taught. But his delicately graduated washes and assured placing of the adjutant storks in the foreground show a sensitive eye. DBB

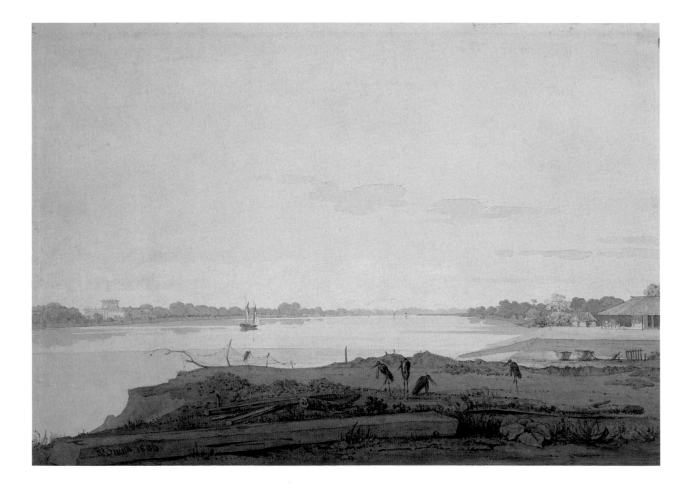

45

John Sell Cotman 1782–1842

Norwich Market-Place c.1809

Watercolour on paper 40.6 × 64.8 cm
Tate. Presented by Francis E. Halsey 1945

This lively scene of the busy Norwich marketplace is characteristic of Cotman's highly individual style of drawing and painting. Cotman was an expert at producing detailed observations of people and places, yet depicted them in a manner of simplified abstraction. As Martin Hardie has noted, Cotman excelled in 'his definition of detail combined with largeness of pattern' (Hardie 1966, vol.1, p.79), shown here in the houses and shop fronts that line the square and the awnings that seem to float into the distance. Cotman was extraordinarily forward looking, yet could also be understood as looking back to the work of Francis Towne (no.36), whose distinctive style of outlining colour washes bears certain similarities to Cotman's own approach to the medium.

Born in Norwich, Cotman moved to London in 1798, but later returned to his home town where he worked as a drawing-master until 1834. He became President of the Norwich School after the death of John Crome; the school was an important regional community of artists, both professional and amateur. AA

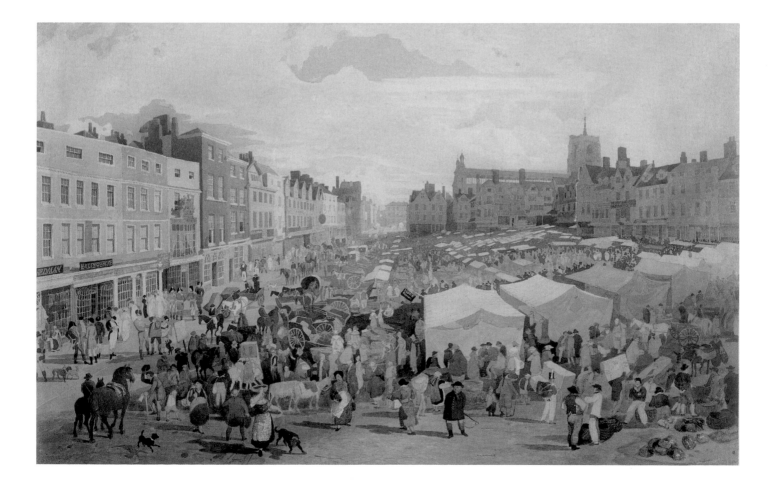

William Capon 1757–1827

A Demolition Site near Westminster Abbey
drawn 1808, painted 1822

Watercolour on paper 19.5 × 23.6 cm; laid down in a large folio album
of *Sixteen Original Watercolours of Views in Westminster* 1801–23
By permission of the Society of Antiquaries of London

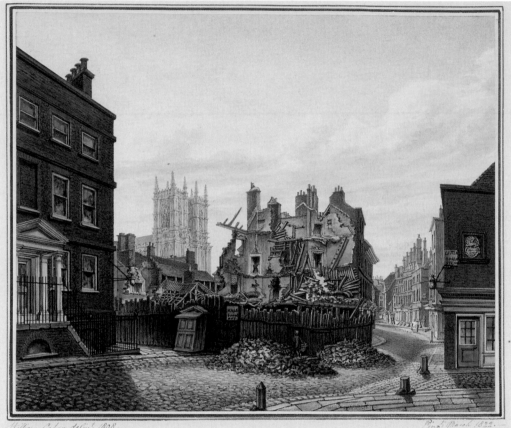

Capon's extensive notes on the mount below this
watercolour identify the location as Princes Street,
Westminster, after a fire early in 1808. After succes-
sive rebuildings, the site on the left is now occupied
by the Queen Elizabeth II Conference Centre, flanked
by Storey's Gate with Old Queen Street opposite.
This album of Westminster views shows how water-
colours continued to fulfil a documentary function,
collected and displayed in portfolios and albums,
at a time when watercolourists were increasingly
competing with oil painters by exhibiting large,
gold-framed works.

The son of a Norwich portrait painter, Capon
moved to London and worked as a designer of
architectural theatre scenery and sometimes of
whole theatres. He had a passion for the past, and
his closely observed, minutely worked antiquarian
drawings and watercolours of ancient London
buildings are held as valuable historical records
at the British Museum, the London Metropolitan
Archives and the Palace of Westminster. MI

47

Richard Parkes Bonington 1802–1828

Verona, Piazza dell'Erbe c.1826–7

Watercolour and pencil on paper 20.6 × 26.5 cm
Tate. Purchased as part of the Oppé Collection with assistance
from the National Lottery through the Heritage Lottery Fund 1996

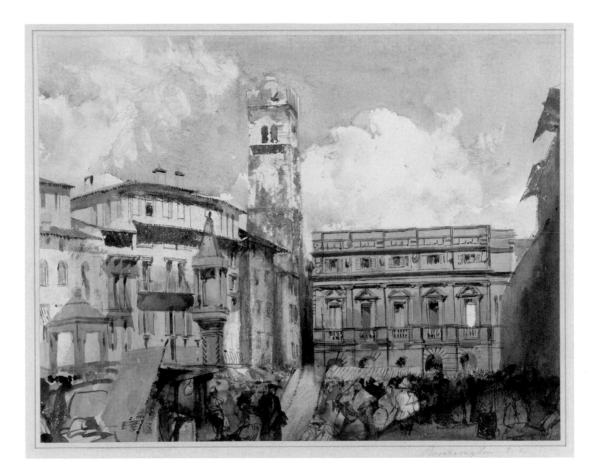

Bonington was born the son of a drawing-master in Nottingham. The family moved to Calais in 1817 after the end of the Napoleonic Wars, where the young Bonington began his artistic training with the Anglo-French watercolour artist, Louis Francia.

Some of Bonington's finest watercolours were inspired by his tour to northern Italy in 1826, including this work, depicting the famous Piazza dell'Erbe in Verona. Named after the herb market that used to take place in the square, formally the site of a Roman forum, this is still an important tourist destination. Although Bonington was an accomplished oil painter, he was highly regarded by his contemporaries for his astonishing skill with watercolour. This work, often thought to be in an unfinished state, demonstrates Bonington's extraordinary range of technical devices employed in his watercolours. He began with a strong pencil underdrawing, used broad washes of colour, both wet and dry, and finally added fine brushstrokes to provide definition and structure to the drawing, as well as scratching out in other areas. AA

David Cox 1783–1859

Tour d'Horloge, Rouen 1829

Pencil and watercolour on paper 34.3 × 25.7 cm
Tate. Presented by The Art Fund (Herbert Powell Bequest) 1967

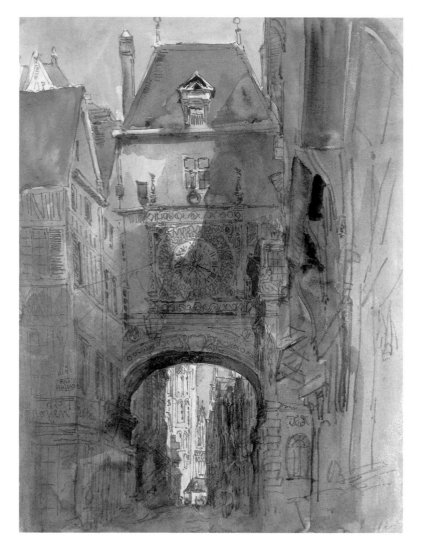

Produced in 1829, this hastily worked watercolour sketch depicts the Tour d'Horloge in Rouen on the Rue du Gros Horloge. The Gros Horloge is one of the principal landmarks in Rouen and was a favourite picturesque subject for British artists in northern France.

Despite his steadfast belief that the British landscape was far superior to any foreign view, Cox made three Continental tours, travelling to Belgium and Holland in 1826 and to France in 1829 and 1832. Many of Cox's watercolour sketches from his 1829 visit to France followed a similar model to that of *Tour d'Horloge*, incorporating a pencil underdrawing with broad washes of simple colour laid over the top. The advantage of using transparent watercolour in this instance ensures that the pencil sketch remains visible, whilst the technique of wet-on-wet painting accentuates the immediacy of his work and captures the various effects of light and shade falling on ancient buildings. AA

Joseph Mallord William Turner 1775–1851

The Blue Rigi, Sunrise 1842

Watercolour on paper 29.7 × 45 cm
Tate. Purchased with assistance from the National Heritage Memorial Fund,
The Art Fund (with a contribution from the Wolfson Foundation and including
generous support from David and Susan Gradel, and from other members of the
public through the Save the Blue Rigi appeal), Tate Members and other donors 2007

The Rigi is seen across Lake Lucerne in Switzerland; there are also contemporary variations on the composition in the *Red Rigi* (National Gallery of Victoria, Melbourne), a sunset view, and the *Dark Rigi*, another dawn scene (private collection). Turner first drew the mountain in 1802, but it was only in the early 1840s that he observed it at leisure on his late tours, making watercolours in sketchbooks and producing semi-complete 'sample studies' (Tate) from which his patrons commissioned the fully realised versions.

These finished Swiss views appear direct and spontaneous, but they are carefully planned and minutely worked with countless small touches over initial broad washes. The mountain becomes a conduit for varying light and colour, comparable with Claude Monet's later series paintings of grainstacks and Rouen Cathedral. The Morning Star and its brilliant reflection may be an allusion to *The White House at Chelsea* (no.42) by Thomas Girtin, which was always a touchstone for Turner. MI

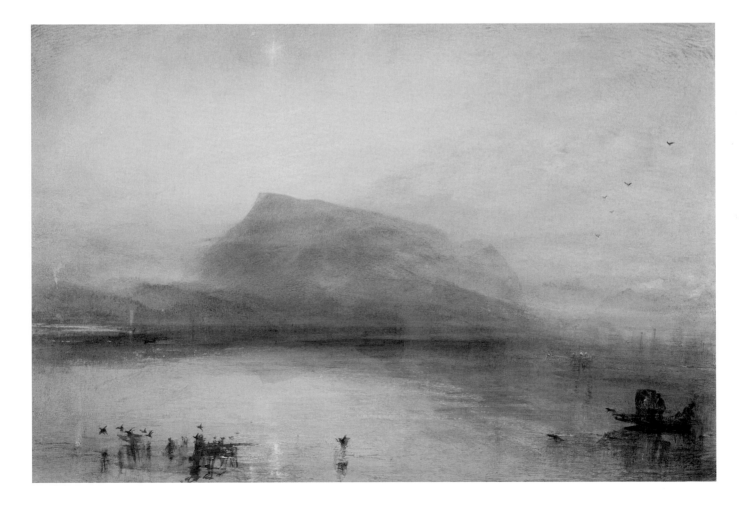

50

50

John Frederick Lewis 1805–1876

The Bazaar of the Ghûriyah from the Steps of the Mosque of El-Ghûri, Cairo 1841–5

Pencil, watercolour and gouache on paper 54 × 37.9 cm
Tate. Purchased as part of the Oppé Collection with assistance
from the National Lottery through the Heritage Lottery Fund 1996

This pencil and watercolour drawing shows the bazaar of the Ghuriyah, a predominantly silk and cotton market that took place in the area surrounding the Mosque of El-Ghuri in Cairo. Lewis had recently arrived in Cairo when he produced this study, and was to stay there for the next ten years. He inhabited a grand residence in the city and lived in an extravagant manner, dressing like the natives and, according to one of his visitors, living like an 'oriental nobleman'.

Lewis made a large number of pencil sketches of sites such as this during his foreign tours. The main purpose was to ensure that he had captured a sufficient number of different subjects so that he was able to use them to produce finished oils and watercolours on his return to England. Lewis filled the drawing with detail, depicting the architectural features of the courtyard and the crowds of people in their brightly coloured clothing buying and selling market wares. He added washes in watercolour and highlighted some features in opaque gouache. AA

51

William Callow 1812–1908

Entrance to the Court of the Ducal Palace, Venice 1852

Watercolour over pencil heightened with
gouache on paper 23.9 × 34 cm
Private collection

Looking south-west along the Riva degli Schiavoni, the Hotel Danieli (Palazzo Dandolo) is on the right, with the Doge's Palace to the right of centre and the columns at the entrance to the Piazzetta beyond. The domes of Santa Maria della Salute are across the Grand Canal from the Hotel Europa, where Callow's stay in 1840 coincided with Turner's on the last of his celebrated visits to Venice. This view was perhaps recorded on Callow's honeymoon in 1846, and he often returned to the city.

Callow had trained as a watercolourist and engraver before living mostly in Paris between 1829 and 1841, latterly as drawing-master to the French Royal family. He was influenced by the clear, airy styles of Bonington (no.47), who had exhibited a similar view in oils in 1828 (Tate), and Bonington's friend Thomas Shotter Boys. Callow shared a Paris studio and went on sketching trips with the latter. MI

51

Richard Dadd 1817–1886

View of the Island of Rhodes 1845

Watercolour on paper 24.5 × 37.2 cm
Victoria and Albert Museum, London

Richard Dadd would have observed this scene on the island of Rhodes when he took up the position of travelling companion and artist to Sir Thomas Phillips, a Welsh lawyer. The pair left England in July 1842, travelling to Switzerland, Italy, Greece, Turkey, Syria, Palestine, Egypt and Malta. During the trip Dadd made a large number of pencil sketches; the intense schedule of travel left little time for more finished studies.

It was while he was on this tour that Dadd experienced a mental breakdown, resulting in a rapid decline. In 1844 he was committed to the lunatic asylum, Bethlem Hospital, for insanity and for murdering his father. During his time at Bethlem Dadd produced exquisite watercolours, drawn largely from memory of scenes he had witnessed on his travels. *View of the Island of Rhodes* was one such work, depicted with almost photographic exactitude. He applied tiny dabs of paint that were either hatched or stippled, building up the image in minute detail. This approach also gives the landscape a hazy appearance, retrospectively capturing the intense arid heat of the Greek summer. AA

53

William Holman Hunt 1827–1910

The Dead Sea from Siloam 1854–5

Watercolour and gouache on paper 25.1 × 35.2 cm
Birmingham Museums & Art Gallery. Presented by Edward Morse,
through the National Art Collections Fund, 1948

Begun in 1854 and completed the following year, this watercolour depicts the landscape observed by Hunt from the Mount of Offence looking towards the Dead Sea and the Mountains of Moab. Hunt was a deeply religious man, and his trip to Jerusalem was as much a journey of religious pilgrimage as an artistic tour. He completed many drawings of sites of biblical significance, imbuing topographical views of the Holy Land with a powerful spiritual understanding.

The intense atmosphere and colour experienced by Hunt on his trip to the Holy Land led him to rethink traditional topographical conventions. Here he minimised his use of shadow, creating a shallow pictorial space modulated with jewel-like touches of gouache across the whole composition. AA

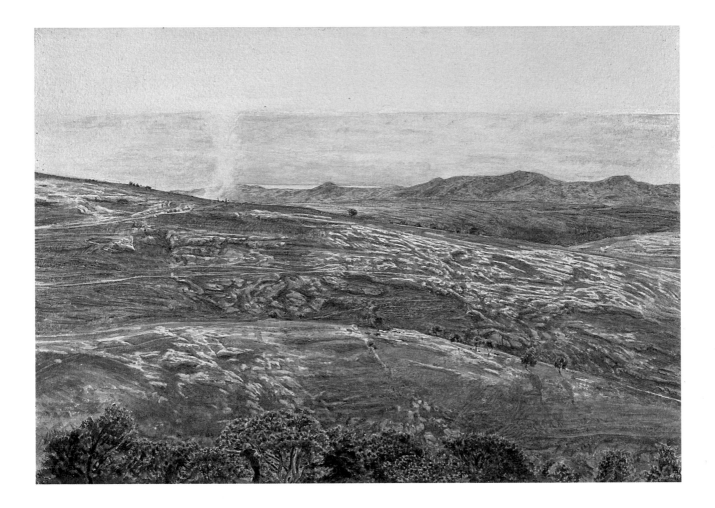

54

John Frederick Lewis 1805–1876

Hhareem Life, Constantinople 1857

Watercolour and gouache on paper 47.6 × 31.7 cm
Laing Art Gallery, Newcastle-upon-Tyne
(Tyne and Wear Archives & Museums)

J.F. Lewis was renowned for returning watercolour to the exquisite detailing associated with Persian miniature painting and the work of early portraitists such as Hilliard (see nos.12, 13). From 1841 to 1851 he lived in Cairo in Egypt where he produced around six hundred drawings and watercolours that provided source material for the works he exhibited following his return to Britain.

Europeans were fascinated by the idea of the Oriental harem, yet often the reality was far removed from the fantasy. As a Western man, Lewis would not have gained access to this most private of rooms, and so this watercolour would have been painted using models within his studio (the woman on the right is believed to be his wife Marian). In this work he domesticates the usually sexual overtones of the harem into a place of feminine ease and friendship. However, the inclusion of a pair of men's slippers, observed in the mirror, can be understood as implying a dominant male presence at all times.

Painted in minutely divided strokes of watercolour with a large amount of gouache, this work is typical of Lewis's handling of the medium. The gouache adds a vibrancy of colour to the scene, and he works in a manner more akin to oil painting, in observing the glowing tiles, scintillating textures and layering of fabric, and in his accurate mimesis of the cat's fur and the peacock feathers. In fact, Lewis painted in both oil and watercolour often duplicating his designs in these different media to create brilliant reality effects. Apparently he disliked displaying watercolours in white mounts, believing that they reduced finished works to the level of sketches. Instead he preferred to exhibit works on paper in gold frames which further made them appear like oils.

Lewis was elected President of the Old Water-Colour Society in 1855 but stepped down from this position in 1858 when he decided to switch permanently to oil, finding watercolour to be too laborious and unrenumerative by comparison. AA

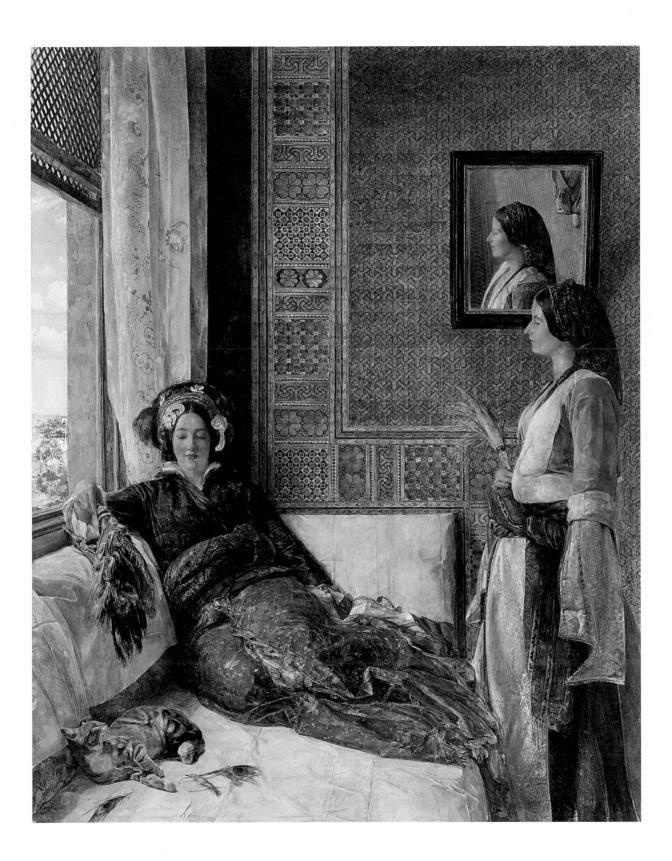

55

Alfred William Hunt 1830–1896

A November Rainbow – Dolwyddelan Valley, November 11, 1866, 1p.m. 1866

Watercolour on paper 50.3 × 75.5 cm
The Ashmolean Museum, Oxford

In this large, highly coloured watercolour of Dolwyddelan Valley in Wales, Hunt's exceptional ability to capture the meteorological effects of the rainbow can be admired in panoramic detail. Hunt was greatly influenced by John Ruskin's principle of 'truth to nature' as well as Turner's distinctive painterly breadth, and was one of a group of progressive artists who adopted a precise yet intensely atmospheric approach to landscape painting. The wide arc of the River Lledr leads the eye to Dolwyddelan Castle, which is perched on a small rocky outcrop to the right of the painting. A lone figure, possibly a cowherd, covers his head against the rain, accompanied by the customary Welsh image of a black and white sheepdog.

Hunt was continually inspired by the appearance of natural forms, whether stone or vegetation, water or sky, and strove to replicate these details to a heightened degree of accuracy, as well as introducing a human element to his landscapes. AA

56

Cecil Lawson 1851–1882

The Hop Gardens of Kent, at Wrotham near Sevenoaks 1874

Pencil, watercolour and gouache laid on wood panel
38.2 × 52.5 cm
Birmingham Museum & Art Gallery. Purchased through the Public Picture Gallery Fund, 1908

In 1874, after a tour of the Low Countries and France, Cecil Lawson settled in Wrotham in Kent. It was here that he gained the inspiration for *The Hop Gardens of Kent*. In the nineteenth century thousands of acres of Kent countryside had been devoted to the growing of hops, an essential ingredient in the brewing of ale. By 1874, the hop garden was at its height, providing a large amount of employment for the county. Lawson has captured the rural charm of this cherished landscape and way of farming that would within a few decades begin its rapid decline.

The painting was exhibited twice, first at the Royal Academy in 1874, and again at the Grosvenor Gallery in 1878, and received complimentary reviews in the press: 'we look over miles of lovely hop country, the red-tiled farmhouses on the hillside foreground being almost embowered in the yellow greenery of the abounding plant. The treatment is at once original and truthful' (*Art Journal*, 1876, p.231). The success of the painting lies in Lawson's ability to capture a specific topographical scene, but to employ watercolour with a great sense of freedom and intensity of colour. AA

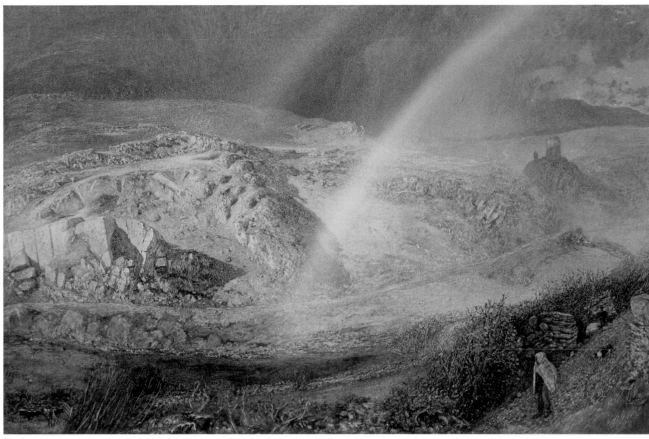

55

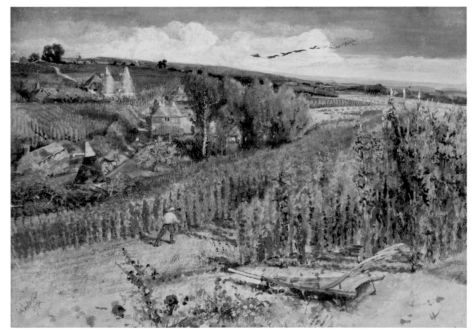

56

57

Charles Rennie Mackintosh 1868–1928

Fetges c.1927

Watercolour on paper 47.4 × 48 cm
Tate. Presented by Walter W. Blackie 1929

The small French village of Fetges, little changed today, is seen from the south against its Pyrenees setting near the Spanish border. While training as an architect, Mackintosh had also attended Glasgow School of Art (for which he famously designed new premises). His architectural and decorative projects developed from the Art Nouveau style and imbued his watercolours with clarity and structural rhythm. The composition is held together and decoratively flattened by the flickering network of fine white lines defining walls and roads.

Mackintosh married the watercolourist and designer Margaret Macdonald, with whom he collaborated. His career in Glasgow tailed off before the First World War, so the couple moved to London, producing botanical watercolours and textile designs. Out of fashion, from 1923 they lived and painted in the Languedoc–Roussillon region of France, mostly at Port-Vendres on the Mediterranean, about fifty miles (80 km) east of Fetges. MI

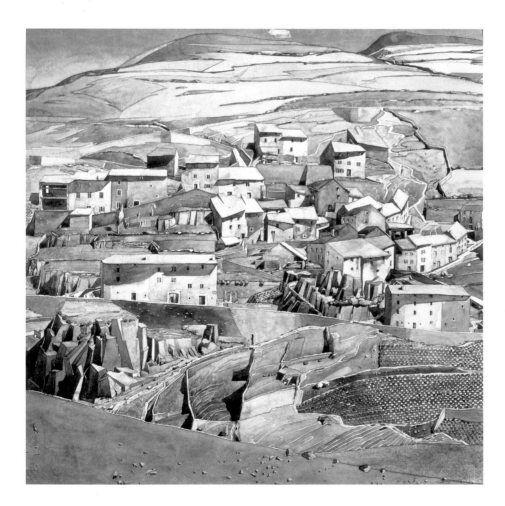

58

Edward Burra 1905–1976

Mexican Church c.1938

Gouache and ink wash on paper laid on canvas
132.1 × 103.5 cm
Tate. Purchased 1940

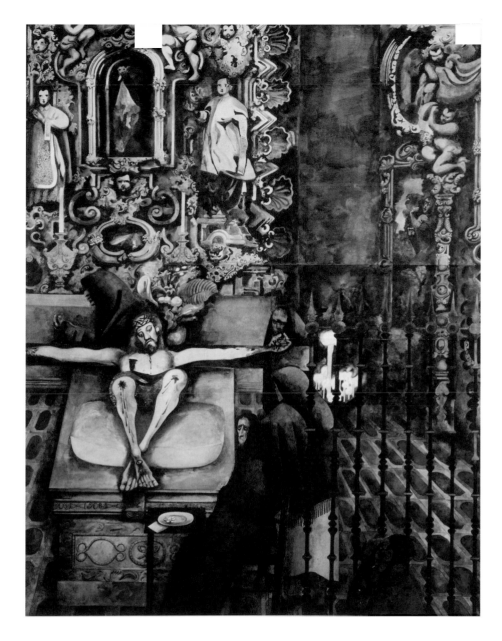

Edward Burra produced this large watercolour following a visit to Mexico in 1937. The ambitious scale was achieved by gluing together five sheets of paper, the edges of which were trimmed before the work was mounted on stretched canvas. Although this image of a sombre church interior dominated by an outstretched effigy of Christ in the foreground was inspired by places Burra visited on his trip, he actually used postcards as source material. The reredos is taken from the Cathedral in Taxco, and the reclining crucifix of *El Seňor de la Preciosa Sangre* from Santa Catarina in Mexico City. Burra added the shrouded shapes of figures in prayer to convey the strength of devotion inspired by the statue and other imagery adorning the reredos. In keeping with his practice he outlined details in pencil before filling these in with gouache. Black ink was added in places to accentuate the gloom and claustrophobia of the image, while also conveying the impression of forms glowing in the dark. Burra's fascination with what he perceived to be the cruelty and hypnotic power of religious iconography is reinforced by the animate patterns of decoration throughout the composition, together with the attention he gives to the wounds and agonised expression of Christ. AS

Eric Ravilious 1903–1942
The Vale of the White Horse c.1939

Pencil and watercolour on paper 45.1 × 55.3 cm
Tate. Purchased 1940

This area between Oxford and Marlborough takes its name from the most famous of the figures carved into the chalk downlands of southern England, marked beside the prehistoric Ridgeway track. Ravilious also painted the eighteenth-century horses at Weymouth and Westbury, Dorset's Cerne Abbas Giant and the Long Man of Wilmington in Sussex, but a planned book was interrupted when, like his friend Bawden (no.60), Ravilious was employed as a war artist, eventually being reported missing in Iceland.

In the 1930s he and artists such as Paul Nash (no.92) and John Piper (nos.61, 62) shared archaeological and antiquarian interests, perhaps partly as an expression of Englishness in the face of the situation leading to the war. The ready-made 'abstraction' of the figures would have appealed to Ravilious's elegant sense of design, while the bold, rolling shapes of the landscape reflect his interest in the simplified, proto-Modernist watercolour forms of predecessors like Cotman (fig.7) and Towne (no.36). MI

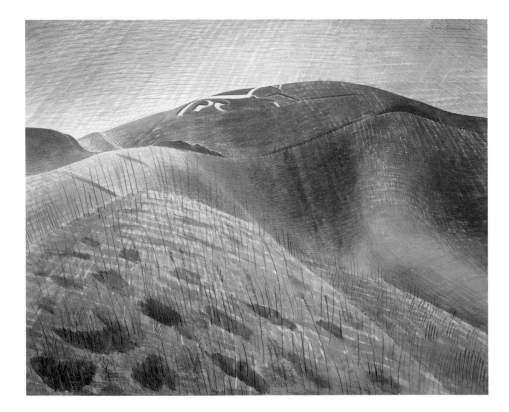

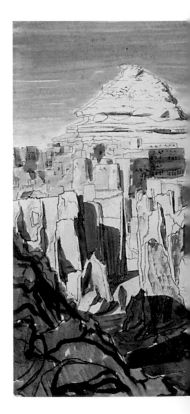

60

Edward Bawden 1903–1989

Siwa Oasis from the Ruined Old Town of Siwa c.1941

Watercolour on paper 45.7 × 117.1 cm
Imperial War Museum, London

With an established career as a topographical water-colourist and designer, Edward Bawden spent much of the Second World War abroad as a commissioned war artist. His periods in Egypt, Abyssinia (Ethiopia), Iraq, Persia (Iran) and Saudi Arabia upheld the Orientalist tradition of Middle Eastern travel exemplified by J.F. Lewis and Holman Hunt (nos.50, 53).

The Long Range Desert Group, operating behind enemy lines, used Siwa in Egypt as its base hundreds of miles west of Cairo. The foreground is dominated by the strange, eroded forms of Berber *karshif* (mud and salt) buildings of the Shali fortress, while the deceptively quiet desert beyond is framed by the Gebel al-Mawta necropolis and the tower of the ancient mosque. A tiny figure on a donkey below the distant minaret emphasises the epic, timeless mood. Bawden sometimes used two Royal-format sheets for panoramic, almost cinematic views, painted separately with consequent slight mismatches of form and colour along the join. MI

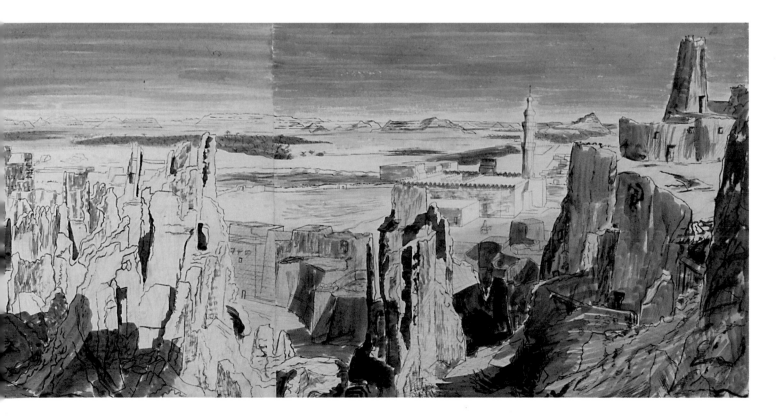

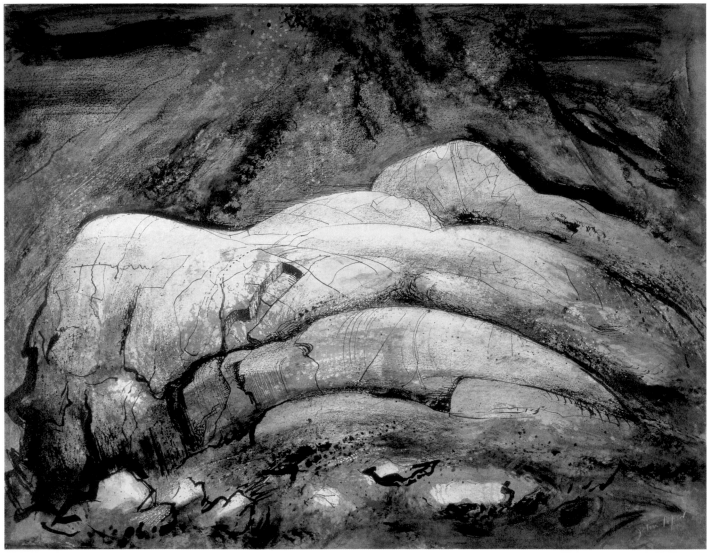

61

61

John Piper 1903–1992

Glaciated Rocks, Nant Ffrancon 1944

Pen, ink and wash on paper 54.9 × 70.7 cm
Tate. Purchased with funds provided by
the Helena and Kenneth Levy Bequest 1991

This view in Snowdonia is characteristic of the
dramatic wartime phase of Neo-Romanticism, a
tendency that combined an interest in the dramatic,
'Sublime' aspects of the Romanticism of the eight-
eenth and nineteenth centuries with a sometimes
disturbing modern psychological sensibility. Piper,
who spent much time in North Wales in the 1940s,
knew and admired the rugged Welsh mountain
landscapes of Richard Wilson, and James Ward's
monumental *Gordale Scar* c.1812–14 (Tate) may have
been another influence.

 Piper had become known as a painter of
consciously 'Picturesque' topography and architec-
ture in pleasing states of decay. Ironically, the
War Artists Advisory Committee subsequently
commissioned intensively worked views in oils and
watercolour of bombed and newly ruined buildings.
Here he uses a similar technique, combining various
media to create a gloomily atmospheric setting for
the rocks he had originally sketched from nature,
but which now seem on the point of transformation
into writhing, primeval figures. MI

62

John Piper 1903–1992

'The Ilchester Arms, Abbotsbury, raining'
15 February 1954

Pencil, wash and gouache on paper 21.5 × 27.2 cm,
in a sketchbook
Tate Archive, London

Today this Dorset pub remains much the same,
including its prominent heraldic sign and pediment.
The viewpoint may have been a car, since heavy rain
is recorded but has not fallen directly on the page,
as can sometimes be seen in Turner's sketchbooks.

 This is the only dated page in a typically diverse
sketchbook including views in the Isle of Wight and
Portland, some with colour notes, nude studies
and a design for a magazine cover. The preceding
page is detached and turned to show a rather more
hospitable scene captured in graphic red and green.
From his youth Piper travelled frequently, particu-
larly in England and Wales, keeping topographical
notebooks and sketchbooks and taking photographs.
Many of these were incorporated in the *Shell Guides*
and *Murray's Architectural Guides*, which he edited
with his great friend the poet John Betjeman, as
well as informing Piper's paintings, watercolours
and prints. MI

62

63

Edward Burra 1905–1976
Valley and River, Northumberland 1972

Pencil and watercolour on paper 101.6 × 68.6 cm
Tate. Presented by the Friends of the Tate Gallery 1973

The specific location of this scene has not been identified, although the artist's sister Anne, who acted as chauffeur on Burra's expeditions, recalled that it was a valley 'south of The Cheviot'. The landscape is typical of Upper Coquetdale, accessible by one of the few roads in this remote area near the Scottish border.

Burra's earlier works were often full of grotesque figures in dramatic urban settings, influenced by Dada and Surrealism, and in the 1930s he had visited Spain, America and Mexico (no.58) in search of the exotic. In his later years he looked nearer to home, producing many large, increasingly empty landscapes expressed with sweeping yet subtle washes, perhaps in reference to the watercolourists of the Romantic era. As with John Piper's paintings (no.61) or Henry Moore's sculptures of reclining figures, there may be a sense of interplay here between the landscape and the contours of the human body. MI

64

Patrick Procktor 1936–2003

Kôm Ombo, Dawn 1984

Watercolour on paper 45.5 × 60.5 cm
The estate of Patrick Procktor, courtesy of
the Redfern Gallery, London

The south-west front of the second-century BC temple of Kôm Ombo, beside the Nile north of Aswan, is shown *contre-jour* against the dawn light in an effect reminiscent of Turner (no.49). This work is thought to have been painted on the spot, and uses a limited palette without preparatory pencil work. It demonstrates Procktor's virtuosity in its combination of direct observation, feeling for composition and atmosphere, and rapid but controlled application, rather different from the intensive techniques of earlier Orientalists such as Holman Hunt (no.53).

A cosmopolitan character, Procktor made his name as a painter of figure scenes, portraying the artists and celebrities of London in the 1960s, but later he often undertook trips abroad, working in Venice, Greece, Egypt, India and China. There, in timeless fashion, he produced many fluent, serene watercolours, sometimes used as the basis of delicate colour aquatint prints. MI

The Exhibition Watercolour

David Blayney Brown

Today, more watercolours are exhibited than ever before, but with less collective impact. The medium is no longer a radical one, nor does it pose any challenge to orthodoxy. Whether in the national, regional or countless local art societies holding exhibitions in Britain and abroad, there is much pleasure to be had, but little of the daring, the burning ambition and *esprit de corps* that once impelled watercolourists to escape from the album and take command of the wall. The artists who founded the dedicated watercolour exhibitions and societies two centuries ago were little short of desperate to show off their technical skills, imagination and the array of new materials available. The 'exhibition watercolour' became an art form in itself, attracting the foremost painters including those who, like Turner, also worked in oils.

Watercolours had already begun to appear in the late eighteenth century in the exhibitions of the Free Society, the Society of Artists and above all the Royal Academy. But their admission by the dominant oil painters was grudging. In 1809, William Blake cited this culture of exclusion as his reason for showing watercolours privately. In fact, he could by then have chosen between two watercolour exhibitions, at the Society of Painters in Water-Colours (SPWC) founded in 1804 and the New Society established in 1807, which had become the Associated Artists in 1808. Probably, his real objection was the predominance of landscape subjects in both exhibitions.

Paul Sandby tried to develop an exhibition profile for his large landscapes, as distinct from his topographical work, by painting them in gouache, hoping that its density and brilliance would stand up to the competition. Closer to Blake's ambition to assert himself as a historical painter in the mixed media he termed 'fresco' was Edward Dayes, who turned from topography to history with *The Fall of the Rebel Angels* exh.1798, enriched with gouache, gum and gold. But according to the collector Richard Colt Hoare it was the appearance of spectacular gouaches of Italian, alpine or historical subjects by the Swiss painter Louis Ducros that spurred 'the advancement from *drawing* to *painting* in water-colours'. In 1822, in reviewing the changes since Sandby was 'monarch of the plain', Hoare declared in his book *The History of Modern Wiltshire* that Ducros had 'proved the force as well as the consequence' of the medium (vol.1, p.82). That Hoare owned thirteen of Ducros's tours de force suggests special pleading, but they were certainly seen by Turner whose Sublime-historical epic *The Battle of Fort Rock* surely reflects their continuing influence.

Turner's *Fort Rock* was exhibited at the Royal Academy in 1815, and meanwhile his views of Swiss scenery based on a Continental tour in 1802 had tended to appear in his own Harley Street gallery, opened in 1804. Despite his friendship with William Wells, the moving spirit behind the formation of the first watercolour society late that year, Turner took no part in it. Whilst an elevating work like John Varley's *The Suburbs of an Ancient City* in the 1808 SPWC exhibition certainly raised the tone, Turner was also an oil painter. He preferred to show his mastery of a newer art form alongside his wider output, rather than as a novelty in itself. In any case, the watercolour exhibitions were even more cluttered than the Academy, hung almost floor to ceiling on fussy swagged drapery. According to the

diary of Joseph Farington for 8 May 1807, one seasoned exhibition-goer, Sir George Beaumont, was repelled by the 'chattering display' (Cave 1982, p.3041).

The new watercolour academy, whatever its pretensions, was not the Royal Academy. Admission cost a shilling and it was obvious that relatively smaller works and more modest prices, despite notable exceptions achieved by suddenly fashionable phenomena like Thomas Heaphy's scenes of common life, would attract a new sort of buyer. Almost 12,000 people visited the first exhibition in 1805, 12,500 in 1806. Soon they could buy off the walls, paying a deposit. Yet if Beaumont found all this rather vulgar, society figures like the Duchess of Rutland, the plutocrat-connoisseur Thomas Hope (who bought Varley's *Ancient City*) and oil painters like Thomas Lawrence were happy to put their names in the sales book. If anything, the boom had the characteristics of a bubble. Could it last?

Yes and no. Since the original society aped the Academy in showing only members and fellows, John Sell Cotman, David Cox and Peter de Wint joined others in the New Society in 1807. Competition proved disastrous, with takings tumbling at both exhibitions. In 1812, having been forced to admit oils, the Associated Artists as the younger society was now known had its exhibition seized in lieu of unpaid rent while the original society disbanded, to regroup in 1813 with oils allowed. Only in 1821, in smaller premises, did it return to watercolour alone. The Associated Artists was reborn in 1831 and renamed the Institute of Painters in Water-Colours in 1863. With Royal charters, the 'RWS' and 'RI' still flourish, the models for countless others, professional and amateur, throughout the English-speaking world.

There is no space here to detail the tortuous schisms, rivalries and regroupings of these and other exhibiting organisations like the Dudley Gallery (incorporated with the RI in 1883), where aesthetes and symbolists discomfited by the usual glut of landscapes would later find a home. The true exhibition watercolour – grand, gold-framed and conceived to rival oil – was more than just a watercolour in an exhibition and reached its peak by mid-century. George Fennel Robson's magnificent *Loch Coruisk* exh. 1826 defined one response to the challenge of oil, in its deep and sonorous tone. Samuel Palmer's *Dream in the Apennine* exh. 1864 dazzled by its layered, stippled brilliance. For decades, artists had been tempted to more vivid colouring by new inventions and combinations of media (ignoring bans on gum or varnish), while critics reached for musical analogies for 'Exhibition pitch' and 'key' (*Library of the Fine Arts*, vol.1, 1831, p.515) or likened the most virtuoso performers to guitarists trying to sing an oratorio (Ray 1955, pp.135, 137).

The question arose – if watercolour was just like oil, why not paint in oil? One answer lay in scaling-down to the exquisite miniatures of William Henry Hunt or the Pre-Raphaelite-inspired naturalism of George Price Boyce and Myles Birket Foster. Yet there were still plenty of artists ambitious to make a bigger splash with their exhibited watercolours. Walter Langley, rare among Victorian artists in making his reputation in watercolour, chose it for his gloomy Newlyn parable '*But men must work and women must weep*' 1882. Burne-Jones announced his somewhat unwelcome arrival at the RWS in 1864 with the rapt, almost Wagnerian symbolism and other-worldly colouring of *The Merciful Knight*, his favourite early work. Arthur Melville ravished the 1897 exhibition with the velvet darkness and glinting light in his *Blue Night, Venice*. His exhibiting career spanned the Royal Scottish Academy and the RWS, and he was given a Memorial Exhibition at the RI in 1906. Later still, Dorothy Webster Hawksley was a regular contributor of watercolours to the Royal Academy, the RI and the Fine Art Society. In her monumental *Nativity* 1924 she herself stands witness, sketchbook in hand.

65

Richard Westall 1765–1836

*The Earle of Essex's First Interview with
Queen Elizabeth after his Return from Ireland* 1789

Ink and watercolour on paper 44.1 × 54.7 cm
Laing Art Gallery, Newcastle upon Tyne
(Tyne and Wear Archives & Museums)

Richard Westall was one of the pioneers of historical
subjects in watercolours, when such subjects were
usually painted in oil or, if drawn, made for engraving.
He designed book illustrations and painted pictures
for Boydell's Shakespeare Gallery, but was most
admired for his watercolours, which he exhibited
regularly at the Royal Academy. As well as ideal,
classical or literary subjects, he took up themes
from national history that proved popular with the
onset of Romanticism. This relatively early work is
still neoclassical in composition but his later works
showed a more decorative, rococo feeling, while
he added gouache and gum to watercolour to enrich
his effects. DBB

66

William Blake 1757–1827

The Penance of Jane Shore in St Paul's Church
c.1793, exh. 1809

Pen and ink, and watercolour on paper 24.5 × 29.5 cm
Tate. Presented by the executors of W. Graham Robertson
through The Art Fund 1949

Based on an earlier watercolour made circa 1779, this work was included by Blakc in a famously disastrous one-man show in London in 1809. In the catalogue he wrote that, feeling himself 'effectually excluded' from the Royal Academy as he worked 'in Water-colours, (that is in Fresco)', he found it 'necessary that I should exhibit to the Public, in an Exhibition of my own'. In fact, Blake could by then have taken his pick from two exhibiting societies of watercolourists, but may have been put off by their preference for landscapes. Reminiscent of pictures by Benjamin West, of whom Blake usually disapproved, this subject from English history was one of the most accessible and formally conventional works in a show otherwise devoted to complex, mystifying allegories, some of them painted in tempera. However, Blake's catalogue stated that it 'proves to the Author, and ... to any discerning eye, that the productions of our youth and of our maturer age are equal in all essential points'. DBB

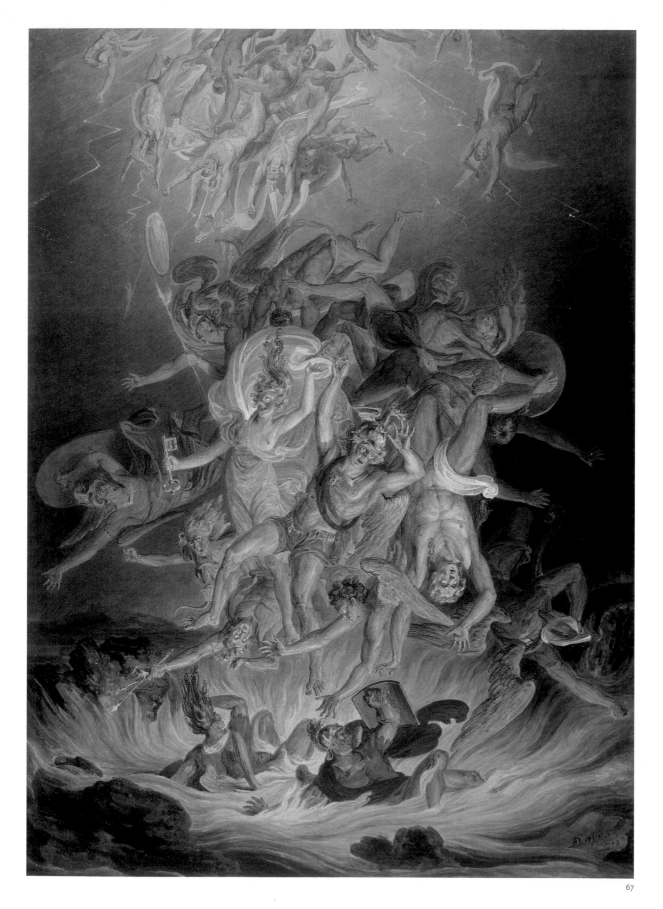

67

Edward Dayes 1763–1804

The Fall of the Rebel Angels exh. 1798

Watercolour, gouache, pen and ink, and gold paint
on paper 91 × 65 cm
Tate. Purchased 1988

Hitherto known for topography, Edward Dayes
turned in 1798 to historical subjects from the Bible
or literature, showing sixteen such watercolours at
the Royal Academy up to 1803, the year before his
death by suicide. Although they just precede the
foundation of the Society of Painters in Water-
Colour in 1804, these works exemplify the new trend
for exhibition watercolours in the boldest manner
and tackling elevated themes hitherto reserved for oil
painting. In this subject from Milton's *Paradise Lost*
watercolour is mixed with gouache and heightened
with gold in details like the helmet and key. Dayes
aimed to transfer the drama and sublimity of
Benjamin West's history paintings or Henry Fuseli's
Milton Gallery to paper. DBB

68

Thomas Heaphy 1775–1835

Fisherman's Cottage exh. 1808

Watercolour on paper 47.5 × 62.9 cm
Laing Art Gallery, Newcastle upon Tyne
(Tyne and Wear Archives & Museums)

Thomas Heaphy was one of the stars of the early
exhibitions at the 'Old' Water-Colour Society,
achieving phenomenal success and extraordinary
prices for his scenes of common life. The equiva-
lents in watercolour of paintings by David Wilkie
appearing at the Royal Academy at the same time,
they were striking exceptions to the predominance
of landscape in the watercolour shows. Based on
studies at Hastings, his pictures of fishing scenes
were sensations for their detail, characterisation
and unsentimental, sometimes cruel, portrayal of
working life realised in a searching, acute technique.
This watercolour was one of twelve exhibits at the
Society in 1808, which together sold for 629 guineas.
In 1809, Heaphy was paid a record 400 guineas for a
single watercolour of a fish market. By 1811, critical
opinion was turning, with the *Repository of Arts*
berating him for 'wasting his skill in the delineation
of brutish character and manners' (p.345). DBB

68

69

Joseph Michael Gandy 1771–1843

*A Selection of Parts of Buildings, Public and Private, Erected from the
Designs of Sir John Soane, Esq., R.A., in the Metropolis and Other Places
in the United Kingdom Between the Years 1780 and 1815* exh. 1818

Watercolour on paper 72.5 × 129.3 cm
By courtesy of the Trustees of Sir John Soane's Museum, London

Joseph Michael Gandy was an architect and designer closely associated with Sir John Soane, with whom he had a complex, ambivalent relationship as a pupil and admirer who also insisted on his own creative identity. Most of his own grandiose projects remained unbuilt and exist only in his visionary watercolours. In this portentously titled work, exhibited at the Royal Academy in 1818, Gandy assembled the corpus of Soane, the Academy's Professor of Architecture, in the form of architectural models together with the many drawings he himself had made for Soane over previous decades.

In an imaginary, Soanian interior, buildings like the Bank of England and Dulwich Picture Gallery are arranged in tiers, in sepulchral gloom pierced by a ray from a reflecting lamp decorated with Soane's adopted armorial devices. In the right foreground, Gandy himself appears, seated at a table working on drawings for the Bank. Gandy's watercolour was acquired by Soane, who hung it in his museum together with watercolours by Turner and other artists that he kept on folding screens to shelter them from light. This ingenious system of display can still be seen in Sir John Soane's Museum today.
DBB

PUBLIC AND PRIVATE BUILDINGS, EXECUTED BY SIR J. SOANE BETWEEN 1780 & 1815.

70

John Varley 1778–1842

The Suburbs of an Ancient City exh. 1808

Watercolour on paper 72.2 × 96.5 cm
Tate. Presented by the Patrons of British Art through
the Friends of the Tate Gallery 1990

John Varley was a founder member of the 'Old' Water-Colour Society and an influential water-colourist and drawing-master. While he advised his students to 'go to nature for everything' and brought them up on a regime of outdoor sketching, he also acquired a vein of idealism from his membership of Girtin's sketching club. This watercolour, exhibited at the 'Old' Water-Colour Society in 1808, is an ideal composition in the manner of the French painter Nicolas Poussin, carefully designed and soberly coloured in broad, flat washes to encourage

meditation on the grandeur of antiquity. However, the mountainous background must be a recollection of Varley's travels in Wales. The watercolour was bought (for £42, a record price for the artist to date) by Thomas Hope, a great collector and advocate of romantic classicism whose house and collections were open to the public. In 1823, Hope lent it to the Society's first loan exhibition, a retrospective of the achievements of the last generation of watercolour painters who had made their names on its walls.
DBB

71

Joseph Mallord William Turner 1775–1851

The Battle of Fort Rock, Val d'Aouste, Piedmont exh. 1815

Gouache and watercolour on paper 69.6 × 101.5 cm
Tate. Accepted by the nation as part of the Turner Bequest

Turner showed this grandiose watercolour at the Royal Academy in 1815, to mark the end of the Napoleonic Wars. Set in Alpine scenery that Turner had seen in 1802, it supposedly referred back to an incident in Napoleon's first Italian campaign in 1796. However, while the magnificent mountainous setting is based on drawings Turner had made in 1802, the narrative is imaginary as no battle is known to have taken place at Fort Roch in the Aosta valley. Instead, it may be based on an encounter between the French and Austrian armies at Fort Bard off the St Bernard Pass. In its drama, rich and dense colour and historical conception, combining the aesthetics of the Sublime with an allegory of recent history, *The Battle of Fort Rock* shows just why Turner was the commanding watercolourist of his generation. However, Turner did not join or exhibit at the new watercolour societies, showing instead at the Academy or, from 1804, in his own London gallery. DBB

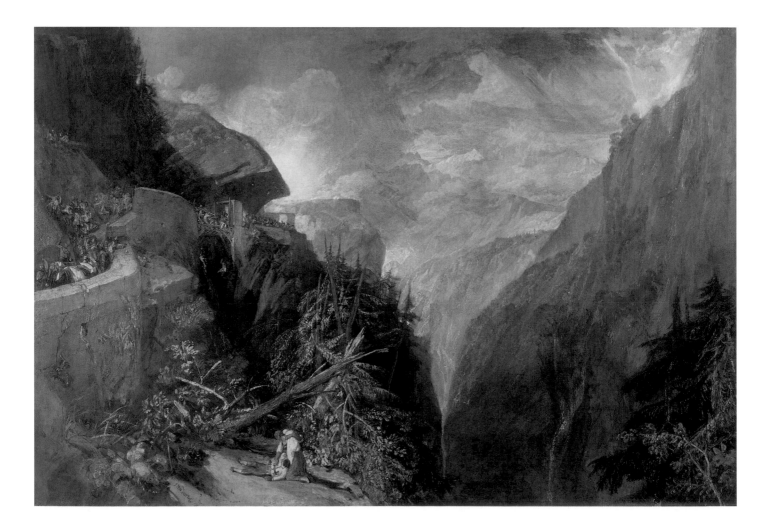

72

George Fennel Robson 1788–1833

Loch Coruisk and Cuchullin Mountains,
Isle of Skye exh. 1826

Watercolour on paper 64.2 × 111.8 cm
Victoria and Albert Museum, London. Townshend Bequest

George Fennel Robson was known at the 'Old' Water-Colour Society for 'delineating the sublime scenery of the Scottish Alps' – the Highlands, which, according to his fellow painter Thomas Uwins, he had first wandered dressed as a shepherd, with Walter Scott's poems in his pocket so as to 'enter entirely into the romance of the country'. Between 1826 and 1832, he showed six watercolours of Loch Coruisk, of which this is the largest and grandest and for which he referred to Scott's *Lord of the Isles*.

In it, Robert the Bruce and his followers, the heroes of Scott's poem, are dwarfed by the greater majesty of nature, and the sombre colouring imparts a sense of lonely melancholy. Ruskin admired Robson's landscapes as 'serious and quiet in the highest degree' but was also critical of their 'forced colour' and 'over-finish'. One practical innovation of Robson's was a private view of his works at home, with 'sold' tickets attached, before sending them to the exhibitions. DBB

William Henry Hunt 1790–1864

Primroses and Bird's Nest c.1830

Watercolour and gouache on paper 18.4 × 27.3 cm
Tate. Bequeathed by Miss Moss 1920

If many of the watercolours designed for exhibition at the watercolour societies made their impact by sheer size as much as by their subjects or technique, William Henry Hunt, or 'Bird's Nest Hunt', as he became known for his favourite subject, showed that it was possible to attract attention for virtuoso skill and exacting naturalism on a small scale. This example of his work cannot be identified with any particular exhibit, but is typical of his regular contributions to the watercolour shows, where he appeared from 1824. Its sharp focus and almost miniature scale is an extraordinary inversion of some of Hunt's earlier work, scene painting at the Drury Lane Theatre, as well as of the grand prospects tackled in other artists' exhibition watercolours. For observation and brilliant colour, inlaid with the precision of a jeweller, Hunt's watercolours anticipate Pre-Raphaelite naturalism though they were rooted in the nature-based teaching of John Varley. Among his admirers (though not entirely uncritical) was Ruskin, who considered him 'the only man we have who can paint the real leaf-green under sunlight'. DBB

74

George Price Boyce (1826–1897)

Streatley Mill at Sunset 1859

Watercolour on paper 39.7 × 51.5 cm
Private collection

George Price Boyce was associated with the Pre-Raphaelite movement and specialised in landscape and architectural subjects, many of which reflect his training as an architect in the attention they give to the details of vernacular structures. In 1859 he made frequent trips to the Thames valley to paint old buildings in their natural surroundings. In this work Boyce avoids the prettifying conventions of the picturesque and attends to the specifics of construction – the alignments of brick, timber, plaster and clapboard, and details such as moss nestling on roof tiles. There are estimated to be fourteen figures in this composition, including couples embracing in doorways. Apart from the man and woman in the foreground these are barely noticeable at first sight, the overall tonal uniformity of the picture serving to camouflage the figures, adding to the sense of a scene brimming with life but in a quiet, understated way.

Boyce had a penchant for green, which was unconventional in watercolour landscape painting, the dominant aesthetic at the OWCS being for Girtinesque brown. This may explain why he was not elected a full member of the organisation until 1878, having been made an associate in 1864. AS

75

Myles Birket Foster 1825–1899

Burnham Beeches 1861

Watercolour and gouache on paper 22 × 33 cm
Private collection

Myles Birket Foster started his career as a wood-engraver and illustrator, but after 1846 specialised in watercolour, applying the stipple techniques of his former occupation to the production of meticulously detailed works, of which this work is a superb example. Minutely observed in terms of detail and with the effect of glowing light streaming through a wood, it demonstrates the skill with which he superimposed gouache over transparent tints to illuminate details such as stray branches or a patch of blue sky glimpsed through dense autumnal foliage. In terms of finish and fineness of execution it matches the *Spectator's* description of the artist's technique as 'a sort of micro-mosaic done with the finest point of the brush' (5 May 1860, p.432).

Foster exhibited a watercolour with the title *Burnham Beeches* (a famous beauty spot in Buckinghamshire) at the OWCS in 1861, and in both the summer and winter exhibitions of 1871. This painting is possibly the 1861 version, judging from contemporary descriptions of the work. AS

74

75

Edward Burne-Jones 1833–1898
The Merciful Knight 1863, exh. 1864

Watercolour and gouache on paper 101.4 × 58.6 cm
Birmingham Museums & Art Gallery. Purchased 1973

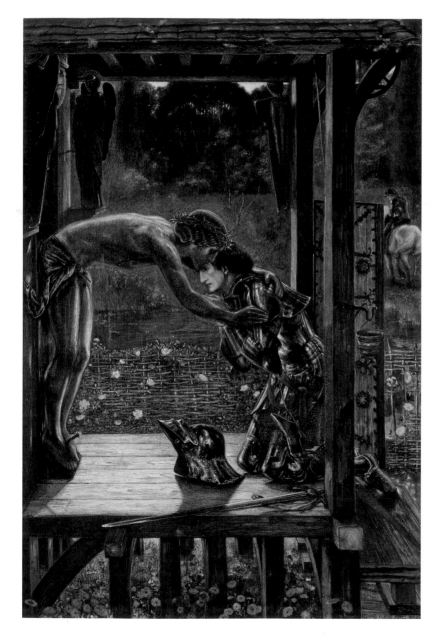

The Merciful Knight is the largest of four works
Burne-Jones exhibited at the OWCS in 1864, the
year he was elected an Associate of the organisation.
Based on Kenelm Digby's chivalric tales *The
Broadstone of Honour* (1822), it shows a medieval
knight being miraculously embraced by a wooden
effigy of Christ at a roadside shrine. The archaism
of the artist's drawing style, with its simplified
perspective and awkward anatomy, corresponds
to the mysticism of the scene, while the dense
application of paint brings to mind the tempera
techniques of early Renaissance painters. Pigment
is applied in layers, and rubbing and scumbling have
been employed throughout to create a dry veiled
surface accentuated by sharp pricks of white.

Compared to the topographical and genre
subjects that formed the staple of the OWCS
exhibitions, this painting must have stood out like
a sore thumb. Burne-Jones later recalled how it was
hung high up out of sight behind the door, in the
hope no one would see it (Lago 1981, p.107).
Although the painting certainly struck a discordant
note with its sinister mood, morbid skin tones and
rugged handling of paint, it influenced the work of
a group of artists who gravitated to the alternative
exhibiting venue the Dudley Gallery. Nicknamed
the 'poetry without grammar school', this group
produced watercolours in a similarly ambiguous
medieval spirit (see no.107).

Despite criticism of the works he exhibited in
the 1860s, Burne-Jones was nevertheless elected
a full member of the OWCS in 1868. He resigned
in 1870 following a scandal over another work, and
did not rejoin the organisation until 1886. AS

77

Walter Langley 1852–1922

'But men must work and women must weep' 1882, exh. 1883

Watercolour on paper 90.5 × 53.5 cm
Birmingham Museums & Art Gallery.
Bequeathed by H.C. Brunning 1908

This watercolour was said to be the artist's favourite work, and is certainly the most emotive and technically accomplished of his early paintings in the medium. All the highlights and paler tones derive from the whiteness of the paper, and details such as the stray strands of hair that might easily be mistaken for gouache are in fact the result of scratching out.

Langley was a member of the Birmingham school, and the style of grainy, heavy watercolour he practised was characteristic of artists in this circle. From 1881 to 1886 he joined the artists' colony in the fishing village of Newlyn in Cornwall, where he painted ambitious figurative subjects based on the community he encountered. These were exhibited in London, including the present work, which was shown at the Institute of Painters in Water Colours in 1883.

The title is a quotation from Charles Kingsley's *The Three Fishers* (1851), which relates to the tragic theme of women grieving over the loss of their husbands and sons at sea. The artist produced an almost identical version of the painting in sepia, which is also in the Birmingham Museum. AS

78

Samuel Palmer 1805–1881

A Dream in the Apennine exh. 1864

Watercolour and gouache on paper laid on wood 66 × 101.6 cm
Tate. Bequeathed by Mrs Hilda Fothergill Medlicott 1950

A withdrawn figure in his younger years, when he cultivated a visionary style of landscape painting in the Kentish village of Shoreham with a few friends known as the Ancients, Palmer was a latecomer to the watercolour exhibitions, sending work to the OWCS only from 1843. This watercolour, shown there in 1864, in the same exhibition as Burne-Jones's *The Merciful Knight* (no.76), is a recollection of the 'golden and glittering' Italy that Palmer had seen during a long honeymoon in 1837–9. Palmer displayed it with a note describing the associations of the landscape for him; 'ground which Virgil trod and Claude invested with supernatural beauty'. Elsewhere, Palmer wrote that 'sight of colour and shade is a sensual pleasure' and the contrast of glowing sky and shady valley helps to build the enraptured mood of this work. Palmer's techniques were complex and painstaking, and here he has used both watercolour and gouache, sometimes building up layers of paint or adding a varnish of gum. DBB

79

Frederick Walker 1840–1875
The Old Gate 1874–5, exh. 1875

Watercolour and gouache on paper 26 × 32.2 cm
Tate. Bequeathed by R.H. Prance 1920

Walker had a reputation as both a black and white illustrator for magazines and as a painter in oils. Some of his designs were subsequently translated into watercolour, including this work, which he painted in 1874 as a replica of the oil he exhibited at the Royal Academy in 1869. Walker followed Hunt in painting in transparent colour and then adding opaque white for areas he wished to highlight, and working into these with colour, the delicate halo around the widow's headdress being a fine example of this method.

Walker described composition as the art of preserving the accidental look. The psychological tension and narrative ambiguity of his works relate to the way he would arrange figures and elements to appear casual. Here the unexplained frisson conveyed by the chance encounter between a pensive widow and a virile labourer is underscored by the faded grandeur of the old gate that frames the woman and the veiled ambience of the surrounding landscape. To achieve his ideal of suggestiveness, Walker would draw with precise touches of the brush and then erase areas of detail, thereby unifying figure and setting.

The Old Gate was exhibited at the OWCS in 1875 and was to be the artist's last exhibited watercolour.
AS

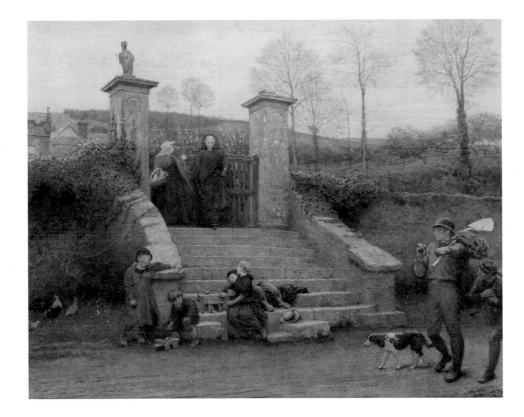

80

Dorothy Webster Hawksley 1884–1970
The Nativity 1924, exh. 1924

Watercolour and gouache on paper: centre panel 102 × 53 cm;
side panels each 102 × 23.5 cm
Birmingham Museums & Art Gallery. Presented anonymously, 1928

Dorothy Hawksley specialised in watercolour.
During the 1920s she became known for her tightly
controlled compositions with decorative schematic
forms, which showed great skill in the laying in of
flat unmodulated fields of colour between which no
join was visible to the naked eye. Although her work
drew on a variety of sources, ranging from Chinese
art to Italian Renaissance painting and the work of
contemporaries such as Cayley Robinson (see no.115),
her style was highly personal, with many subjects
including women and children painted with exquisite
grace and refinement. A creator of timeless worlds,
Hawksley's paintings shift between the past and
present, with scenes from the Bible and mythology
often assuming an air of everyday domesticity.
However, despite the strong decorative nature of
her work, she maintained that 'decoration should
not be a dry abstraction but a helpful means to a
pictorial end' (West 1922, p.260). She was also keen
to engage the beholder, her theory being that the
artist creates work 'which is fulfilled by the spectator'
(Mories 1948, p.107).

The Nativity is one of Hawksley's most ambitious
watercolours and was accorded a prime position at
the RA exhibition in 1924. Based on Sandro Botticelli's
Mystic Nativity c.1500–1 in London's National Gallery,
the painting is distinctly Oriental in terms of design
and costume, while also having an Art Deco feel with
its sinuous lines and elegant facial types. Apart from
Joseph, the kings and shepherd, all the characters
are women, including a self-portrait of Hawksley
herself sketching the scene on the right. Some are
engaged in mundane tasks, such as hanging up
laundry and carrying wood, while others have a
more symbolic role, notably the figure of Pandora
curiously glancing up at the scene from her grave.
Whether the painting was conceived as a feminist
statement concerning women's representation in
art, or an image affirming a more nurturing and
decorative role, it certainly succeeds in domesticating
the grand narratives of the past. AS

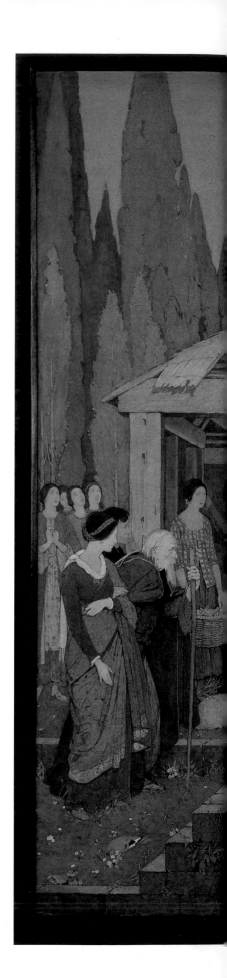

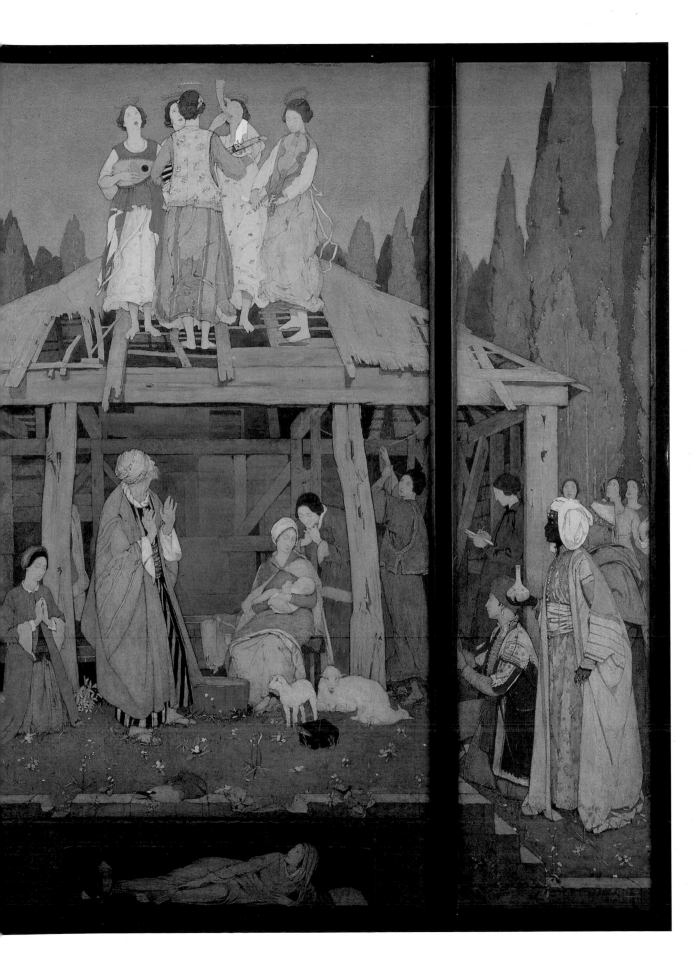

81

Arthur Melville 1855–1904
The Blue Night, Venice 1897, exh. 1898

Watercolour on paper 86 × 61 cm
Tate. Presented by W. Graham Robertson, 1940

The Scottish painter Arthur Melville is regarded as one of the great experimenters with the watercolour medium. Reacting against the dense textures of the mid-Victorian tradition, he evolved a new manner of working, painting on specially prepared paper saturated with diluted Chinese white and then modifying the effect with sponges to produce a decorative surface. In Melville's work colour often exists as a stimulus in its own right rather than as a means of describing a form or object, and because of this his art is often seen to epitomise the purist view that watercolour should exploit the fluid characteristics of water and appear wet to the eye. In fact his method was not as accidental as might appear, as he would often place glass over a picture to try out the effect of spots before applying pigment to the paper.

His nocturne *The Blue Night* was one of a group of watercolours Melville produced following a visit to Venice in 1894. It was exhibited at the Royal Watercolour Society in 1898. The scene represents, in the words of the connoisseur W. Graham Robertson, 'the great Piazza after "lights out", Saint Mark's and the Doge's Palace dimly lit by a reflected glare from the Piazzetta, and the Campanile towering up to lose itself in blue infinity' (Robertson 1931, p.284). Here Melville's highly individual technique is used to animate shadow with touches of light. AS

Watercolour and War

Alison Smith

Although watercolour might be assumed to be too delicate a medium for representing the grim realities of war, it has proved to be a highly practical, resilient and versatile technique for use in extreme situations. Not only does it allow for swift execution but it also reminds the viewer of the human agency behind the image, which more mechanical forms of reproduction sometimes encourage us to forget. Watercolour is less of a public medium than oil, sculpture or even photography, but its private character has perhaps given artists greater licence in their attempts to represent experiences of pain and upheaval.

In situations of war, watercolour has often functioned as a diversion from the main task at hand and as a means of alleviating boredom. Writing to a friend in the early 1940s Edward Burra discovered that watercolour brushes were becoming scarce, as the forces were buying them up for sketching in their spare time. British water-colour practice was largely circumscribed by a convention of the picturesque, which probably explains why the medium was used in extraordinary circumstances as a form of relief as well as a means of illustrating what the nation felt it was defending. The defining moments of war are often quick and messy and therefore difficult for the onlooker to confront both physically and psychologically, hence the link with trauma. This can be defined as an injury or wound to the body, or a mental state provoked by physical or emotional shock. In the early twentieth century Freudian psychoanalysis investigated ways in which the mind constructs defence mechanisms as a means of deflecting traumatic experience. Arguably the artist responds in a similar way, diffusing horror by falling back on older archetypes or established modes of representation such as the picturesque or pastoral. War drawings by artists versed in the British romantic tradition are often said to possess an elegiac quality that somehow mitigates the psychological impact of an event, in contrast to the more pungent politically motivated work of artists working in different contexts, for example, George Grosz in Germany or Nancy Spero in the United States. This said, the Gothic or Surreal strand in British watercolour, especially Blake's intense, overwrought images of bodies under duress, has provided a powerful visual vocabulary from which painters have developed emotive, psychologically compelling works, in this sense connecting more with the German 'traum' (meaning dream) than with the Greek 'traumata' (wound).

Most of the watercolours in this section were made in response to the circumstances of war, and range from visceral traumatological drawings for a specific branch of scientific study to watercolours more expressive of the artist's attitude to a given subject aimed at public consumption. One of the early functions of watercolour was for purposes of military surveying, because the medium was portable and easy to use in remote locations. Techniques of perspective and topographical drawing were regularly taught at military academies and used by officers to record enemy positions and the customs of colonised peoples. Thus, until the development of illustrated newspapers in the 1840s, artists deployed in the field were invariably officers, part of the longstanding tradition of the well-to-do amateur. The emergence of the modern idea of the war artist in the mid-nineteenth century paralleled the rise of the war correspondent, both professions made possible by the development of the mass media and effective systems of transport and communication. Although topographical conventions were utilised for purposes of documentation and to

provide official versions of events, the independent status of the war artist sanctioned a degree of interpretive licence as seen, for instance, in William Simpson's dream-like vision of a Crimean battlefield where natural specimens are about to be blasted out of existence by a cannon ball. The prominence given to the convolvulus in the foreground, a plant recognised at the time as possessing hallucinatory properties, further encourages the viewer to think of the scene as an illusory fantasy rather than as a sight actually witnessed by the artist.

It was during the First World War that artists were employed in significant numbers for purposes of documenting conflict, with the establishment of the Ministry of Information in 1916. The Ministry's scheme dispatched artists to the front line for short periods to make visual records. Photography was not a viable option at this time because it still required long exposures and was occasionally subject to military censorship. Photographic equipment was also heavy and difficult to set up in zones of conflict, and so drawing was practised as a lighter and more expedient tool. Although the aim of the project was documentation, the Great War affected what many artists understood as truth, resulting in a tension between the demands of illustration and the underlying reality many felt compelled to represent.

The tone of works produced varies according to how close artists were to sites of action. John Singer Sargent, who toured northern France in 1918, maintained a certain distance, confessing he had never encountered anything in the least horrible (Little 1998, p.14). His watercolours focus on scenes peripheral to the conflict, allowing him to maintain earlier formal preoccupations while disturbing the preconceptions of the viewer through tactics of juxtaposition and understatement, as seen in the seemingly benign landscape of *A Crashed Airplane* 1918. Younger artists engaged closer to the front found that their direct experiences of modern warfare made it impossible for them to sustain former modes of expression. Paul Nash was jolted out of the romantic landscape tradition that had

nurtured him in his youth, and expressed his anger at the violation of the landscape he encountered by envisaging the battlefield as a traumatised body, with cesspools standing for wounds and a blasted tree for a limbless figure, in his *Wire* 1918–19. Here colour is deliberately made dirty and opaque by being mixed with ink and chalk, as if the artist wanted to contaminate the medium by denying its pure translucent qualities. William Orpen, who had made his reputation as a portrait painter, made the ordinary soldier the focus of his art, employing watercolour to physically swathe the gaunt, spectral figures he depicted in ethereal light to convey a sense of disorientation, exhaustion and futility.

The War Artists Advisory Committee (WAAC) of the Second World War employed artists on similar terms to those of the scheme of 1916–18, but with an increased emphasis on depicting collateral damage and the stoicism of civilians. As well as encouraging documentary art, the WAAC wanted artists to promote British liberal cultural values in deliberate contrast to the strident propaganda of the Nazi dictatorship in Germany. This objective arguably encouraged a widespread use of watercolour given the association of the medium with land, ownership and individual rights, not to mention empathy between individuals. Artists' experience of the First World War had led many to reject earlier heroic modes of representing war, and drawing on this experience the diffidence of the watercolour medium was utilised for more subtle purposes. Although interpretation was encouraged by the WAAC, the works produced under the scheme generally lacked the incisive critical edge of the watercolours made during the earlier war, with many artists avoiding violent or confrontational subjects altogether. There were, of course, exceptions, notably Burra, who was however not employed in an official capacity, and whose large, sharply defined macabre paintings have more in common with the satirical art of Grosz that the documentary work of Bawden and Ravilious.

Some of the most forceful watercolours produced during the Second World War were dreamscapes inspired by the London Blitz of 1940. Graham Sutherland's *Devastation* 1941 is a dark Gothic landscape that combines watercolour and ink with water-resistant wax crayon to create opaque, sullied, acidic surfaces as if the artist sought to traumatise watercolour itself in conveying the savagery of the destruction he encountered in the East End. The question of how far watercolour, a flimsy material, traditionally used for intimate recreational purposes, could be galvanised to express extremes of human endurance can be asked of both surreal and more documentary uses of the medium. Context often provides an answer, as in the case of Eric Taylor, who found it easier to draw what he witnessed at Belsen than to talk about it. Despite the personal nature of the studies he made of victims at the concentration camp, the only place these could be comfortably accommodated was within public institutions (the drawings are now in the possession of both the Imperial War Museum and the Wiener Library, both in London).

In more recent times television, photography and digital media have acclimatised the eye to different representations of tragedy. It could also be said that these new technologies have made traditional uses of watercolour obsolete, especially as none of the conflicts involving Britain since the Second World War has resulted in national art programmes on the scale of earlier schemes. As a consequence there are fewer war artists operating today, and those employed tend either to be confined to restricted zones or dispatched after the main action has taken place, as Gordon Rushmer has admitted: 'Generally you record the aftermath of war: that's the time you see the effect of war and that's what you record' (Smith 2009a, p.264). The difficulties of accommodating artists in contemporary theatres of conflict have led others to explore different media, or to represent the horror of destruction in other ways. However, the accessibility of watercolour in situations of disaster, and its ability to testify to internal and external trauma, means it still has the power to shock where the familiarity and sophistication of other media risk numbing our emotional response.

Charles Bell 1774–1842

Number 9: Sabre wound to abdomen, Peltier, Belgian Hospital, 2 July.
[From: *Sir Charles Bell's watercolours of wounds sustained by soldiers at the Battle of Waterloo*] 1815

Watercolour on paper 31.2 × 45.8 cm
Army Medical Services Museum and Wellcome Library, London

Charles Bell was a distinguished surgeon, anatomist and artist. In June 1815 he went to Belgium to tend both English and French soldiers wounded in the Battle of Waterloo, taking his sketchbook along with his surgical instruments. In 1836 he turned seventeen of the studies he made into watercolours for use in his lectures, the enlarged scale and addition of watercolour washes allowing for easy recognition of anatomical parts as well as drawing attention to gruesome details of the wounds. The mass on the abdomen of the French lancer in this study,

together with the agonised expression on his face, provide shocking visual proof of Bell's inscription on the sheet:

> Belly opened by a sabre. Immediately the bowels protruded. Before he was off the field he had two stools and none since downwards. When brought into the hospital the third day of the battle, the mass was gangrenous . . . A large portion of the mass comprehending the colon came away after he [Dr Kluyskens] had made two openings. AS

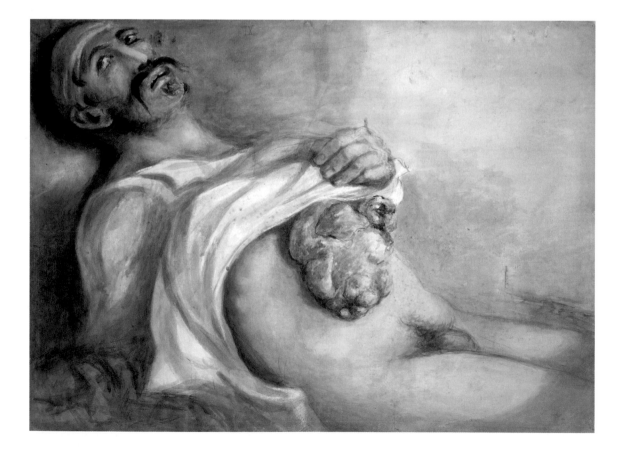

83

William Simpson 1823–1899

Summer in the Crimea 1857

Watercolour over pencil on paper 24.9 × 35.4 cm
The British Museum, London

William Simpson trained as a lithographer and made his name as the first British war artist, after receiving a commission from the print publisher Colnaghi to illustrate the Crimean War for a series of lithographs published in two volumes as *The Seat of War in the East* (1855–6). This was the first of a long series of tours Simpson made to distant locations to report on colonial wars.

Most of the drawings Simpson made can be described as straightforward reportage, anticipating modern photojournalism. This work, made after the event, strikes a different note, being a surreal combination of natural history and a battle scene. In the centre of the image a butterfly alights on an enormous cannonball, which is about to explode. Brightly coloured, the watercolour was reproduced in chromolithography with the following explanatory text:

Flowers, around which the bright lizards play, deck the earth; the convolvuli twine around the now rusty messengers of slaughter, while in the distance, the bombardment still continues, shot and shell dealing death around; the soldier's fate suggested by the butterfly fluttering over the burning bomb (quoted in Stainton 1991, p.68). AS

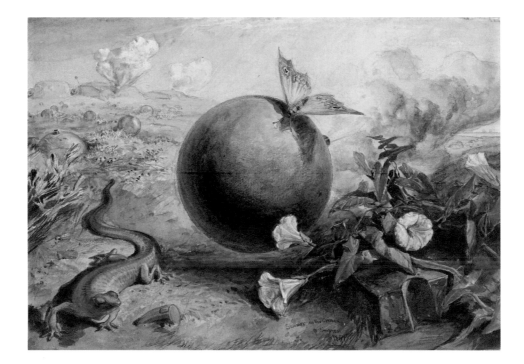

84–89

Sidney Hornswick [dates not known]
Private Howard 23 August 1918 (no.84)

Daryl Lindsay 1889–1976
Sergeant Lee 29 August 1918 (no.85)
Private Potts September 1918 (no.86)

Herbert Cole 1890–1962
Private Green 2 April 1918;
23 September 1918; 10 October 1918 (nos.87–9)

All watercolour on board 29.2 x 24.1 cm
Gillies Archive, Queen Mary's Hospital, Sidcup, Kent

This group of surgical portraits was produced by artists in the employ of the pioneering New Zealand-born surgeon Harold Gillies, who in 1917 established a purpose-built facility for treating facial injuries at Queen Mary's Hospital in Sidcup, Kent. The trench warfare of the First World War made the risk of facial injury extremely high, and the close range and relatively low muzzle velocity of rifles frequently resulted in large entry wounds, necessitating new approaches to anaesthetics and plastic surgery (see Bamji 1994). Gillies was keen that the task of reconstruction be aided by documentation in the form of plaster casts, photographs and watercolours. Not being a proficient draughtsman himself he enlisted others for the job, the most notable being the Australian Daryl Lindsay, whose talent as an artist on the front resulted in him being posted to Sidcup where, on the artist and surgeon Henry Tonks's recommendation, he was granted one day per week to study at the Slade School of Fine Art (Lindsay later became Director of the National Gallery of Victoria, Melbourne). Other artists included the hospital draughtsman Sidney Hornswick and the New Zealander Herbert Cole, neither as technically accomplished as Lindsay.

The watercolours were painted from casts and photographs to be filed with patient records and were produced around the time of admission or discharge from the unit, although some, like those of Private Green, record different stages of the operative process. All follow a similar format, with the head presented in profile or at an angle to the viewer, and are annotated with the date, patient's name, rank and number at the bottom. Watercolour was chosen as a medium not only because it was clean and uncomplicated, but also because it allowed the artist to pick out visceral details not easily recognisable in the form of a monochrome photograph, for example, the torn submandibular salivary gland in the portrait of Lee and the jaw fractures of Potts (who underwent eleven operations between 1919 and 1920). Colour also encouraged the artists to think in terms of portraiture, to convey the individuality of the men represented. This further allowed them to focus on identifiable features, such as the red hair of Green, which would have been lost in black and white reproduction. AS

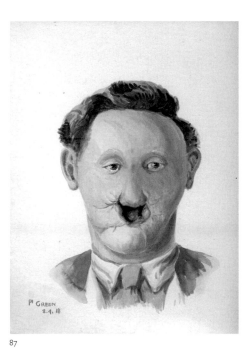

900225 Pᵗ HOWARD. SURREYS
28.8.18.

84

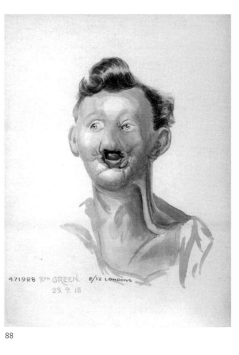

52433 Sgᵗ LEE G. M.G.C.
29.8.18

DARN. LINDSAY 18

Sgᵗ Lee
29.8.18

85

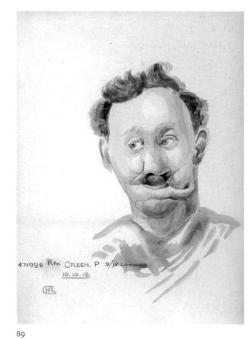

DARN LINDSAY SEPT.18

86

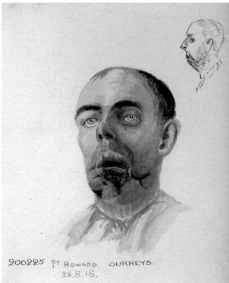

Pᵗ GREEN
2.9.18

87

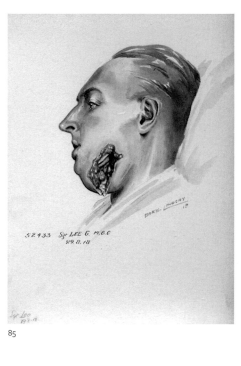

471928 Rᶠⁿ GREEN. 8/12 LONDONS
23.9.18

88

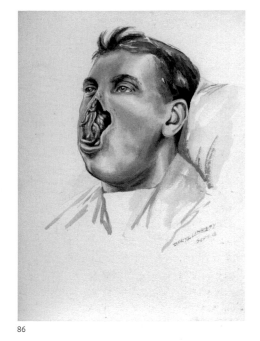

471928 Rᶠⁿ GREEN. P 9/12 LONDONS
10.10.18

89

133

90

William Orpen 1878–1931

A Man with a Cigarette 1917

Chalk, pencil and watercolour on paper 58.4 × 44.4 cm
Imperial War Museum, London

William Orpen, a highly successful portraitist,
was one of the first painters to be employed by the
Ministry of Information in 1917, and he remained
in France longer than any other war artist. From
the time he arrived at the front, Orpen was aware
that he held a privileged position in contrast to
the ordinary soldier, whom he depicted with grim
humour and sympathy, as seen in this bold drawing
of a shell-shocked and wounded Tommy standing
resignedly in a trench. The watercolour mixes sharp
observation with imaginative insight, the brilliant
contrasts of blue and white representing not only
mud bleached white by the heat of the summer
sun, but a vision of a figure wandering aimlessly in
Hell. Bold washes of colour and extensive rubbing
across the surface add to the expressive power
of the image. AS

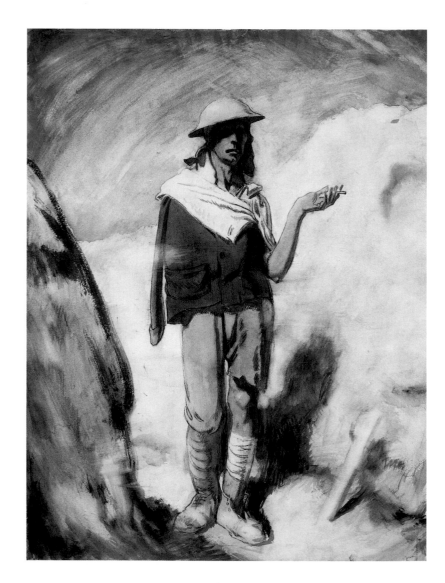

91

John Singer Sargent 1856–1925

A Crashed Airplane 1918

Watercolour on paper 34.2 × 53.3 cm
Imperial War Museum, London

John Singer Sargent was the most fashionable painter of his age, renowned for his dazzling society portraits. In the last decades of his life he turned increasingly to watercolour, finding it a fresh and convenient medium to use on the travels he undertook for recreational purposes with friends. He tended to paint in the direct light of the sun, delighting in fragmentary, impromptu effects.

Sargent was in the United States from 1916–18, but upon his return to England was commissioned as a war artist by the Ministry of Information. During a visit to the Western Front he made a number of watercolours, ten of which he presented to the Imperial War Museum in 1919. *A Crashed*

Airplane was painted during the summer of 1918, and on first sight appears to be a peaceful harvesting scene demonstrating the energy and virtuosity of the artist's technique, with watercolour applied in a wet manner with white paper reserved in selected areas to register highlights. However, so intent are the two labourers in the foreground shown to be in their task of cutting and binding wheat, that they are oblivious to the wreckage of a plane in the neighbouring field. Sargent's observation that the disasters of war quickly become absorbed into the routines of daily life is accentuated by the posts scattered across the field, which are ominously suggestive of grave markers. AS

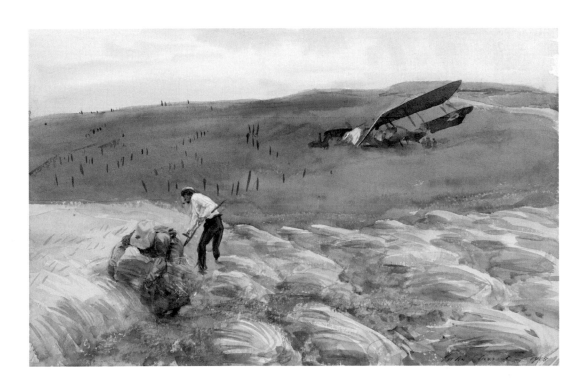

Paul Nash 1889–1946

Wire 1918–19

Ink, chalk and watercolour on paper 48.6 × 63.5 cm
Imperial War Museum, London

Nash was made an official war artist after exhibiting
a group of drawings in 1917 based on his experiences
of the Western Front. He returned to Flanders in
November, shortly after the Battle of Passchendaele
had devastated the battlefields of Belgium leaving
the land muddy, inhospitable and waterlogged.
Touring the front line in a chauffeur-driven car he
was able to work rapidly in chalk and watercolour,
producing around twelve to twenty sketches a day.
Nash was appalled by what he witnessed, lamenting
'I have seen the most frightful nightmare of a coun-
try more conceived by Dante or Poe than by nature'
(quoted in Abbott and Bertram 1955, p.99).

In this drawing cavernous crate pools encircle
a blasted tree shrouded in webs of barbed wire.
Watercolour is smeared with ink and chalk to create
a heavy, repellent surface. As a young artist Nash
had been influenced by the British Romantic water-
colour tradition, which emphasised reverence for
place, but here he wanted to express anger at the
obliteration of nature through war. AS

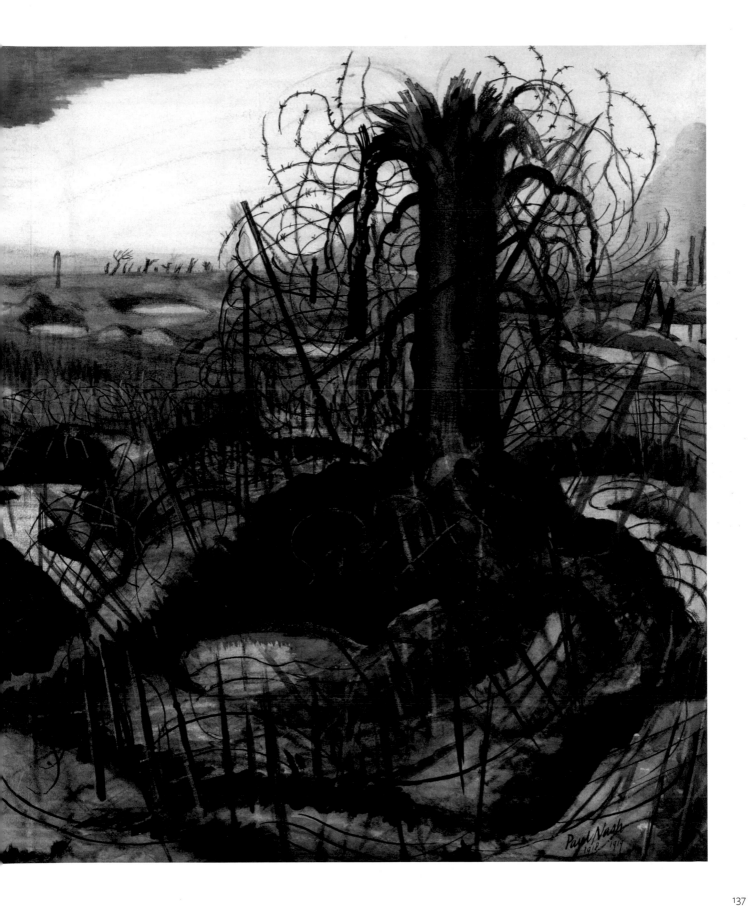

Paul Nash
1918 - 1919

93

Edward Burra 1905–1976
Soldiers at Rye 1941

Gouache, watercolour and ink wash on
three sheets of paper 102.9 × 207.4 cm
Tate. Presented by Studio 1942

In later life Burra recalled that this painting had
been inspired by military manoeuvres around his
home town of Rye, East Sussex, when a German
invasion seemed imminent following the fall of
France, but that it also coalesced in his mind with
the Spanish Civil War. In the painting soldiers cavort
in a frieze-like arrangement across the composition,
framed by nets and a swirling mass of red drapery.
The men sport tin hats and red and yellow Venetian
carnival masks, a bizarre combination that under-
scores the theme of camouflage and conflict as
a ritualised form of male behaviour. The red
suggests lust and mutilation while the armoured
bodies also emphasise the sexual prowess of the
men, as conveyed by the protuberant buttocks of
the central figure.

The composition was painted in layers of
gouache, watercolour and ink over pencil, and
spreads across three sheets of paper. These were
either added piecemeal as Burra worked on the
design or were conceived from the onset as parts of
a single entity. AS

94

Edward Burra 1905–1976
Wake 1940

Gouache and ink wash on paper 102.2 × 69.8 cm
Tate. Purchased 1940

Edward Burra was fascinated with all aspects of
human behaviour, especially cruelty. An illustrator
by temperament, he delighted in the burlesque and
theatrical, rejecting any idea of art as a means of
moral or political protest. In the late 1930s he aban-
doned social subjects for more sombre imagery,
which can be seen as a highly personal response to
the tensions underpinning the Spanish Civil War
of 1936–9, and the crisis in Europe that precipitated
the Second World War. Often based on religious
iconography, his watercolours recall both the horrific
imagery of Francisco Goya's Black Paintings of
1819–23 and the bizarre perspectives and rhetorical
gestures used by Mannerist painters such as El Greco.

Burra described *Wake* as a 'double picture', or
two images conceived as one. The diptych presents
fifteen shrouded figures assembled around a deep
open grave, gesticulating at a corpse with their long
bony fingers. In the distance other figures are shown
strung out along the aisles of an arcade, the plunging
perspectives of which contrast sharply with the
exaggerated musculature of the figures peering
into the ground. Painted in thin muted washes of
colour, Burra sets the carefully gradated tones of
the foreground against the dramatically illuminated
architecture of the distance, as if to suggest
exhumation carried out in full daylight. AS

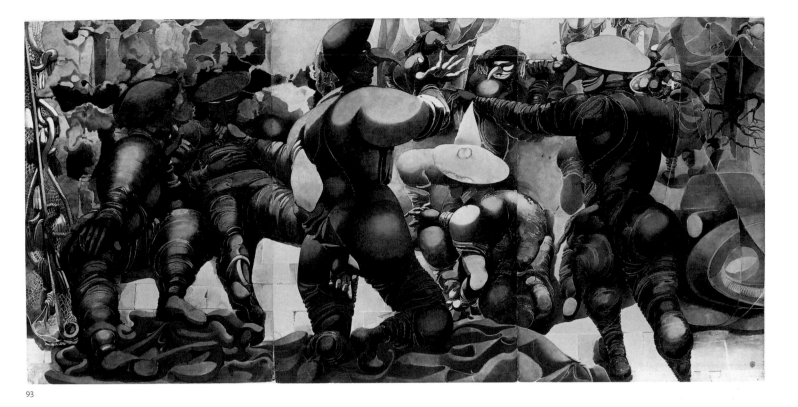

93

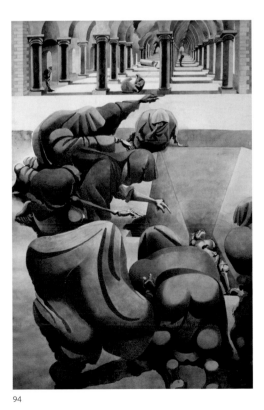

94

95

Graham Sutherland 1903–1980

Devastation, 1941: An East End Street 1941

Ink, watercolour, gouache, crayon and pencil on paper
64.8 × 114 cm
Tate. Presented by the War Artists Advisory Committee 1946

As an official war artist Graham Sutherland was commissioned to record the bomb damage caused by the London Blitz, which started on 7 September 1940 and lasted for nine months, killing around 20,000 civilians. As the artist later recalled: 'I became tremendously interested in parts of the East End where long terraces of houses remained: they were great – surprisingly wide – perspectives of destruction seeming to recede into infinity and the windowless blocks were like sightless eyes' (Imperial War Museum 1982, p.2).

Although this work looks like a nocturnal scene, it was based on sketches made during the day when Sutherland travelled up to London from Kent. He also applied for a licence to take photographs, finding it difficult to draw in some places 'without rousing a sense of resentment in the people' (ibid. p.15). The drawing is both a documentary record of a road in Silvertown, East London, and a visionary interpretation of the scene. Central receding lines of perspective ironically recall the ideal of a Renaissance city, but now metamorphosed into a melancholy alien environment, with the flimsy facades of houses framing a strange worm-like shape at the centre. Different media interact to bring distant forms into collision with the picture surface and to create dense surface textures. AS

96

Eric Taylor 1909–1999

Human Wreckage at
Belsen Concentration Camp 1945

Watercolour on paper 40.6 × 63.5 cm
Imperial War Museum, London

Eric Taylor enlisted in the Royal Artillery in 1939 and remained in the army throughout the war. He served initially as an instructor at the Northern Command Camouflage School and from 1943 to 1945 as a sergeant in the Royal Engineers. Although he failed to secure a position as an official war artist he produced works in his role as an ordinary soldier, many of which were based on first-hand experience of the destruction left behind in the wake of the Allied advance into Germany.

Following the liberation of the Belsen concentration camp in north-western Germany by British troops in April 1945, Taylor made a number of drawings on the spot which, with the approval of survivors, he later completed as large watercolour drawings with the intention of making a forceful testimony to the scenes he encountered. This drawing represents a line of corpses of victims killed through starvation, disease and brutality in the camp. The skeletal outlines of their forms are broken up by strong accents of colour. AS

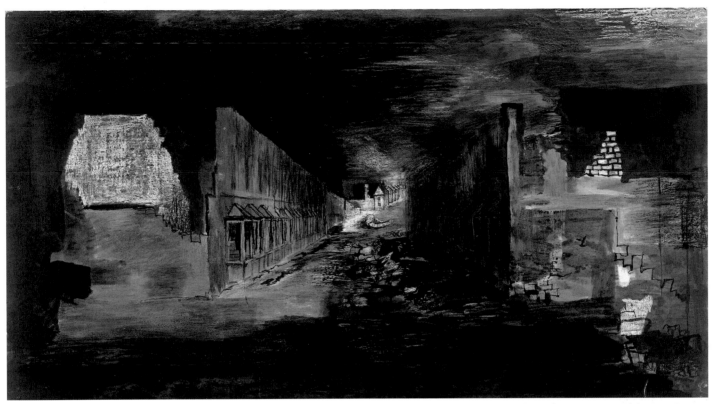

95

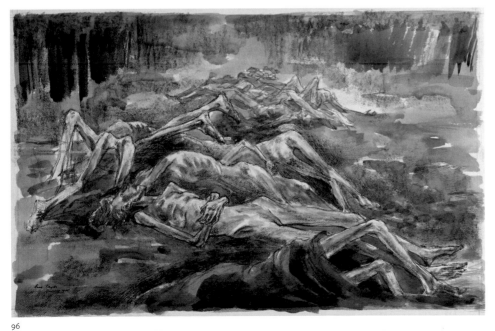

96

97

Gordon Rushmer b.1946

The Burning of Gornji Vakuf, Bosnia 1997

Watercolour on paper 6 × 26 cm
Courtesy of the artist

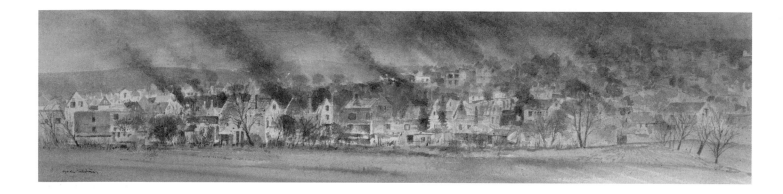

Gordon Rushmer is one of the few independent war artists working in Britain today. Since first taking on this role in 1997, he has accompanied the Royal and Dutch marines to zones of conflict in Eritrea, Ethiopia, Bosnia, Kosovo, Iraq and Afghanistan. Rushmer says his experience of living with soldiers over an extended period of time has not only allowed him access to areas usually denied artists working in a more official capacity, but has also made him sympathetic to those employed on such missions. This has encouraged him to produce works of a documentary nature rather than offer a partial or emotive view of a subject. He works in watercolour, finding it an immediate, suggestive and tight medium for conveying accurate information.

This small watercolour derives from Rushmer's experience in Bosnia, which he visited in the aftermath of the intrastate conflict in the Balkans. The destroyed Bosnian town of Gornji Vakuf remained unchanged since the offensive launched by Croat artillery in 1993. This watercolour was painted as a re-creation of the shelling, the long horizontal format conveying destruction on a scale he had never before witnessed. AS

142

98

Uwe Wittwer b.1954

Ruin 2008

Watercolour on paper 130 × 113 cm
Private collection, courtesy of Judan Nolan Gallery, Berlin

The Swiss-born artist Uwe Wittwer has long been interested in British Romantic watercolour painting and the practice of using the white of the paper to register light. He also speaks of the pure watercolour method as an intellectual way of working, something akin to chamber music in exposing every fault, and which requires him to work in a slow, deliberate manner.

Wittwer works with images downloaded from the internet with the aim of traversing boundaries of geographical space and time. He is particularly drawn to photographs relating to war that have deteriorated with age, which he then translates into the immediacy of watercolour. Paint is applied in sepia colour suggestive of old scratched film, as if he were seeking to revivify the original emotional impact of the subject. He prefers to paint rather than draw with colour and this requires him to think in reverse. Accordingly he paints in dark areas first, leaving the paper and washes covering it exposed as highlights. With attention focused on opaque patches he occasionally inverts the original altogether as in *Ruin*, based on a digital copy of an original photograph taken during a bombing raid on Frankfurt between 1943 and 1945, which appears like a negative with forms piled up in a two-dimensional pattern. Dramatic contrasts of light and dark correspond to the theme of conflict and evoke a range of imagery on the subject of devastation, from Hiroshima to the bombed cities of Europe. AS

99

Jitish Kallat b.1974

Traumanama (*the cry of the gland*) 2009
Gouache, acrylic, tea-wash, spray paint and pencil on paper
134.6 × 94 cm
Courtesy of the artist and Haunch of Venison, London

Traumanama is the title the Mumbai-based artist Jitish Kallat gives to a group of works on paper that explore the idea of the body as the site of urban pressure and conflict. While the title is inspired by those of Mughal epic miniature portfolios such as *Razmnama* (the Art of War) or the *Hamzanama* (the Mythical Adventures of Amir Hamza), Kallat also alludes to traditional herbarium and medical illustrations in exploring a theme across the open pages of a book.

In this work the figure is imagined as a Rorschach blot (inkblots used in psychiatry as a diagnostic tool). Clusters of stretched, stained and dripping forms suggest bodily fluids and by extension the idea of a city as a place that both sustains and violates life. Gouache is employed in combination with other watery substances such as tea, which is used to stain the paper, and acrylic for denser areas of colour. These materials are applied in a variety of ways, including being blown across the surface with a vacuum cleaner as if to physically reinforce ideas of performance and aggression. AS

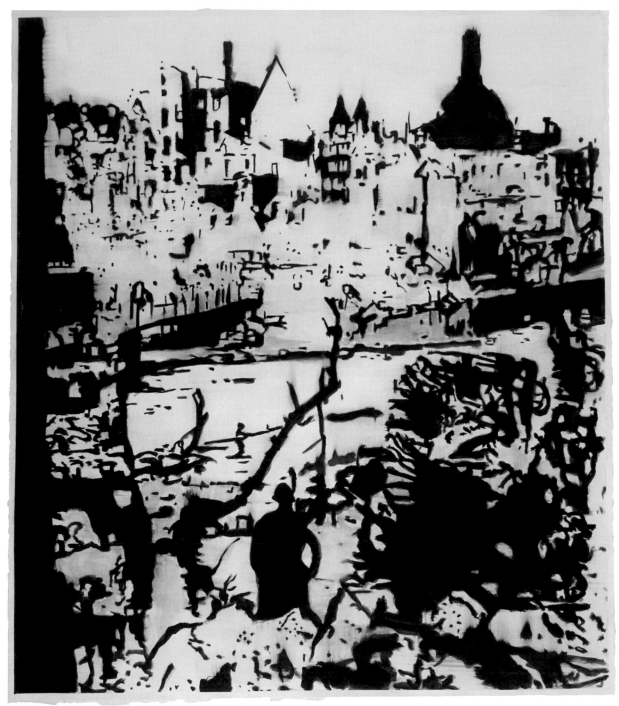

98

99

Inner Vision

Philippa Simpson

Just as watercolour has been described as a peculiarly British medium, so a mode of 'visionary' art-making has been seen as an important component of the national heritage. Unlike painters of observed subjects, or of abstract works developed out of earlier figurative practices, the visionary artist turns to his or her imagination as a source of unique, internal imagery. In order to capture their fleeting impressions, painters have been attracted to the speed of execution, and variety of effect, offered by watercolour.

The medium has therefore developed in close dialogue with a visionary tradition, initiated, in part, by the work of William Blake. For Blake, the decision to work almost exclusively in watercolour was both an aesthetic and an ideological matter, connected to a desire for truth and accuracy. Since 'A Spirit and a Vision are not … a cloudy vapour or a nothing' but 'organised and minutely articulated beyond all that the mortal and perishing nature can produce' he wanted materials that would produce 'clear colours unmudded by oil, and firm and determinate lineaments' (Erdman 2008, pp.541, 530). The results he achieved, however, varied greatly, from the dream-like atmosphere of *The River of Life* c.1805, created using thin, almost translucent washes, to the oppressive environment of *The Night of Enitharmon's Joy* c.1795 constructed using large quantities of densely mixed paint.

During the nineteenth and twentieth centuries, these two styles were employed by artists as alternative modes of picturing the visionary; one characterised by freedom and lucidity giving an impression of the transitory, the other resulting in the sinister, stifling atmosphere of the nightmare. For conservative critics, the distinction between these methods came to carry a moral weight, as the sense of immediacy associated with watercolour was co-opted to serve a discourse of artistic integrity. When the Pre-Raphaelites and their followers began to mix white pigment with their watercolour solutions, resulting in a dry, opaque finish, one journalist complained of 'the use of opaque colour which … threatened to corrupt the *purity* of the practice of former years' (my italics) (*Art Journal*, 1866, p.175).

The sense of inertia created by this application of thick, chalky paint corresponded to the Pre-Raphaelite interest in interiority, visible in the works of Dante Gabriel Rossetti and Edward Burne-Jones. Both of these artists looked to medieval legends as a source of imaginative experience but, while Rossetti's intimate scenes were never publicly exhibited, Burne-Jones's work was regularly seen at the Old Water-Colour Society (OWCS) during the 1860s, and was to have an impact on many artists of his generation and beyond. Simeon Solomon and Robert Bateman, for example, adopted a similar mode of psychological absorption in their works, many of which were exhibited in the new Dudley Gallery (see p.107, above). Pictures such as these presented a challenge to the narrative emphasis of Victorian painting, and were censured, in the *Art Journal*, for displaying 'dreaminess instead of definiteness, and smudginess instead of sentiment' (*Art Journal*, 1869, p.81).

Other watercolour artists embraced these qualities of imprecision and elusiveness, exploiting colour and line to evoke textures, scents and sounds in a form of 'synaesthesia'. Robert Anning Bell and Edward Robert Hughes, for instance, both treated musical subjects, using tonal modulations to appeal directly to the viewer's aural imagination. In Aubrey Beardsley's *Frontispiece to Chopin's Third Ballade*

1895, line and shade generate lyrical rhythms.

With Beardsley, watercolour moves towards a more linear appearance, closer to drawing than painting. The precision of this style relates to the clarity demanded by book illustration, of which Beardsley was a great practitioner, and which was to have a significant impact upon the development of watercolour painting. Colour-printed designs found in publications for an elite audience and later commercialised were generally made from watercolour originals. The detail of many watercolour pictures can be understood as a response to this new method of reproduction. Frederick Cayley Robinson and Edmund Dulac were both noted illustrators, who produced watercolour works of a striking intricacy, drawing the viewer into microcosmic worlds. Cayley Robinson presents simple scenes, heavy with atmosphere, whilst Dulac constructs visual webs through an obsessive rendering of minutiae.

Dulac's attention to detail recalls natural history illustrations, although he replaces an ostensible scientific detachment with an unsettling combination of precision and chaos. As one of the earliest, and most prevalent uses of watercolour, botanical diagrams had a marked impact upon the use of the medium, even within the realm of 'visionary' art. The organic forms of Charles Rennie Mackintosh's work, for example, owe much to earlier scientific drawing, and rely upon this allusion to imply a synchronicity between the physical and the metaphysical. These connections become explicit in images by Ithell Colquhoun, who reworks recognisable body parts into allegorical sites, and fully exploits the liquid quality of the paint in suggesting bodily fluids.

As well as engaging with an illustrative tradition, many visionary artists have looked to the 'golden age' of watercolour landscape painting, experimenting with form and technique to transform conventional scenes into atmospheric, esoteric environments. One of the first to explore this territory was Samuel Palmer (a disciple of Blake), who built up thick layers of paint covered in varnish to produce a surface at once intensely dark and iridescent.

Later in the nineteenth century, Victor Hugo produced views of a similar visceral intensity, referring to the scene, in this instance, as the *souvenir* (memory) of a place. Drawing on the work of Blake and Palmer, Paul Nash also turned to landscape imagery as a means of interpreting personal experience. Nash applied weak paint solutions very lightly, to create a sense of impermanence and instability, resonant with the anxious political climate of the war and inter-war periods during which he worked. These are psychological rather than physical landscapes, forming a distinct tradition, which is continued today in the work of Christopher Le Brun. Using meticulously applied brushstrokes to create fragmented, chimerical structures, Le Brun introduces fantasy architectural forms into familiar wooded environments, unsettling the viewer's sense of reality.

The value placed upon the imagined or surreal in visionary art has given rise to an interest in psychological disorder as a source of creativity. Two individuals in particular – Richard Dadd, who murdered his father and was subsequently certified insane, and David Jones, who suffered two nervous breakdowns – have been posited as examples of artists whose works display evidence of unusual psychological experience. Dadd, who spent most of his working life in prison, relied heavily upon his memory and imagination, selecting faint tones and thin washes, which imbue his pictures with a sense of ephemerality. A mood of disquiet also pervades Jones's work, in which mythical themes and everyday motifs are enmeshed. The reputation of these painters as troubled or 'outsider' artists has in many ways been reinforced by their use of watercolour, traditionally (and persistently) seen as a marginal medium, used by amateurs or for preliminary sketches. It is clear, though, that the specific and varied qualities of watercolour have been exploited by all manner of artists, in giving pictorial form to a broad range of emotional and psychological encounters.

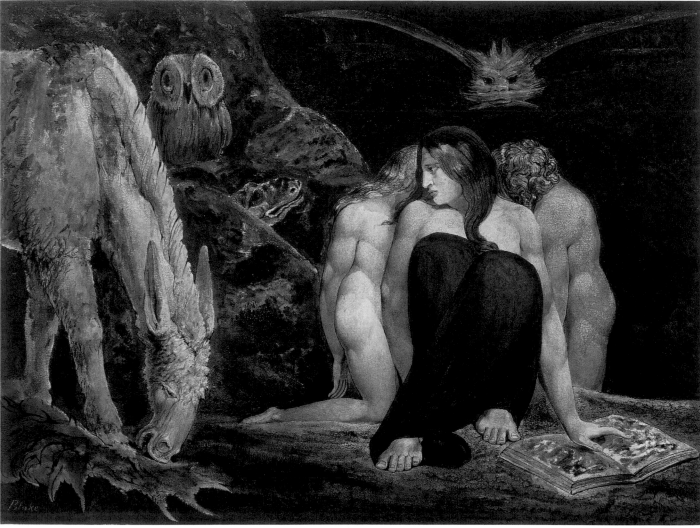

100

William Blake 1757–1827

The Night of Enitharmon's Joy
(formerly called 'Hecate') c.1795

Colour print finished in ink and watercolour on paper
43.9 × 58.1 cm
Tate. Presented by W. Graham Robertson 1939

This scene is taken from William Blake's own creation myth, which incorporated elements of Christian and classical mythology, as well as his own idiosyncratic philosophy. Enitharmon appears as the first female and the mother of many important figures including Satan and John Milton, himself a major source of inspiration for Blake. She has also been characterised as the figure of poetic inspiration, and so this picture can be seen to deal in a direct sense with the subject of creative experience.

Blake initially made this picture using an inventive mode of colour printing, which results in peaks of ink as the plate is removed, giving a rough texture (seen on the rocks). He then painted over the image using thin watercolour to emphasise form, and to highlight particular aspects (for example, the red wash on the owl's eyes). PS

William Blake 1757–1827

The River of Life c.1805

Pen and ink and watercolour on paper
30.5 × 33.6 cm
Tate. Bequeathed by W. Graham Robertson 1949

Blake rejected observed figures or scenes as subjects for his art, stating that 'this World Is a World of Imagination & Vision' (Erdman 2008, p.702). This image is an inventive response to lines from the Book of Revelation, 'The River of Life flows from the throne of God to the Tree of Life'. Blake translates the spiritual metaphor into literal visual form, also introducing figures of his own invention. Using translucent washes, he gives the impression of a vision, while the liquid quality of the paint, used to suggest the flowing river, also functions to unsettle a sense of physical reality, as the figures both float in and walk on the water.

Between 1799 and 1805, Blake was commissioned to make a series of watercolour illustrations to the Bible for his patron Thomas Butts who recognised the potential of Blake's unusual style for tackling spiritual subjects. PS

Samuel Palmer 1805–1881
A Hilly Scene c.1826–8

Watercolour and gum arabic on paper on mahogany
20.6 × 13.7 cm
Tate. Purchased 1948

Samuel Palmer belonged to a group of artists called
'the Ancients', who saw themselves as disciples of
Blake. Heavily influenced by the esoteric qualities of
Blake's art, Palmer painted small-scale landscapes,
rejecting the topographical precision or sublime
grandeur of those by many of his contemporaries.
Instead, he flattened perspective to undermine any
sense of real space, and presented natural detail as a
series of symbols – the corn, the hill, the moon, the
star. In this way, the scene takes on the quality of an
icon, establishing an intimate, affective relationship
with the viewer. This is augmented by the delicate
and varied application of watercolour, which invites
close inspection. PS

103

Dante Gabriel Rossetti 1828–1882

The Tune of the Seven Towers 1857

Watercolour on paper 31.4 × 36.5 cm
Tate. Purchased with assistance from Sir Arthur Du Cros Bt
and Sir Otto Beit KCMG through the Art Fund 1916

Using an intense but limited palette and a complex compositional structure, Dante Gabriel Rossetti recalls illuminated manuscripts in this work. The static figures' stultified expressions evoke an unnerving sense of self-absorption, while the pole cutting across the foreground arrests the eye, emphasising the intimacy of the scene. Rich fabrics are rendered in thick layers of paint, while the patterning of the surface webs the figures and the background together into one picture plane, creating a claustrophobic atmosphere.

While the exact subject of this work remains a mystery, the musical reference relates to an interest in synaesthesia among later nineteenth-century artists. This may account for the melancholic mood of the figures, who seem to be reflecting intently upon something, possibly the 'tune' of the title. PS

Richard Dadd 1817–1886

The Child's Problem 1857

Watercolour heightened with gouache on paper 17.1 × 25.4 cm
Tate. Presented by Dr R.C. Neville 1955

Richard Dadd was a specialist in fairy painting. As a young man he developed a schizophrenic type of illness and murdered his father, spending the rest of his life in mental institutions where he produced pictures of extreme delicacy and detail. Most of these were watercolours (as he painted in a confined space for most of the time), in which forms were created through fine hatching with minute touches of the brush.

Dadd's watercolours are strange in that they contain a wealth of information, the details of which do not add up to make a story. *The Child's Problem* is essentially a chain of ideas on the theme of black and white, most of which relate to interests harboured by the artist such as chess and slavery. However, these do not cohere to form a comprehensible argument or narrative, so any final meaning remains obscure and hidden.

Dadd gave the drawing to Charles Neville, the attendant in charge of him at Bethlem Hospital. The references to slavery in the image may be a private allusion to their relationship, that of master and inmate. AS

105

Richard Dadd 1817–1886

The Pilot Boat 1858–9

Watercolour and pencil on paper 28.2 × 45.1 cm
Tate. Purchased 1970

Dadd produced a number of works depicting boats and coastal landscapes during his confinement, largely based on memories of his childhood at Chatham or on sketches he made as a travelling artist in 1842–3. *The Pilot Boat* shows a boat leading a convoy near a shore littered with rocks. The treatment of the sea exemplifies the artist's idiosyncratic technique, with the waves appearing as lace or the jagged surface of a stone, which lends the scene a static, hallucinatory quality.

Many of Dadd's works appear pale to the eye. This was partly because he painted faintly, not being concerned with producing bold exhibition pieces, but also because his works have faded through over-exposure to light. As his watercolours were not on the whole owned by specialist collectors accustomed to looking after fragile works on paper, but rather regarded as curiosities, they were vulnerable to this sort of treatment. AS

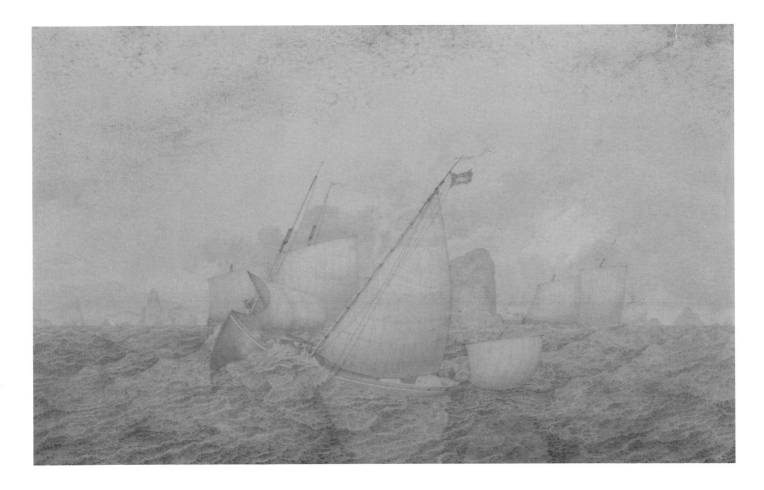

Victor Hugo 1802–1885

Souvenir de Normandie 1859

Watercolour and ink on paper 31.2 × 26 cm
Maisons de Victor Hugo, Paris and Guernsey

Victor Hugo's reputation as a visual artist was only truly established after his death. His decision not to exhibit his works reflects to some degree their very private nature. In this instance, Hugo has employed a strikingly innovative manner of application to record a 'memory' of Normandy, made while he was in Guernsey, in exile from France. During this period he created an enormous amount of works on paper, in watercolour and ink, a choice of medium influenced by his desire for spontaneity. Seen as a major figure within the Romantic tradition, which placed an unusual premium upon the artist's imagination as a creative source, Hugo experimented at a very early stage with a means of accessing what Sigmund Freud would later term the subconscious. Said to have often drawn with his eyes closed, or while participating in seances, Hugo seems to have been interested in expressing an internal 'truth', in the most direct way possible. PS

Robert Bateman 1842–1922

Three Women Plucking Mandrakes c.1870

Gouache and paper laid on canvas 31.2 × 45.8 cm
Wellcome Library, London

Although a fully trained artist, Robert Bateman perceived himself to be an amateur in that he was under no pressure to earn a living from his art. Watercolour painting was an interest he shared together with botany and horticulture, his knowledge of which informs this painting of a group of women attempting to extract a mandrake from the earth using a system of pulleys.

The mandrake, a South European plant, was believed to possess magical properties, capable of curing infertility but also of frightening the onlooker to death with the shriek it uttered when drawn from the ground. Bateman's painting reveals an erudite understanding of the folklore associated with the plant (possibly influenced by the artist's reading of Sir Thomas Browne's *Pseudoxia Epidemica* of 1646), but goes further in creating a menacing atmosphere by picking out crisply delineated details, such as the resolute expression of the central woman against an indeterminate background as if the scene were a dream-like fantasy or apparition.

Bateman was the leader of a clique inspired by the watercolours Burne-Jones exhibited at the OWCS in the 1860s. Collectively known as the Dudley School the works produced by the group were frequently criticised for being degenerate and morbid, as indeed this work was when it was exhibited at the Dudley Gallery in 1870. AS

108

Edward Burne-Jones 1833–1898

The Annunciation 1886

Watercolour heightened with gold on three pieces
of joined paper 245 × 96.2 cm
Norwich Castle Museum and Art Gallery

Watercolour painting on this large a scale is rela-
tively unusual, and reveals the ambitions that the
Pre-Raphaelites had for the medium. This grew
largely out of their endeavour to challenge the
distinctions between art forms, specifically those
between the so-called 'decorative' and 'fine' arts.
This particular piece was made as a cartoon, or
preparatory study, for an oil painting of the same
subject, and was later reworked as a watercolour
in its own right.

The story of the Annunciation represents
a moment of extreme introspection, as Mary
absorbs the news imparted to her by the angel.
It was therefore singularly well suited to the later
Pre-Raphaelite programme of exploring interior
psychological experience. The format of the work
and the use of gold highlights recall grand-scale altar
painting, while the delicate, hazy tonality creates the
impression of a fading dream. This combination of
universal spirituality and private personal experience
is one of the means by which visionary artists
invested their images with a mystical quality. PS

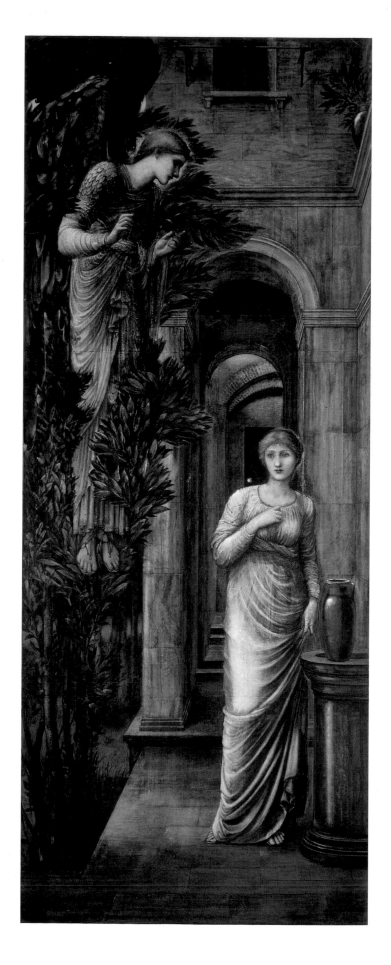

109

Simeon Solomon 1840–1905

Creation c.1890

Watercolour on paper 22.9 × 30.5 cm
Victoria and Albert Museum, London

Simeon Solomon was one of a generation of artists who responded both to the Pre-Raphaelite movement and to artistic developments in France, in particular the new slogan of 'art for art's sake', which gained currency on both sides of the Channel. This motto was adopted by the art critic and historian Walter Pater, and was at the heart of the Aesthetic movement, within which Solomon's work played a key role. Embracing the values of idealised beauty and non-narrativity that characterise Aesthetic art, Solomon produced a number of images showing figures in a state of emotional or psychological absorption. His somnambulistic 'portraits' suggest a moment of visionary encounter, or spiritual transcendence, inviting an equivalent response of engrossed reflection from the viewer. Solomon often worked in watercolour, as it offered a delicacy of touch and tone suited to the sense of intimacy he wished to construct. PS

Charles Rennie Mackintosh 1868–1928

Harvest Moon 1892

Watercolour on paper 35.2 × 27.6 cm
The Glasgow School of Art

Charles Rennie Mackintosh studied at the Glasgow School of Art, where he and his fellow students developed their own style of Art Nouveau design. Early in his career, Mackintosh made a large number of botanical studies, which he drew upon in his work as an architect and interior designer. His watercolours also incorporate stylised organic forms, which function to give an unsettling sense of physical familiarity to dream-like scenes. In *Harvest Moon*, flowing tubes appear to emanate from the central figure, who floats suspended in a womb-like moon, recalling diagrams of reproductive organs, as well as the process of conception. In the foreground, plant forms incorporate blood-like globes of liquid paint. Their tangled stems obstruct the vision of the viewer, obscuring the mysterious scene beyond.

Mackintosh's choice of title suggests an observed landscape, but also sets the scene at night, with its attendant associations of dreams and spiritual visitations. This tension between real and unreal, seen and unseen (or imagined) lies at the heart of visionary art. PS

111

Aubrey Beardsley 1872–1898

Frontispiece to Chopin's Third Ballade 1895

Pen and ink and ink wash on paper 26 × 24.5 cm
Tate. Presented by the Patrons of British Art through the Tate
Gallery Foundation 1999

Aubrey Beardsley, like Solomon, was associated with the Aesthetic movement, and placed a particular value on line and pattern as the fundamental aspects of his practice. Like many artists of his generation, Beardsley saw a close connection between different art forms, and strove to attain a visceral, musical effect in his drawing. Looking to the surface qualities of the work as a means of appealing to the sensibility of the viewer, he often created a tension between unsettling imagery and an attractive delicacy of treatment. In this instance, the subject of the work can also be interpreted as a comment upon the process of artistic production itself. Chopin's ballade was dedicated to a mysterious muse, Mademoiselle Pauline de Noailles, a creative influence that may be seen to find its visual equivalent in the female rider, and her domination of the wild horse, possibly representing the unruly imagination. PS

Robert Anning Bell 1863–1933
Music by the Water 1900

Watercolour and gouache on paper 38.7 × 54 cm
Tate. Bequeathed by Major-General Sir Mathew Gossett KCB 1909

Robert Anning Bell was an illustrator and decorative artist closely involved with the Arts and Crafts movement. He also worked in watercolour and was a regular exhibitor at the Royal Watercolour Society (as the Old Water-Colour Society came to be called from 1881), specialising in Symbolist works that take abstract ideas as the basis for their composition. This work, a *fête champêtre* in the manner of Giorgione and Titian, is painted in cool tones to create a sense of deliquescence and liquidity appropriate to the theme and medium. It is one of two works by Bell in the Tate collection that explore the theme of synaesthesia, or the correspondence between design and music, the other being *The Listeners* 1906. Around the turn of the century, the critic T. Martin Wood wrote sensitively about the 'musical' properties of watercolour in a series of articles in the *Studio*, suggesting that both were amenable to alterations of mood and feeling. Wood's words on *The Listeners* can equally be applied to *Music by the Water*:

> Beardsley's famous illustration to The Third Ballade of Chopin [no.111] ... is a real illustration to music, a fantasy born at least from the memory of sound. And the attitude of the figures in Mr Bell's picture becomes unattractive if by a mental effort we attempt to separate the arrangement of the design from the association of music (Wood 1910, p.256). AS

113

Edward Robert Hughes 1851–1914

Blondel's Quest 1912

Watercolour on paper 56 × 44 cm
The Ashmolean Museum, Oxford. Presented by
the E.R. Hughes Memorial Committee, 1915

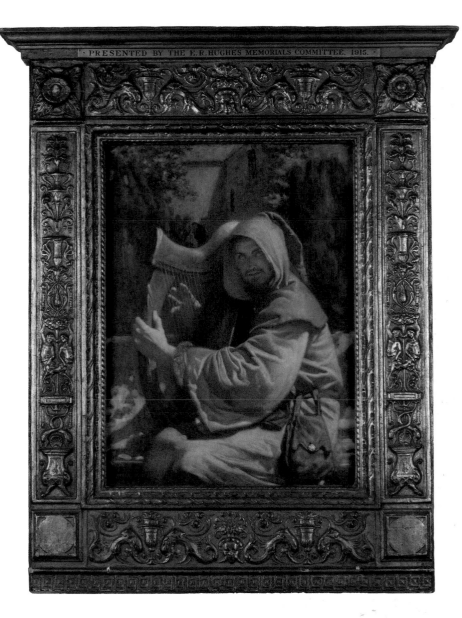

Much of Hughes's work is characterised by the saturated blue tonality apparent here, lending it an air of unreality. The unusual subject of this image is taken from the story of Richard I (commonly known as Richard the Lionheart). When Richard was captured and imprisoned after his third crusade, Blondel, his squire, sang outside the castle in which he was held. Choosing the moment at which Blondel takes up his lyre, Edward Robert Hughes engages with the idea of 'synaesthesia', whereby painting aspires to the emotive power of music.

Hughes knew Burne-Jones and worked for William Holman Hunt for a time, and it may have been these connections that inspired his interest in medieval history. Unlike Burne-Jones, however, Hughes chooses to focus closely on one figure, who confronts the viewer with an unnerving stare, giving a sense of immediacy and intensity to the historical scene. As an isolated artist absorbed in his music, Blondel in some ways represents the ideal 'visionary'. The work thereby raises the issue of creative expression via its subject, as well as through Hughes's own act of historical imagination. PS

Edmund Dulac 1882–1953

The Entomologist's Dream from 'Le Papillon Rouge' 1909

Pen and ink and watercolour and crayon on paper 27.4 × 29.5 cm
Victoria and Albert Museum, London. Given by Mr C.D. Rotch
through the Art Fund

The French-born Edmund Dulac first came to
England in 1904. Here he established a reputation
as an illustrator and decorator capitalising on
watercolour as the ideal basis for book illustration,
with the development of the half-tone reproductive
process in the late nineteenth century. This is one
of three illustrations for 'Le Papillon Rouge', a tragic
love story and fantasy he devised for the Christmas
number of Henri Piazza's magazine *L'Illustration*
in 1909, and is a superb example of how Dulac
utilised his characteristic nocturnal blue-tinted
style to conjure up the nightmare experienced by
an entomologist as he haplessly watches his prize
collection of carefully assembled butterflies come
alive and escape from their cases to animate the
room with their iridescent colours and markings.
Watercolour had been used to record and classify
natural specimens in the past. In acknowledging
this tradition, Dulac has the butterflies reassemble
in an artistic rather than a scientific pattern, as if
he were seeking to symbolise the confusion of
science by art.

Dulac employed a variety of techniques to
differentiate the textures of the objects in the
room, including rubbing coarse ochre crayon over
the painted surface, and dabbing wet colour with
sponges and blotting paper to accentuate reflections
of broken glass. AS

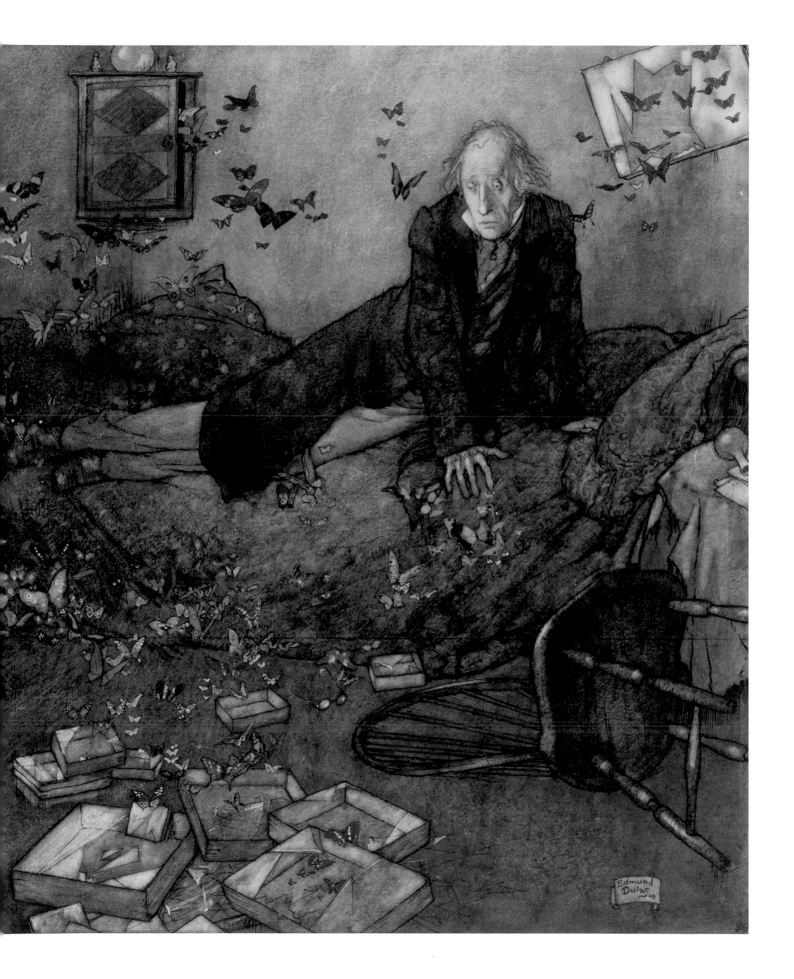

115

Frederick Cayley Robinson 1862–1927

The Renunciants 1916

Gouache on card 30.2 × 37.7 cm
Victoria and Albert Museum, London

Frederick Cayley Robinson was a Symbolist painter
and designer, closely involved with the mural revival
of the early twentieth century and well known for
the *Acts of Mercy* paintings he produced for the
Middlesex Hospital between 1915 and 1920.
Robinson practised watercolour as an adjunct to
his work in tempera and oil, and the images he
produced in the medium are similarly strikingly
frozen in appearance, as if he deliberately sought to
deny the fluid properties of the vehicle employed.
The heavy fresco-like texture of the wall that
dominates *The Renunciants* was produced using
gouache and then scratching into the surface.
Huddled on the extreme edges of the composition
are silent and solemn figures of all ages who are
presented as if engaged in a ritual, the meaning of
which it is impossible to fathom. AS

116

Edna Clarke Hall 1879–1979

Catherine c.1924

Pencil and watercolour on paper 47.7 × 57.8 cm
Laing Art Gallery, Newcastle upon Tyne (Tyne & Wear
Archives & Museums)

Edna Clarke Hall (née Waugh) studied art at the Slade School of Fine Art during the 1890s, where she took to watercolour as a medium with which she could work quickly and instinctively to seize her impressions. The Slade had a reputation as a progressive school and attracted a considerable number of female students, many of whom identified with the idea of the 'New Woman' in disregarding conventions of feminine behaviour and in seeking a more liberated, autonomous lifestyle. However, following her marriage in 1898, Clarke Hall felt her artistic ambitions restrained by the demands of domesticity, a tension that led her to identify with the character of Catherine in Emily Brontë's *Wuthering Heights* (1847), and the novel became a source of inspiration during periods of emotional crisis. This watercolour is one of many illustrations Clarke Hall made in relation to the novel. It shows the tragic heroine standing isolated and awkward against a bleak landscape. The chain on the lower left suggests entrapment, while the boats are perhaps symbolic of the freedom she feels she is denied. Colour is employed in fluid atmospheric washes in combination with expressive brushwork, adding to the overall sense of estrangement and alienation. AS

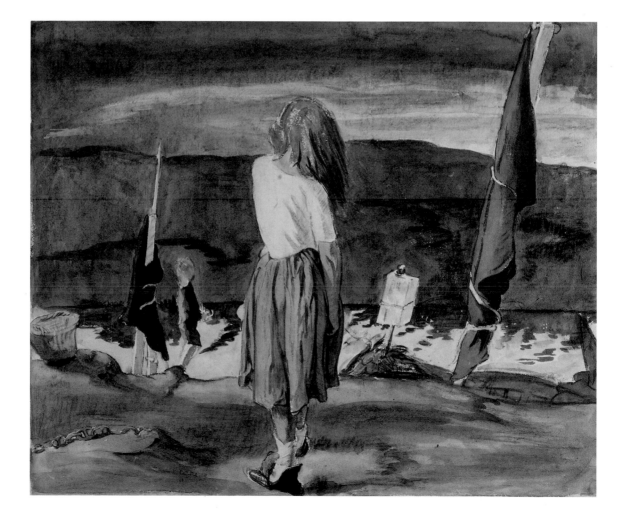

117

Paul Nash 1889–1946

Mansions of the Dead 1932

Pencil and watercolour on paper 57.8 × 39.4 cm
Tate. Purchased 1981

In his watercolours of the 1930s, Paul Nash harnessed Surrealism to earlier British romantic traditions of landscape to express interior states of mind and feeling. He was also intent upon finding a visual language for the transmission of literary and metaphysical concepts. This is one of a group of watercolours Nash produced in relation to a series of illustrations for a 1932 edition of Sir Thomas Browne's *Urne Buriall and the Garden of Cyrus* (1658), which concerns the rituals of death and questions of immortality. In Nash's words the watercolour shows 'aeriel habitations where the soul like a bird or some such aeriel creature roamed at will' (quoted in Causey 1980, p.224). As with Blake's *The River of Life* (no.101), which also imagines the soul's release, this watercolour is essentially a drawing with perspective lines interpenetrated with pale washes of colour, to present gravity-defying structures hovering among clouds. AS

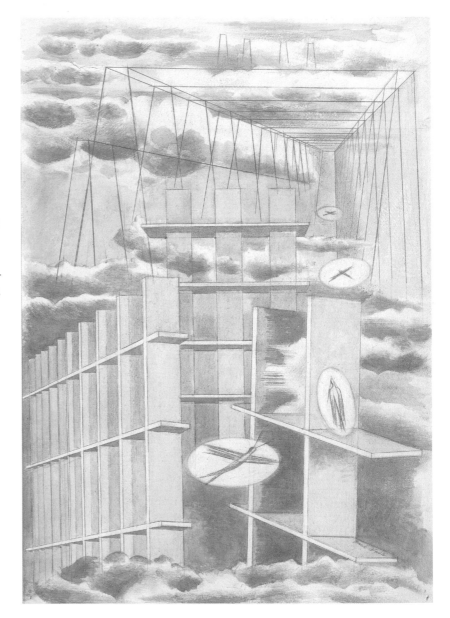

118

Paul Nash 1889–1946

Three Rooms 1937

Pencil, crayon and watercolour on paper 39.2 × 29.7 cm
Tate. Purchased 1981

The compartmentalisation of different elements
in this watercolour lends it an air of strangeness
characteristic of Surrealist art, while the hieratic
centrally placed forms recall the Symbolist art of
Blake. Loosely based on an eighteenth-century
perspective treatise, the image suggests the cross
section of three floors in a building. In the lowest
room the sun sets on a flooded interior. The
middle floor metamorphoses into a grove of trees,
the descending lines of which converge on to a
mysterious closed door in the midst of the com-
position. Clouds penetrate the uppermost chamber,
perhaps symbolising the presence of the dead among
the living. Despite the formality of the design, water-
colour is employed in a free, direct manner, the
white of the paper introducing luminosity and
harmonising the disparate elements of the
composition. AS

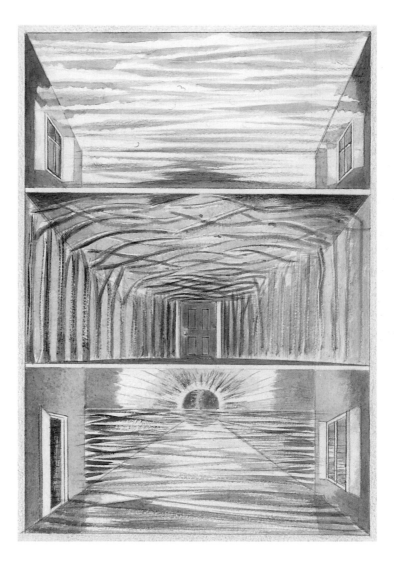

119

David Jones 1895–1974

Guenever 1938–40

Pencil, pen and ink, and watercolour on paper 62.2 × 49.5 cm
Tate. Purchased 1941

120

David Jones 1895–1974

Aphrodite in Aulis 1940–1

Pencil, pen and ink and watercolour on paper 62.9 × 49.8 cm
Tate. Purchased 1976

This is one of two large drawings Jones produced on Arthurian themes around 1940. Both concern the story of Launcelot in Thomas Malory's *Morte d'Arthur* (completed 1470) who, though flawed by his adultery, was marked as a type of Christ (Hills 1981, pp.65–6). Here he is shown wounded with stigmata marks as he bursts through the window of Guenever's chamber, his contorted pose echoed by the crucifix above the reclining figure of his lover. In this work Jones conceived of the love of Launcelot and Guenever as an allegory of Christ for His Church, with the sleeping knights in the foreground alluding not only to the wounded men the queen attends to in the legend, but also to sleeping figures of all ages, from medieval effigies to the soldiers Jones witnessed in their dugouts in the First World War.

The interpenetration of line and brushwork is so close in this drawing that it threatens the coherence of the composition. The figure of Launcelot thus appears enmeshed in the fabric of the window he destroys. Such confusion was a consequence of a long process of drawing and revision. Some areas are rubbed and softened, while other details are emphasised in pen and ink to allow forms to merge into the flickering surface of the design. AS

Regarded as one of David Jones's major drawings of the early 1940s, this work epitomises his preoccupation with myth and legend as living traditions. It presents Aphrodite, the classical goddess of beauty and sexual love, as a sacrificial victim, chained to an altar and flanked by British and German soldiers standing like sentinels at the base of a crucifixion. The image is densely packed with symbols and archetypes from all periods of world history, which cohere to suggest an endless cycle of regeneration and renewal.

Jones described water as 'the womb of all life' and here it acts as a kind of amniotic fluid, the watery dispersal of paint across the surface holding past and present in suspension. Streaks of soft translucent pigment are applied in layers, so the colour merges with nervous energetic lines to communicate the interplay of intangible forces and collapsing boundaries of space and time. AS

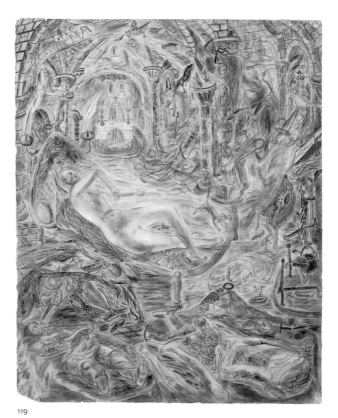

119

120

121

Ithell Colquhoun 1906–1988
Mausoleum, Male Genitalia c.1944

Pen and ink, watercolour and gouache on paper 31.1 × 21.7 cm
The British Museum, London

While watercolour offers unparalleled opportunities
for translucent, hallucinatory effects, it can also be
used with more visceral results without abandoning
a visionary sensibility. The physical similarities
between the paint solution and human bodily fluids
has allowed artists to create works of arresting
immediacy. In *Mausoleum, Male Genitalia* by the
Surrealist artist Ithell Colquhoun, the image
oscillates between metaphor, description and
embodiment, as the paint outlines an invented
representation of the penis and at points adopts
the consistency of semen. Colquhoun's description
of her style as 'magic realism' recognises these
different elements of her work. Although she
embraced the physicality of her subjects, she was
also fascinated by the mystical and occult (an interest
that prompted her to produce a set of tarot cards
in 1949). PS

122

Christopher Le Brun (b.1951)

Ziggurat 2007

Watercolour on paper 57 × 76 cm
Todd Longstaffe-Gowan and Tim Knox Collection, London

Christopher Le Brun is best known as a sculptor and painter. His recent venture into watercolour came when he injured his hand and turned to the medium as it was easier to use than oil, and then became fascinated with it as a subtle means of painting landscape. Using smooth or semi-rough Fabriano paper, he works delicately with the brush to create dream-like environments that invite the viewer to explore the imagined space rather than employing it extrovertly to dramatise the means of execution. For Le Brun the ease and intimacy of watercolour encourage the memory to operate fluently. Drawing on a repertoire of imagery derived from experiences of art and nature, he seeks to stir similar patterns of connection within the mind of the spectator.

Le Brun's watercolours evoke the atmospheric and illusionist landscape formats used by British romantic painters such as Palmer (no.78) and Nash (nos.117, 118). Many contain fantastic architectural forms, such as the Bruegel-like Tower of Babel structure nestled behind a veil of protective trees in *Ziggurat*. AS

Watercolour Today: Inner Vision

Katharine Stout

Artists today often work freely between different forms of art, selecting a particular type of medium or technique for the idea or image they wish to explore. American art historian Rosalind Krauss has led the way in offering a theory for how artists since the 1960s have sought to reinvent the idea of a medium rather than conform to the historical, institutional, commercial and theoretical frameworks that have been placed around it. In her short book *A Voyage on the North Sea: Art in the Age of the Post-Medium Condition* (Walter Neurath Memorial Lectures, 1999), Krauss introduces her topic: 'At first I thought I could simply draw a line under the word medium, bury it like so much critical toxic waste, and walk away from it into a world of lexical freedom. "Medium" seemed too contaminated, too ideologically, too dogmatically, too discursively loaded'. She goes on to articulate the move away from a Modernist drive to develop work concerned solely with the material properties of a medium whilst arguing that medium specificity is still a relevant concern for contemporary practitioners. Artists have largely discarded the idea that a specific medium, such as watercolour, possesses intrinsic qualities to be adhered to and enhanced, wishing instead to determine new possibilities for themselves. In many ways this stance can be seen as closer to a pre-modern approach to watercolour and painting in general, in which artists such as Blake and Turner interrogated and developed the potential of the medium in close dialogue with the character of the imagery they wished to explore, rather than for purely formal reasons. This could explain why these artists or others such as Dadd or Beardsley (i.e. those who were marginalised for not following the rules of the Royal Academy or other institutional conventions) often seem more relevant to contemporary concerns than those they were challenging (or ignoring) in their own time. The drive to articulate and define a unique language, technique or style for art, is a central motivation for artists today, just as it led artists of the past to break with their teachers and peers. Today, contemporary practice and within this the application of watercolour is more fragmented and individualised than ever before, with artists usually actively avoiding or rejecting the idea of schools or movements.

During the nineteenth century the status of watercolour painting shifted: from being viewed as primarily a private, secondary activity (which, for example, a female artist could pursue in the domestic realm), it came to attain a significant presence in private galleries and public museums. For the contemporary artists represented here watercolour is an essential, though not necessarily exclusive, aspect of their public, internationally celebrated practices. Museums and galleries across the world present exhibitions that focus solely on work in watercolour by these individuals, and they also exhibit their watercolour paintings alongside other media. The fact that watercolour now has an established public platform, and is fully assimilated within contemporary art practice, supports the argument that this medium is not limited to the role to which it was designated historically. Paradoxically it is also true that a surprising number of artists continue to experiment with watercolour in the privacy of their own studio, turning to it as an immediate, direct means to hone ideas and skills.

This section focuses on contemporary work that explores figurative imagery derived from the artist's memory or imagination rather than literal descriptions of observed scenes. Many artists today wish to go beyond responding to or illustrating our natural

or built environment, especially since this mode of image making was explored so thoroughly by artists in the past. Instead they seek to invest an image with an emotional charge that transcends representation to offer a much more personal, subjective view of landscapes, figures and objects. This leads on from the previous section, which explored the idea of the visionary in art making over the last three centuries, suggesting that this genre has been developed in close association with the history of watercolour. Today it remains true that, in a variety of ways, artists exploit the mythological status of water-colour as unmediated to create imagery that is intuitively and quickly derived from the imagination, making work that is imbued with the apparent veracity of the indexical trace of the artist's hand, as seen in the work of David Austen, Lucia Nogueira or Sophie von Hellermann. Some artists such as Peter Doig or Neal Tait set out to explore why certain images or figurative motifs retain such a strong personal impression, using watercolour to produce works whose imagery is just as striking and uncanny for the viewer as it is for the artist. However, since the ideas that underpin the study of psychoanalysis now inform an understanding of ourselves in relation to others, and the way we process and assess our emotions, the artists who create surreal, and at times unsettling, visualisations perhaps do so in a more knowing manner than their historical predecessors. It is no coincidence that highly personal, interiorised subjects that were historically restricted to those deemed outsiders, or on the fringes of both the artistic community and society, are a dominant area of concern in contemporary art, not just for artists working in watercolour but in all forms of art.

The way the artists in this section are using watercolour, whether gouache, tempera or pure watercolour, reflects the broad range of ends to which this medium is being used today, echoing for example its historical deployment as an analytical recording device, or as a versatile, effective means to capture the most fleeting imagery or emotion. At opposite ends of the spectrum, watercolour is applied very precisely, using the brush as a drawing tool as in the work of Bethan Huws, Lucy Skaer or Nicola Durvasula, or with loose washes that offer the barest notion of an image as in the works of Tracey Emin. Certain artists, such as Lucy Skaer or Silke Otto-Knapp, approach the medium of water-colour in a carefully predetermined, systematic manner that partly seeks to counter its reputation as a medium best suited to a spontaneous means of expression, creating paintings that are as much about the artifice or construction of an image as the particular subject they are addressing. For these artists, as for many others, there is a fusing together of the materiality of the work, their treatment of the medium and the ideas that inform the piece.

123

Lucia Nogueira 1950–1998

Untitled 1994

Watercolour and ink on paper 40.5 × 50 cm
Tate. Presented by Tate Members 2009

As a Brazilian who made her home in London, Lucia Nogueira had a distinct and important place within the British art world in the late 1980s and 1990s. Though she worked primarily in sculpture and video, drawing and watercolour featured consistently throughout her practice. The work illustrated here is one of a number she painted in the years leading up to her premature death at the age of forty-eight. These exquisite paintings share some of the characteristics of her three-dimensional work – fragility, a sense of underlying threat or menace, a harnessing of the energy of movement and chance encounters – yet they also possess self-contained imagery and motifs. Her interest in the notion of trapped forces and the transition from one state to another was communicated into poetic and disquieting works in all media. Yet the works on paper in particular contain a highly playful and at times childlike quality, albeit with a dark and surreal edge. Found elements such as containers, funnels and ladders from her sculptural work feature in the drawings. Animals such as elephants, fish or snails emerge from more abstract shapes and forms in other works. Yet the works' simplicity and directness belie Nogueira's dexterity and inventiveness in the use of this medium. ĸs

124

Bethan Huws b.1961

Blue Rush Boat 1997

Watercolour on paper 35.5 × 44cm
Leeds Museums and Galleries (Leeds Art Gallery)

Bethan Huws's exquisite watercolours, produced over the last twenty years, cover an imaginative spectrum of concerns. These range from her attempts to recall experiences, events and things from her childhood in North Wales, natural or abstract forms, motifs extracted from dreams and visual testaments, to her belief in the importance of the work of Marcel Duchamp. Drawn lightly with a brush, Huws's paintings use the subtlest colours and line to convey form that draws upon and unites concrete experience, ideas and memory. One theme that links her varied practice, comprising writing, sculpture, film and performance, is a fascination with boats and water. This interest originates from a game Huws played at home as a child – the children would take a rush-stem and roll and knot it to form a boat, which they would release in the stream. For the artist the motif of the boat, as rendered for example in this painting, allows her to retain links to the idea and experience of a time and place, whilst also acknowledging that she has left it behind. The image is infused with a concentrated emotional charge despite, or indeed because of, the simplicity and economy with which it is depicted. ᴋꜱ

125

Tracey Emin b.1963

Berlin The Last Week in April 1998 1998

Watercolour on paper 43.5 × 47 cm
Courtesy of the artist

Tracey Emin is one of the leading figures of an internationally celebrated group of British artists who emerged in the early 1990s. She is best known for her candid works that take the form of video, sculpture, monoprint, quilting, writing and painting to offer highly intimate and sometimes explicit personal memoirs. Although Emin has made relatively few works with watercolour compared to her work in other media, she has included her paintings in this medium in key exhibitions such as the Turner Prize 1999, when she represented Britain at the Venice Biennale in 2007, and as part of her major retrospective *Tracey Emin: 20 Years* at the Scottish National Gallery of Modern Art (2008), which subsequently toured to Malaga (2008) and Bern (2009). As their title suggests, this group of watercolour paintings recalls the memory of a particular time in Berlin. The delicate, loosely painted images offer a portrait of the artist herself taking a bath with her partner at the time. These almost abstract images are painted from a series of Polaroids and are reminiscent of other works that reveal private female moments that have featured as a subject for painters throughout art history. KS

1998.

126

Peter Doig b.1959

Yara 2001

Watercolour on paper 70.5 × 53 cm
Ole Faarup Collection, Copenhagen

Peter Doig's works on paper explore many of the
themes and images that recur in his perhaps better-
known works on canvas. His subjects are often
informed by photographic sources and draw upon
places he has lived and other personal memories.
These watercolour paintings are not simply prepara-
tory studies for Doig's larger-scale canvases, but
rather allow him the freedom to evolve an image,
exploring the potential for a figurative painting to
go beyond the representation of a direct encounter
or even a memory to become something more
complex and resonant.

His recent work shows the influence of the
colours, light and landscapes of Trinidad, where
Doig now lives. In *Yara* he depicts a beach in
Trinidad, yet this is not a romantic impression
of an idyllic Caribbean scene, but a haunting,
dreamlike landscape. Doig exploits the immediacy
of watercolour to capture this view in quick, loose
brushstrokes, verging on monochromatic abstraction.
This work relates to other paintings that were
prompted by a particular, unsettling incident Doig
observed on a remote beach when a man appeared
to be drowning the bird. In a number of paintings in
watercolour and oil, he has set out to create a visual
record of the strangeness of witnessing such an
event and the way it became an image in his mind.
Born in Edinburgh, Doig was brought up in Trinidad
and Canada, before coming to London to attend art
school in 1979. KS

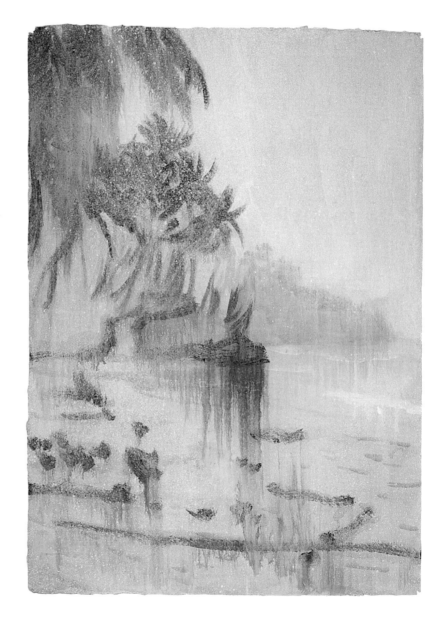

127

127

Lucy Skaer b.1975

Cell #1 (with rules and exceptions) 2005

Watercolour on paper 150 × 140 cm
UBS Art Collection

128

David Austen b.1960

Untitled (Woman on Man's Shoulders) 11.6.05 2005

Watercolour and pencil on paper 25 × 25 cm
Courtesy of the artist and Ingleby Gallery, Edinburgh

In drawings, sculptures, films and installations, Lucy Skaer investigates the potential and limits of representation, often using photographic sources as her starting point.

She frequently takes an image either found or originated, and subjects it to a process of transformation until it becomes barely recognisable as it approaches the point of abstraction. Drawing underpins Skaer's practice, and she was interested to apply the same, linear precision that characterises her work to watercolour, consciously challenging its traditional role as a medium best suited to spontaneity and expressive gesture. In the *Cell* paintings, Skaer transforms photographs of prison cells into a series of paintings drawn with the brush, in which the original motif is fragmented and almost entirely erased. Rendered in alternating coloured stripes that give the image spatial texture and depth, *Cell #1 (with rules and exceptions)* becomes less a depiction of a recognisable scene than a study in optical illusion. Skaer devised a scheme in which the dark areas translate into regularly spaced red and green stripes and light areas into blue and yellow, which serves to reinforce the regulatory nature of the prison cell. The areas in which figures once stood remain white, giving a sense of the image disappearing. KS

David Austen works in a variety of media, most recently moving into film. However, for many years he has been primarily acclaimed as a painter. He is acutely attuned to the unique material properties of individual paints and paper, selecting each for their appropriateness to the image he wishes to depict. His ongoing series of poignant figures are deftly painted in quick, concise brushstrokes that draw upon the pure, translucent qualities of watercolour. Captured in pairs as well as individually, nude or semi-clothed and in various positions, these are intimate and occasionally disquieting studies in figuration that have an arresting presence. The various aspects of Austen's practice at times appear multi-authored, so distinct are they in character and form. What unifies his work is a poetic or philosophical approach that is informed by literary sources as well as everyday situations. Whilst playful, there is a darker emotional charge to his enquiries into the fragile nature of the human condition and how this is informed by the relationships that challenge and define us. KS

128

179

129

Neal Tait b.1965

Country Booby 2008

Acrylic and tempera on linen 50.8 × 50.8 cm
Courtesy of the artist and White Cube

Neal Tait's paintings and drawings offer elusive images of figures and things that appear to have been lifted from the artist's immediate surroundings and transferred to an imaginary parallel world. Heads, bodies and everyday objects are transformed into enigmatic, surreal forms that mutate and multiply, appearing at times to exist within their own space, or to float on the surface of the canvas. Tait freely mixes and layers different types of paint in his work to pull out particular figurative details or create more abstract areas of colour. In some paintings he works with watercolour or gouache to allow for a more immediate way of image-making, whilst in others, he works more slowly, over a period of time, repainting and developing key areas. In the painting *Country Booby* he uses acrylic and a modern form of water-based tempera, employing its opaque chalkiness to create the strange worm-like cloak that envelopes the main character. Although this haunting central figure seems to come from one of the darker versions of a children's fairy tale, it exists within a solitary, dream-like world entirely of the artist's creation. KS

130

Nicola Durvasula b.1960
Eighty Three 2009

Watercolour, gouache, pencil on paper 33.2 × 20.5 cm
Courtesy of the artist and Rachmaninoff's, London

During the 1990s, whilst living and working in India,
Nicola Durvasula produced a series of drawings on
Lucky Parchment and standard account-book paper.
Ten years later, having relocated back to England,
she reworked and completed these drawings. The
artist comments on her decision to work over these
nearly forgotten pieces: 'It was not so much to relive
the accumulations of memories contained within
these lines, as to simply rework them from another
perspective and another time.' These drawings,
which mostly feature dream-like figures floating
on the untouched paper, are rendered precisely
with a brush using watercolour and gouache, built
up in delicate layers. Just as the figures seem more
generic than specific representations of people whom
Durvasula encountered in India, so the drawings
have a timeless quality. Stylistically and thematically
they relate to aspects of Indian art such as the tradi-
tions of miniature and narrative painting, yet they
also contain abstract elements that can be traced
back to a more Western art history. These enigmatic
works on paper do not adhere neatly to one cultural
history or another, but instead subtly and intrigu-
ingly offer a visual testament to the way in which
Durvasula's artistic vocabulary and approach has
been informed over time by her experiences in
different places. KS

Silke Otto-Knapp b.1970

Figure (horizontal) 2009

Watercolour and gouache on canvas 80 × 110 cm
Courtesy of the artist and Galerie Daniel Buchholz, Cologne

Over the last decade Silke Otto-Knapp's compelling paintings have explored themes ranging from gardens to showgirls to contemporary dance, in parallel with an investigation into the potential of the medium of watercolour. Her highly individual technique of painting layers of watercolour and gouache on a prepared canvas allows Otto-Knapp to build up and break down the pictorial place, so that the figurative motif appears almost buried within the painted surface. *Figure (horizontal)* draws upon the recent stage productions of contemporary dancer and choreographer Michael Clark, in particular the performances of one of his principal dancers. By focusing on an individual figure that recurs in several paintings in varied positions, Otto-Knapp explores the formal qualities of the human body, treating it almost as a ghostly object reduced to the barest outline and volume. Otto-Knapp's paintings exploit the celebrated delicacy and ethereal lightness of her chosen medium to produce haunting works that conversely contain a material toughness and spatial complexity. It is for this distinctive character that her work has been recognised internationally as well as in Britain, where she now lives and works. KS

132

Sophie von Hellermann b.1975

Nurture with love (busy busy stop stop) 2010

Watercolour on paper 57 × 76.7 cm
Courtesy of the artist and Vilma Gold, London

Sophie von Hellermann's paintings in watercolour share a distinctive language with her larger-scale paintings on unprimed canvas using water-based acrylic paint. Her smaller works on paper are distinguished by their crisp, linear quality, which for the artist aligns them closely with the act of drawing. She works swiftly and prolifically to capture figurative images that come out of autobiographical, literary, mythological narratives or current affairs, yet go beyond these starting points into the realms of fantasy and the imaginary to succinctly combine thought, memory and experience. The thinly washed, spontaneous quality of her painting style perfectly suits the dream-like, playful nature of her subject matter. The topic of this painting arose out of the increasing difficulty of getting her young daughter to attend violin lessons, and in this image von Hellermann transfers their journey under water and enlists the help of a ship of slaves. Born in Munich, von Hellermann lives and works in London. Her practice is recognised internationally for its ability to draw upon various traditions of painting whilst creating a unique style that appears deceptively effortless. ĸs

Abstraction and Improvisation

Nicola Moorby and Katharine Stout

The development of a non-figurative language for painting, to create abstract imagery that can be evocative of an experience or encounter with the reality of the world and exist independently as an investigation into pure form and colour, is regarded as predominantly a twentieth-century phenomenon. In bringing together works from across three centuries this section proposes that the theme of abstraction and improvisation is not an exclusively modern concern. There is an established history of artists exploiting the natural fluidity of watercolour as a creative stimulus for experimental work that goes beyond representation. In his posthumously published *Trattato della pittura* (Treatise on Painting, 1651), the Renaissance master Leonardo da Vinci (1452–1519), advised artists to look at the stains or patina found on an old stone wall. He believed that accidental resemblances suggested by the random marks could liberate and inspire the imagination. More than two hundred years later his theory was echoed by the compositional methods of Alexander Cozens, a drawing master who devised a teaching system based on semi-accidental ink blots. The positive or negative outlines of imprecise, swiftly drawn shapes were intended to provide the basis for finished landscape compositions, with room for artistic interpretation. The resulting studies are startlingly bold, suggesting the essence of a scene through stark contrasts in light and dark.

Another couple of centuries on, and a redefining of the boundaries between representation and abstraction became a central preoccupation for many twentieth-century artists. This often took the form of a particular focus on landscape, as seen most notably here in the work of Peter Lanyon. His highly inventive paintings succeed in their intended wish to go beyond merely illustrating the Cornish landscape that he grew up with and returned to, offering instead a sense of his own bodily experience of the land from multiple perspectives. A fellow Cornish resident, Roger Hilton also shifted constantly between these different modes of painting, but was primarily concerned with evoking the figure. His playful, almost infantile works on paper painted from his sick bed convey the pleasure of their making through an audacious use of line and colour.

The works in this section incorporate not only conventional watercolour, but also inks and alternative water-based pigments, either used in isolation or mixed with other media. There are examples of acrylic paint used in dilute liquid form, and print techniques designed to perpetuate and extend the watercolour tradition. In some recent work, watercolour and gouache are combined with more unusual materials such as shampoo or found objects, not for the sake of controversy but as a way to engage the act of painting more closely with the world we inhabit. True of most of the artists in this catalogue, but arguably most visible in this section, is that each seeks to be specific to the potential of their chosen medium. Perhaps voicing a sentiment shared by many artists represented here, Patrick Heron stated:

My gouaches are not a substitute for the oil paintings. Nor are they preliminary sketches, or means for trying out new colour-shapes or configurations of dovetailed colour shapes to feature in later paintings on canvas. They are works in their own right. (Patrick Heron 'A Note on my Gouaches' (1985), in Waddington Galleries 2005, p.5)

The first artist accredited with the sustained use of experimental, loose, wet washes was Turner. The undisputed genius of nineteenth-century watercolour, he was celebrated during his lifetime for virtuoso paintings where the complexity and artistry of the finished product obscured their technical secrets. In private, however, he honed his abilities through free and rapid studies known as 'colour beginnings'. These exercises were never intended to be exhibited in public, and are not abstract in the contemporary sense of the word. Nevertheless, they demonstrate a reduction of the elements of landscape to a tonal arrangement of form and colour. Like Cozens, Turner aimed to capture the general impression of the whole effect in his mind. Yet these works should not be seen as merely unfinished or preparatory sketches. Rather they represent the distillation of the creative process, and are complete and perfect statements in themselves.

The distinct properties of water-based pigment make it an ideal agent for exploring the abstract potential of colour and form. The loose, unconfined nature of wash lends itself to images based upon mass and tone, rather than linear outline, while the innate transparency of the medium gives the artist the opportunity to access the seductive force of pure, rich colour. Artists such as Heron and Howard Hodgkin create areas of saturated colour to great effect, giving their work a powerful emotive charge. Ian McKeever carefully layers and juxtaposes transparent and opaque forms and areas of colour in his painting, opening up an intriguing spatial complexity that sits lightly on the surface of the paper. Other artists working today, such as Callum Innes, exploit the renowned immediacy and transparency of watercolour in a carefully preconceived and ordered rather than spontaneous manner, to create works that are imbued with a presence that is powerful and captivating. This serves to question the assumption that the medium is best suited to forms of expressionism derived exclusively from intuition and emotion.

The unpredictable process of creating a work ultimately determines the physical appearance and form of pieces by other artists represented here. For example, Sandra Blow's *Vivace* 1988 was made by throwing a can of red paint at the canvas and captures an explosion of energy and feeling that is further enhanced by its title. Like Blow, Karla Black aligns herself with artists from recent art history, for whom the physical act of creating the work itself is an essential aspect of the finished piece. Her inclusion of substances more familiar from the domestic realm also aligns her practice with those artists who have expanded their range of materials beyond those traditionally used for art, in order to make the physical properties and associations of products such as toothpaste and hair gel an integral part of the work. Hayley Tompkins also brings the everyday into her practice, painting over items that are common in the natural or urban environment. These can be viewed as a way of challenging the rarefied status of the art object, and making our encounter with art more at one with our experience of the world.

133

Alexander Cozens 1717–1786 and a pupil
A Blot, based on *A New Method,* plate 10

Brush and ink on paper 48 × 38.2 cm
Tate. Purchased as part of the Oppé Collection
with assistance from the National Lottery through
the Heritage Lottery Fund 1996

The landscape artist and drawing master Alexander Cozens is best remembered for his unusual teaching practices. He devised a means for creating different types of landscape images from chance assemblages of monochrome ink, intended to focus the instincts of the artist towards tone and mass, since in nature 'forms are not distinguished by lines, but by shade and colour' (Lyles and Hamlyn 1997, p.72). Despite the apparent simplicity of the resulting images, Cozens's method is highly intellectualised. Hard to follow, it was often ridiculed, earning him the nickname 'Blotmaster-General'. The principle involved making swift strokes with diluted ink on a blank sheet of paper, preferably crumpled to increase the haphazard arrangement of the forms (Hardie 1966, vol.1, pp.85–6). Yet, unlike the results of automatic drawing or Rorschach inkblot tests, the effects were not entirely arbitrary: it was necessary to employ a conscious artistic impulse, driving the brush according to a preconceived notion of the final subject. NM

134

Alexander Cozens 1717–1786

Plate 7 from *A New Method of Assisting the Invention in Drawing Original Compositions of Landscape* c.1785

Aquatint on paper 24 × 31.4 cm
Tate. Purchased 1980

After twenty-five years of teaching his 'accidental-on-purpose' blot technique to individuals, Cozens codified it for a wider audience in a treatise entitled *A New Method of Assisting the Invention in Drawing Original Compositions of Landscape* (1785–6). In addition to a full written explanation, the publication included sixteen illustrations of 'blot landscapes' that could be placed underneath a thin sheet of paper and traced over as the basis for more elaborate finished compositions. Each example represented a different type of scenery, codified and labelled by Cozens, such as the section of 'high foreground' shown here. The essential abstracted qualities of these categories could then be interpreted according to the memory, observations or imagination of the individual artist.

The plate is a reproduction of Cozens's original ink drawing in aquatint, a tonal engraving process developed during the eighteenth century in order to imitate the appearance of watercolour washes. NM

133

134

135

Joseph Mallord William Turner 1775–1851
A Beginning after c.1830

Watercolour on paper 22 × 27 cm
Tate. Accepted by the nation as part of the Turner Bequest 1856

136

Joseph Mallord William Turner 1775–1851
A Wreck (possibly related to 'Longships Lighthouse, Land's End') c.1835–40

Watercolour on paper 33.8 × 49.1 cm
Tate. Accepted by the nation as part of the Turner Bequest 1856

Turner's so-called 'colour beginnings', of which these are two examples, are part of a wider creative process, representing a developmental stage between an 'on-the-spot' sketch and a finished studio watercolour. They denote the 'beginnings' of ideas for landscape paintings, reducing the tonal properties of a view to broad masses of colour. Freed from the fiddly processes of preserving or creating detail, the artist was able to work in a swift, instinctive manner, dropping and sweeping liquid washes on to wet paper and driving the paint around in order to articulate the ideas crowding his mind. The forms are generally left diffused and unresolved, but retain a powerful sense of movement and atmospheric effect.

Each study adheres to a basic formula. The line of the horizon cuts the picture plane in half, imposing a natural structure around which Turner balances a simple composition of sky and sea or land. This system could be endlessly exploited with unique permutations of colour and content. However, it is sometimes possible to identify moments when the artist worked in series, building up batches of images in rotation using the same restricted palette. He could make several views on a single large sheet of paper, applying a tone on one before moving on to a new variation whilst the wash was drying on the previous attempt. The sheet would then be cut into individual studies, although certain examples still exist that have been left together. Turner painted hundreds of colour beginnings and, although they were unknown during his lifetime, they have since become among the most appreciated aspects of his watercolour output. Breathtaking in their simplicity, they represent the artist's inherent ability to think about landscape as broad masses of colour, as well as his intuitive, experimental use of watercolour.
NM

135

136

137

Peter Lanyon

Coast 1953

Watercolour, gouache, pencil and charcoal on paper 46.6 × 62 cm
Tate. Bequeathed by Jean Sheers 2000, accessioned 2002

Returning to the area of his birth after serving in the Royal Air Force during the Second World War, Peter Lanyon's work during the postwar years align his observations of the natural beauty of the Cornish landscape with his subjective experience of living in Cornwall. *Coast* is characteristic of a series of paintings begun in 1951 in which he depicts the Penwith coastline familiar from his upbringing. The painting is typical of the way he sought to offer the sense of an immersive relationship with the landscape through colours and form. Rather than represent a specific location, he creates a more universal impression of the way in which the land meets the sea that verges upon abstraction but stops just short. Using washes of watercolour and gouache overlaid with pencil and charcoal lines, he layers multiple perspectives to convey different viewpoints, and suggest the movement of the sea, light and weather. Influenced by the work and teaching of artists such as Ben Nicholson, Barbara Hepworth and Naum Gabo who moved to St Ives in 1939, Lanyon is regarded as the most original and celebrated of artists who settled in south Cornwall during the 1950s and 1960s. KS

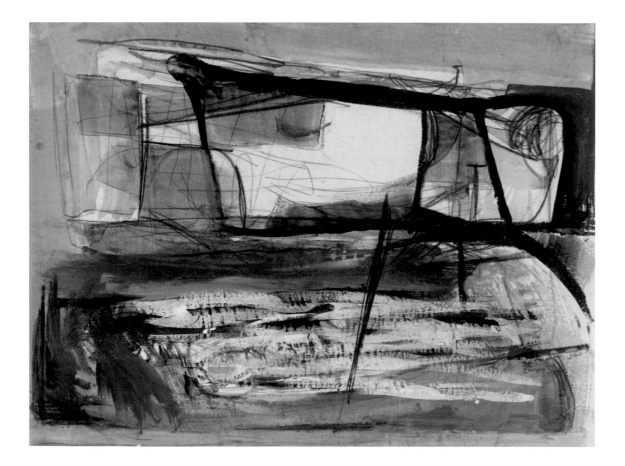

138

Roger Hilton 1911–1975

Two Dogs 1973

Gouache and charcoal on paper 38 × 56 cm
Tate. Bequeathed by David Brown in memory of Mrs Liza Brown
2003

Roger Hilton was one of the most inventive artists in postwar British art to explore the relationship between figuration and abstraction. Influenced by European artists such as Piet Mondrian and Constant, he prioritised an improvisatory and expressionist approach to his paintings. A strong personality he was also an influential character amongst the communities of artists in London and in Cornwall where he spent more time from 1956 onwards. He drew every day, creating images with a dexterous application of line in conjunction with bold use of colour that often appear at once repre- sentational and a celebration of pure form and colour. Towards the end of his life he was confined to his bed due to illness and embarked upon a prolific series of playful and rich gouaches that were informed by the objects, animals and people around him, as well as his still vital imagination. *Two Dogs* reveals the way in which he often adopted a childlike perspective in these raw and often crude works. They indicate a shift back to a more figurative mode of painting, but are still driven by joyful combinations of colour shapes and confident line. KS

139

Howard Hodgkin b.1932

A Storm 1977

Gouache and lithograph on paper 51.7 × 61.3 cm
Tate. Purchased 1984

Since the early 1960s, Howard Hodgkin has created compelling and formally inventive paintings and prints that offer images of experiences and events that have affected him, but which go beyond representation. This work is unusual in that it was prompted by an account Hodgkin heard during a visit to Oklahoma of the terrible storms that had engulfed the area, rather than a first-hand experience. The description of these storms also reminded Hodgkin of the wild stormy skies painted by the American artist Thomas Hart Benton (1889–1975), which had made a striking impression on him many years earlier. A central, dense inky cloud floods over the characteristic thick frame-like border that is incorporated into the image, evoking the primal force of the storm. The way in which the layers of green and blue gouache washes have been painted over this lithograph made from three plates (the work is numbered 40 from an edition of 100) makes it difficult to distinguish between the colour-saturated printed and painted marks. Hodgkin continues to be one of the most celebrated artists working today and has had many exhibitions in Britain and abroad, including a retrospective exhibition at Tate Britain in 2006. KS

140

Patrick Heron 1920–1999

January 9: 1983: II 1983

Gouache on paper 77.5 × 60 cm
Tate. Lent by the Tate Gallery Foundation 1988

This work is an example of the paintings Patrick Heron produced during the 1980s and 1990s, in which he deployed gouache to develop his investigations into colour as both subject and a means of creating an abstract image. The spatial complexity of the colour forms in these works appears more improvised than those articulated in his oil paintings. In 1985 he commented: 'My gouaches have always had this fast-moving fluidity of drawing, and a softness, coming from the watery medium itself, which oil paintings cannot share.' Heron's practice was primarily engaged with formal concerns but was also informed by a response to his environment, for example the immediate surroundings of his garden at Eagles Nest in Zennor, Cornwall, where he lived from 1956 until his death in 1999. Acknowledged as the leading pioneer of post-war painterly abstraction in Britain, he was also engaged in a critical dialogue with some of the American Abstract Expressionist artists, and his work was acclaimed in the United States. KS

141

Sandra Blow 1925–2006

Vivace 1988

Acrylic and collage on canvas 260 × 260 cm
Tate. Presented by Tate Members 2007

Sandra Blow's paintings successfully coalesce their distinct material presence with a non-figurative exploration of form, space and colour. In conversation with art historian Sarah O'Brian-Twohig in 1994 (Royal Academy 1994, p.32), Blow commented on *Vivace*, a late, defining work:

> I remember wanting my work to be more daring, which is a state of mind. *Vivace* is a spontaneous free-flung-on, risky painting. The red was secondary to the idea but it fitted to my mood while I was making the picture.

Behind the painting remained a characteristic wish to create a compositional balance between colour and shape, achieved by the juxtaposition of the collaged pieces on the right and the black line that edges the left corner, with the expressionistic splash of colour that animates the centre. This central motif was created by throwing a can of acrylic paint on to the canvas lying on the floor and follows in the tradition of American Action painters. Although acrylic paint is not a focus for this exhibition, this work captures a gestural spontaneity that is only achievable with the fluidity of watered-down paint. An important figure in twentieth-century British art, Blow spent many years in Cornwall and was close to other artists whose work is included in this section, such as Heron, Hilton and Lanyon. KS

140

141

Karla Black b.1972
Opportunity For Girls 2006

Cellophane, watercolour, emulsion, acrylic paints, Vaseline, glass,
shampoo, hair gel, toothpaste, thread 380 × 400 × 280 cm
Collection of Günter Lorenz

Karla Black makes striking three-dimensional works
from matter that is inherently formless. She often
incorporates familiar domestic products such as
shampoo and hair gel, alongside more traditional
art materials. In this case she has covered a sheet of
cellophane in watercolour, along with other types
of water-based paints such as emulsion and acrylic,
and substances such as Vaseline and toothpaste.
As with much of her practice, the final form of this
piece was determined during the process of making
and installing it *in situ*. Her work evokes the dramatic
gesture of other forms of abstract art, but is in
fact often carefully planned and positioned. Black
explores a mode of making non-figurative art that
brings together the accidental and the deliberate
material gesture, and investigates ideas that unite
her conscious and unconscious thought processes.
She comments: 'While there are ideas about psycho-
logical and emotional developmental processes held
within the sculptures I make, the things themselves
are actual physical explorations into thinking, feeling,
communicating and relating.' Black has exhibited
widely internationally and in this country, and will
represent Scotland at the 54th Venice Biennale
in 2011. KS

143

Hayley Tompkins b.1971
From *Day Series* 2007

Gouache and enamel on wood, two parts
50 × 52.5 × 3 cm
Courtesy of the artist and The Modern Institute, Glasgow

Hayley Tompkins's concise, minimal works are conceived and executed with an intuitive precision that is conveyed in their striking visual economy. She makes watercolour and gouaches on small fragments of board, on sheets of paper, and at times directly onto the wall, alongside applying paint to found and constructed objects. These resolutely small objects have a compelling presence that belie their scale. They possess a tactile quality that evokes the trace of the artist's hand – Tompkins describes her process of painting as a very visceral one, a form of thinking through touch. She selects the found objects from things she happens upon around her, seeking to draw upon their casual, familiar status, whilst singling them out for particular attention. Works such as this piece from Tompkins's *Day Series* invokes the real, but also carries a dream-like quality that is removed from the everyday. Whether a fragmented work on board, or a painted twig, her works hover between an image and a physical object. The arrangement of the works for Tompkins is key, informed by a consideration of the viewer's encounter with the work. Tompkins lives and works in Glasgow, and her work has been included in numerous group exhibitions, in Britain and abroad. KS

Ian McKeever b.1946

Assembly Gouache 2007

Gouache and pencil on paper 80 × 121 cm
Courtesy of the artist and Alan Cristea Gallery, London

Ian McKeever's work is informed by his lengthy travels around the world, his appreciation of art, literature and music and his own state of being during these encounters. Yet his paintings and works on paper do not seek to illustrate these journeys or directly represent his knowledge of art history and literature, but instead offer a more abstract insight into the artist's instinctive and intellectual responses to his chosen themes. In parallel the work explores the properties of light, form and colour and the way they collide and merge through a process of subtle layering and overlapping in his paintings. He often works in groups, and this gouache is one of a series of works on canvas and paper that are collectively titled *Assembly*. They represent the last suite of McKeever's *Four Quartets* that draw upon T.S. Eliot's 1944 poem of the same name. In this *Assembly* work on paper, the ovoid shape dominates, articulated in gouache and pencil, as McKeever opens up seemingly negative and positive spaces that exist within a shallow frontal plane, held together in a loosely symmetrical, organic structure. His skilful use of gouache allows him to interweave transparent areas with more opaque, apparently solid forms. Since the 1970s McKeever has been recognised internationally for the distinct language he uses in his painting, which engages with the materiality of the world alongside more metaphysical concerns. KS

145

Callum Innes b.1962

Cadmium Orange Deep / Delft Blue 2010

Watercolour on paper 56 × 77 cm
Courtesy of the artist and Frith Street Gallery, London

Since the mid-1980s, Callum Innes has developed a unique language for the monochrome, which has been a constant format for abstract painting throughout the twentieth century and continues to preoccupy artists today. In parallel with his work in oil on canvas, Innes has consistently explored and evolved the possibilities of pure colour though the medium of watercolour. In contrast to his technique of removing layers of oil paint with turpentine to create thin veils of pigment, Innes builds layered washes of watercolour in often opposing rather than complementary pigments, to create remarkably sensuous and rich fields of colour. He has produced a large series of works that explore numerous combinations of colours available in the medium. In the watercolour illustrated here, the vibrant edges of the first wash of Cadmium Orange Deep are revealed through a deliberately imprecise registration of the overlapping square of Delft Blue. The literalness of the title indicates Innes's rational, rather than overtly expressive or emotional, approach to his work. Based in Edinburgh, Innes was shortlisted for the Turner Prize in 1995, and is seen as one of the most interesting artists of a generation that emerged during the late 1980s, and has continued to exhibit widely since then. KS

List of Works

In addition to the works illustrated on pp.40–197, the following works are also included in the exhibition.

If a work is undated, this is because the date is unknown.

Measurements are given in centimetres, height before width.

David Austen b.1960

Untitled (blonde) 2005
Watercolour and pencil on paper 25 × 25
Courtesy of the artist and Ingleby Gallery, Edinburgh

Untitled (pink top hat) 2005
Watercolour and pencil on paper 25 × 25
Courtesy of the artist and Ingleby Gallery, Edinburgh

Untitled (woman with blue hair) 2005
Watercolour and pencil on paper 25 × 25
Courtesy of the artist and Ingleby Gallery, Edinburgh

Heneage Finch, Fourth Earl of Aylesford 1751–1812

Tenby c.1803
Pen and ink and watercolour on paper 21 × 24.8
Tate. Purchased as part of the Oppé Collection with assistance from the National Lottery through the Heritage Lottery Fund 1996

George Howland Beaumont 1753–1827

Waterfall at Keswick 1803
Chalk and wash on paper 31.1 × 27.9
Tate. Purchased 1970

George Price Boyce 1826–1897

A Girl's Portrait c.1868
Watercolour on paper 24.9 × 18.2
Tate. Purchased with assistance from the Abbott Fund 1987
[Fig.4 on p.13]

Edward Burne-Jones 1833–1898

Clerk Saunders 1861
Watercolour on paper 69.9 × 41.8
Tate. Presented by Mrs Wilfred Hadley through the Art Fund 1927
[Fig.3 on p.12]

Edward Burra 1905–1976

Wake 1940
Gouache and watercolour on paper 102.2 × 69.8
Tate. Purchased 1940

Arthur Harry Church 1865–1937

Tiger Lily (Lilium tigrinum) 1908
Watercolour and gouache on board 30 × 20
Natural History Museum, London

Chimaera Dracula Orchid (Dracula chimaera, formerly Masdevalia chimaera)
Watercolour and gouache on board 30 × 20
Natural History Museum, London

Samuel Cooper c.1608–1672

James, Duke of York, later James II 1670–2
Watercolour on vellum 7.8 × 6.4
National Maritime Museum, Greenwich, London. Caird Collection

Lady Carew late 1650s
Watercolour on vellum 7.6 × 5.1
Private collection

John Sell Cotman 1782–1842

Doorway of the Refectory, Rievaulx Abbey 1803
Watercolour and pencil on paper 31.9 × 25.5
Tate. Purchased as part of the Oppé Collection with assistance from the National Lottery through the Heritage Lottery Fund 1996
[Fig.22 on p.34]

On the Downs c.1835
Watercolour and gouache on paper 23.5 × 39
Private collection
[Fig.7 on p.19]

David Cox 1783–1859

Still Life
Watercolour on paper 17.1 × 21
Tate. Bequeathed by J.R. Holliday 1927
[Fig.6 on p.18]

Alexander Cozens 1717–1786

Plate 2 for *A New Method of Assisting the Invention in Drawing Original Compositions of Landscape* c.1785
Aquatint on paper 24 × 31.4
Tate. Purchased 1980

Plate 14 for *A New Method of Assisting the Invention in Drawing Original Compositions of Landscape* c.1785
Aquatint on paper 24 × 31.4
Tate. Purchased 1980

William Crotch 1775–1847

Behind Wetherall Place, Hampstead 1807
Pencil and watercolour on paper 11.5 × 17.8
Tate. Presented by Anne Lyles in memory of Henry Wemyss (1956–2010) 2010

F. Davis active 1750–1790

Study of a Flamingo with the Castle and Settlement of Christopher Codrington in Barbadoes
Watercolour on paper 34.5 × 24.5
Private collection

Peter de Wint 1784–1849

Bridge over a Branch of the Wytham, Lincolnshire
Watercolour and pencil on paper 41.6 × 51.4
Tate. Bequeathed by John Henderson 1879
[Fig.20 on p.30]

Clee Hills, Shropshire c.1845
Watercolour on paper 38.1 × 52.7
Private collection
[Fig.2 on p.10]

Peter Doig b.1959

Pelican 2001
Watercolour on paper 79 × 64
Private collection

Nicola Durvasula b.1960

Seventy Three 2009
Watercolour, gouache and pencil on paper 33.5 × 20.5
Courtesy of the artist and Rachmaninoff's, London

Tracey Emin b.1963

Berlin The Last Week in April 1998 1998
Watercolour on paper 10.5 × 14.7
Collection of Robert Diament

Berlin The Last Week in April 1998 1998
Watercolour on paper 10.5 × 14.7
Courtesy of the artist

Jenny Franklin b.1949

Scorched Earth, Regeneration 2001
Watercolour and ink on paper 48 × 68.5
Courtesy of the artist

John Fullwood 1883–1931

Three Stones (from an album of *Stones*), 1894–1928
Watercolour on paper 14.3 × 8.8
The Natural History Museum, London

Thomas Girtin 1775–1802

La Rue St Denis, Paris 1802
Pencil and watercolour on paper 39.3 × 49.5
Private collection

Andy Goldsworthy b.1956

Source of Scaur 1991–2
Watercolour on paper 235 × 121
Victoria and Albert Museum, London
[Fig.1 on p.8]

John Gould 1804–1881

A Monograph of the Trochilidae, or Family of Hummingbirds, vol.3, 1861
Printed book with handcoloured lithographs in watercolour and gold leaf 60 × 39
Zoological Society of London

John Gould 1804–1881 and **William Hart** 1830–1908

Colour pattern, or template, for *Topaza pella (Crimson Topaz)*, from John Gould, *A Monograph of the Trochilidae, or Family of Hummingbirds* (1849–61), vol.2, plate 25
Handcoloured lithograph, gold leaf and pencil 54 × 37.4
Henry Sotheran Ltd, London

Samuel Hieronymous Grimm 1733–1794

The Glacier of Simmenthal 1774
Watercolour on paper 29.5 × 37.1
Tate. Purchased 1983
[Fig.17 on p.29]

Francis Hill active 1698, d.1711

An Estate Map of Warminghurst, West Sussex 1707
Watercolour on vellum 66 × 167
The British Library, London

Nicholas Hilliard c.1547–1619

George Clifford, Earl of Cumberland c.1590
Watercolour and goucahe on vellum,
laid on panel 25.8 × 17.6 cm
National Maritime Museum, Greenwich,
London. Caird Collection
[Fig.21 on p.33]

*Portrait of a Lady, possibly Penelope,
Lady Rich* c.1590
Watercolour on vellum 5.7 × 4.6
The Royal Collection

Roger Hilton 1911–1975

Foliage with Orange Caterpillar 1973
Gouache and charcoal on paper 36 × 44
Tate. Bequeathed by David Brown in
memory of Mrs Liza Brown 2003

Howard Hodgkin b.1932

Here we Are in Croydon 1979
Watercolour, gouache and lithograph
on paper 55.9 × 76.5
Tate. Purchased 1984

Wenceslaus Hollar 1607–1677

*Tangier from the South West; View from a
Grassy Slope, below Catherine Fort* c.1669
Pen and ink with watercolour on paper
32.4 × 89
The British Museum, London

Lucas Horenbout d.1544

Henry VIII c.1525–6
Watercolour on vellum laid on card
6 (circular)
Département des Arts graphiques,
Musée Louvre, Paris

John Hoskins c.1590–1664/1665

Unknown Lady
Watercolour on vellum on card 5.2 × 4.3
Private collection

Bethan Huws b.1961

Duchamp's Bicycle Wheel 1997
Watercolour on paper 36.5 × 45
Leeds Museums and Galleries
(City Art Gallery)

Duchamp's Turn 1996
Watercolour on paper 36.5 × 45
Leeds Museums and Galleries
(City Art Gallery)

Pool Ripples 1997
Watercolour on paper 36.5 × 45
Leeds Museums and Galleries
(City Art Gallery)

Callum Innes b.1962

Cadmium Red Light / May Green 2010
Watercolour on paper 56 × 77
Courtesy of the artist and Frith Street
Gallery, London

*Ultramarine Blue Deep / Transparent
Orange* 2010
Watercolour on paper 56 × 77
Courtesy of the artist and Frith Street
Gallery, London

Inigo Jones 1573–1652

*Costume design for an unknown masque:
A Lady Masquer* c.1610
Pen and ink and watercolour on paper
29.2 × 18.2
The Trustees of the Devonshire Settlement

Anish Kapoor b.1954

Untitled 1990
Earth, PVA and gouache on paper 56.2 × 76.1
Tate. Presented by the artist 1991
[Fig.15 on p.28]

Edward Lear 1812–1888

Whiptail Wallaby (Macropus parryi) 1834
Watercolour on paper 30 × 22
Zoological Society of London

Alexander Marshal c.1620–1682

*Cabbage Rose (Rosa centifolia), European
Grass Snake (Natrix natrix) and Drinker
Moth Caterpillar Larva* before 1682
Watercolour and gouache on paper
46 × 32.9
The Royal Collection

Margaret Mee 1909–1988

Neoregelia Margaretae 1979
Watercolour on paper 66.1 × 48.3
Courtesy of the Director and the Board
of Trustees, Royal Botanic Gardens, Kew

Paul Nash 1889–1946

*The Messerschmidt in Windsor
Great Park* 1940
Pastel, pencil, and watercolour on paper
40 × 57.8
Tate. Presented by the War Artists
Advisory Committee 1946

Lucia Nogueira 1950–1998

Untitled 1990
Watercolour, pencil and ink on paper
50 × 40.5
Tate. Presented by Tate Members 2009

Untitled 1994
Watercolour, pencil and ink on paper
50 × 40.5
Tate. Presented by Tate Members 2009

Untitled 1994
Watercolour and ink on paper 42 × 24.5
Tate. Presented by Anthony Reynolds
Gallery, London 2009

Untitled
Watercolour, ink and pencil on paper
40.5 × 50
Tate. Presented by Tate Members 2009

Untitled (Ladder with Elephant) c.1993–7
Watercolour and ink on paper 62 × 70.5
Tate. Presented by Tate Members 2009

Isaac Oliver 1560 or 5–1617

Prince Charles 1615–1616
Watercolour on vellum 5.1 × 4
Private collection
[Fig.16 on p.29]

Matthew Paris c.1200–1259

Map of the British Isles c.1250
Watercolour on vellum 35 × 26
British Library, London

Gabriel Smith 1724–c.1783
after **Sydney Parkinson** 1745–1771

Copper plate for *New Zealand
Honeysuckle (Knightia excelsa)*
45.5 × 29.3
The Natural History Museum, London

Thomas Rowlandson 1756–1827

Longways Dance
Pencil, pen and ink and watercolour
on paper 7 × 17.2
Tate. Purchased as part of the Oppé
Collection with assistance from
the National Lottery through the
Heritage Lottery Fund 1996

Longways Dance
Pencil, pen and ink and watercolour
on paper 7.1 × 17.1 cm
Tate. Purchased as part of the Oppé
Collection with assistance from
the National Lottery through the
Heritage Lottery Fund 1996

Longways Dance
Pencil, pen and ink and watercolour
on paper 7.7 × 18.4
Tate. Purchased as part of the Oppé
Collection with assistance from
the National Lottery through the
Heritage Lottery Fund 1996

Rebecca Salter b.1955

untitled RR40 2009
Watercolour on paper 122 × 99
Courtesy of the artist and Beardsmore
Gallery, London
[Fig.8 on p.20]

John Singer Sargent 1856–1925

*Miss Eliza Wedgwood and Miss Sargent
Sketching* 1908
Watercolour and gouache on paper
50.2 × 35.6
Tate. Bequeathed by William Newall 1922
[Fig.23 on p.36]

Samuel Scott c.1702–1772

A Lady in Full Dress, Seen from Behind
Pencil and watercolour on paper
24.3 × 15.3
Tate. Purchased as part of the Oppé
Collection with assistance from
the National Lottery through the
Heritage Lottery Fund 1996
[Fig.12 on p.26]

John Smart 1742/1743–1811

Portrait of an Unknown Man 1793
Watercolour on ivory 6.8 × 5.4
Victoria and Albert Museum.
Bequeathed by Mrs K. Gifford Scott

Portrait of an Unknown Woman 1780
Watercolour on ivory 4 × 3.2
Victoria and Albert Museum, London

Hayley Tompkins b.1971

Untitled 2005
3 parts: part 1, gesso on wood
23.5 × 18 × 0.5: part 2, gouache on wood
6 × 4; part 3, gouache on wood 6.5 × 5 × 0.5
Courtesy of the artist and The Modern
Institute, Glasgow

From *Day Series* 2007
Gouache on wood and found object
3 × 13.1 × 1
Courtesy of the artist and The Modern
Institute, Glasgow

Joseph Mallord William Turner
1775–1851

A Beginning after c.1830
Watercolour on paper 22.2 × 27.1

A Beginning after c.1830
Watercolour on paper 22.2 × 27.2

Blue and Yellow after c.1830
Watercolour on paper 21.9 × 28

Boats at Sea after c.1830
Watercolour on paper 22.2 × 28

*Fountains Abbey: Huby's Tower from
the South Part of the Chapel of Nine
Altars* 1797
Pencil and watercolour on paper
36.8 × 26.2

The Rigi (from the *Lucerne* sketchbook)
1844
Watercolour on paper 22.8 × 32.5

The Scarlet Sunset c.1830–40
Watercolour and gouache on paper
13.4 × 18.9
[Fig.14 on p.27]

Sea and Sky after c.1830
Watercolour on paper 22.1 × 27.1

Shields Lighthouse c.1826
Watercolour on paper 23.4 × 28.3

Storm Clouds after c.1830
Pencil and watercolour on paper
24.7 × 30.6

A Stormy Sky c.1840–5
Watercolour on paper 24.7 × 30.4

Study of Sky c.1820–30
Watercolour on paper 24 × 34.5

Yellow and Blue c.1840
Watercolour on paper 24.5 × 30.6

All works: Tate. Accepted by the nation
as part of the Turner Bequest 1856

James Abbott McNeill Whistler
1834–1903

Beach Scene with Two Figures 1885–90
Watercolour and gouache on paper
laid on card 12.5 × 21.3
Birmingham Museums & Art Gallery
[Fig.5 on p.14]

Select Bibliography

Place of publication or exhibition venue is London unless otherwise stated

ABBOTT AND ANTHONY 1955
Abbott, C.C., and Anthony, Bertram (eds.). *Poet and Painter: Being the Correspondence between Gordon Bottomley and Paul Nash*, Oxford 1955

ALLDERIDGE 1974
Allderidge, Patricia. *The Late Richard Dadd 1817–1886*, exh. cat., Tate Gallery 1974

ATTENBOROUGH ET AL. 2007
Attenborough, David, et al. *Amazing Rare Things: The Art of Natural History in the Age of Discovery*, 2007

AYRTON 1947
Ayrton, Michael. *Aspects of British Art*, 1947

BACKHOUSE 1996
Backhouse, Janet. *The Hastings Hours*, 1996

BACKHOUSE 1997
Backhouse, Janet. *The Illuminated Page: Ten Centuries of Manuscript Painting in the British Library*, 1997

BAILEY 2009
Bailey, Kate. 'The Reeves Collection: An Outstanding Example of Early Nineteenth Century Chinese Botanical Illustration', *Illustration*, no.21, Autumn 2009

BAMJI 1994
Bamji, Andrew. *Queen Mary's Sidcup 1974–94: A Commemoration*, 1994

BAMJI 2006
Bamji, Andrew. 'Sir Harold Gillies: Surgical Pioneer', *Trauma*, vol.8, no.143, 2006, pp.143–56

BARBER 2009
Barber, Peter. *King Henry's Map of the British Isles: BL Cotton MS Augustus I I 9 Commentary by Peter Barber*, 2009

BAYARD 1981
Bayard, Jane. *Works of Splendor and Imagination: The Exhibition Watercolour, 1770–1870*, exh. cat., Yale Center for British Art, New Haven 1981

BERMINGHAM 2000
Bermingham, Ann. *Learning to Draw: Studies in the Cultural History of a Polite and Useful Art*, New Haven and London 2000

BINYON 1946
Binyon, Laurence. *English Water-Colours*, 1946

BLAMIRES 1971
Blamires, David. *David Jones: Artist and Writer*, Manchester 1971

BLUNT AND STEARN 1994
Blunt, Wilfrid, and William T. Stearn. *The Art of Botanical Illustration*, revised edn., Woodbridge 1994

BONEHILL AND DANIELS 2010
Bonehill, John and Stephen Daniels (eds.). *Paul Sandby: Picturing Britain*, exh. cat., Royal Academy of Arts, 2010

BOWER 1990
Bower, Peter. *Turner's Papers: A Study of the Manufacture, Selection and Use of his Drawing Papers 1787–1820*, exh. cat., Tate Gallery, 1990

BOWER 1999
Bower, Peter. *Turner's Later Papers 1820–1851*, exh. cat., Tate Gallery, 1999

BRADLEY 2006
Bradley, Fiona (ed.). *Callum Innes from Memory*, exh. cat., The Fruitmarket Gallery, Edinburgh 2006

BROUGHTON ET AL. 2005
Broughton, Michael, et al. *The Spooner Collection of British Watercolours*, exh. cat., Courtauld Institute of Art, 2005

BROWN 1991
Brown, David Blayney. *Original Eyes: Progressive Vision in British Watercolour, 1750–1850*, exh. cat., Tate, Liverpool 1991

BROWN 1994
Brown, Michelle. *Understanding Illuminated Manuscripts: A Guide to Technical Terms*, 1994

BROWN 1996
Brown, David Blayney. 'Watercolour', in Jane Turner (ed.), *The Dictionary of Art*, vol.32, London and New York 1996, pp.898–902

CAIGER-SMITH 2007
Caiger-Smith, Martin. *Ian McKeever: Four Quartets, Malerei / Paintings 2001–2007*, exh.cat., Morat-Institut für Kunst und Kunstwissenschaft, Freiburg 2007

CALMANN 1997
Calmann, Gerta. *Ehret: Flower Painter Extraordinary*, Boston 1977

CASTERAS AND DENNEY 1996
Casteras, Susan P., and Colleen Denney (eds.). *The Grosvenor Gallery: A Palace of Art in Victorian England*, New Haven and London 1996

CAUSEY 1975
Causey, Andrew. *Paul Nash: Paintings and Watercolours*, exh. cat., Tate Gallery, 1975

CAUSEY 1980
Causey, Andrew. *Paul Nash*, Oxford 1980

CAVE 1982
Cave, Kathryn (ed.). *The Diary of Joseph Farington*, New Haven and London 1982, vol.8

CHERRY 1993
Cherry, Deborah. *Painting Women: Victorian Women Artists*, 1993

CHRISTIAN 1989
Christian, John. *The Last Romantics: The Romantic Tradition in British Art. Burne-Jones to Stanley Spencer*, exh. cat., Barbican Art Gallery, 1989

CLARKE 1981
Clarke, Michael. *The Tempting Prospect: A Social History of English Watercolours*, 1981

COHN 1977
Cohn, Marjorie B. *Wash and Gouache: A Study of the Development of the Materials of Watercolor*, exh. cat., Fogg Art Museum, Boston, 1977

COOMBS 2006
Coombs, Katherine. *The Portrait Miniature in England*, revised edn., 2006

DALLAS MUSEUM OF ART 2005
Peter Doig: Works on Paper, exh.cat., Dallas Museum of Art and touring 2005

DRAWING ROOM 2005
Lucia Nogueira: Drawings, exh. cat., The Drawing Room, 2005

EGERTON 1986
Egerton, Judy. *British Watercolours*, 1986

ELPHICK 2004
Elphick, Jonathan. *Birds: The Art of Ornithology*, 2004

ENGEN 2007
Engen, Rodney. *The Age of Enchantment: Beardsley, Dulac and their Contemporaries 1890–1930*, exh. cat., Dulwich Picture Gallery, 2007

ERDMAN 2008
Erdman, David (ed.). *A Descriptive Catalogue of Pictures, Poetical and Historical Inventions by William Blake (1809)*, 2008

FENWICK AND SMITH 1997
Fenwick, Simon, and Greg Smith. *The Business of Watercolour: A Guide to the Archives of the Royal Watercolour Society*, 1997

FINBERG 1905
Finberg, A.J. *The English Water Colour Painters*, 1905

FINBERG 1961
Finberg, A.J. *The Life of J.M.W. Turner, R.A.*, 2nd edn., Oxford 1961

FINE ART SOCIETY 2008
Sandra Blow RA 1925–2006, exh.cat., The Fine Art Society, 2008

FREEMAN 2006
Freeman, Julian. *British Art: A Walk Around the Rusty Pier*, 2006

FRUITMARKET GALLERY 2008
Lucy Skaer, exh. cat., The Fruitmarket Gallery, Edinburgh 2008

HACKETT-FREEDMAN GALLERY 2008
Drawing Space in Colour: Paintings of Patrick Heron, exh. cat., Hackett-Freedman Gallery, San Francisco 2008

HARDIE 1966–8
Hardie, Martin. *Water-colour Painting in Britain*, 3 vols. (vol.1: *The Eighteenth Century*, 1966; vol.2: *The Romantic Period*, 1967; vol.3: *The Victorian Period*, 1968), 1966–8

HARRIS AND WILCOX 2006
Harris, Theresa Fairbanks, and Scott Wilcox. *Papermaking and the Art of Watercolor in Eighteenth-Century Britain: Paul Sandby and the Whatman Paper Mill*, New Haven and London 2006

HILLS 1981
Hills, Paul. *David Jones*, exh. cat., Tate Gallery, 1981

HULTON 1977
Hulton, Paul. *The Work of Jacques le Moyne de Morgues: A Huguenot Artist in France, Florida and England*, exh. cat., British Museum, 1977

HUTCHISON 1986
Hutchison, Sidney. *The History of the Royal Academy: 1768–1968*, 1986

IMPERIAL WAR MUSEUM 1982
Sutherland: The War Drawings, exh. cat., Imperial War Museum, 1982

JACKSON 1998
Jackson, Christine. *Sarah Stone: Curiosities from the New Worlds*, 1998

JOHNSON 1994
Johnson, Lewis. *Prospects, Thresholds, Interiors: Watercolours from the National Collection at the Victoria and Albert Museum*, Cambridge 1994

KAISER WILHELM MUSEUM 1999
Bethan Huws: Watercolours, exh.cat., Kaiser Wilhelm Museum, Krefeld, and touring 1999

KAVANAGH 1989
Kavanagh, Amanda. 'Robert Bateman: A True Victorian', *Apollo*, Sept. 1989, pp.1/4-9

KING 1996
King, J.C.H. 'New Evidence for the Contents of the Leverian Museum', *Journal of the History of Collections*, vol.8, no.2, 1996, pp.167-86

KUNSTHALLEN BRANDTS 2007
Ian McKeever: Assembly. Malerier / Paintings 2002-2007, exh.cat., Kunsthallen Brandts, Odense 2007

LAGO 1981
Lago, Mary (ed.). *Burne-Jones Talking: His Conversations 1895-1898 Preserved by his Studio Assistant Thomas Rooke*, 1981

LEITH-ROSS 2000
Leith-Ross, Prudence, with Henrietta McBurney. *The Florilegium of Alexander Marshal in the Collection of Her Majesty The Queen at Windsor Castle*, 2000

LEWIS 1996
Lewis, Adrian. *The Last Days of Hilton*, Bristol 1996

LEWISON 1996
Lewison, Jeremy. *Anish Kapoor: Drawings 1997-2003*, London and Cologne 2005

LITTLE 1998
Little, Carl. *The Watercolours of John Singer Sargent*, Berkeley 1998

LLOYD 2004
Lloyd, Jill. *Ian McKeever: Recent Paintings and Ten Years of Drawing*, exh.cat., Kettle's Yard, Cambridge 2004

LOMAZZO 1598
Lomazzo, Giovanni Paolo, trans. Richard Haydocke. *A tracte containing the artes of curious paintinge caruinge buildinge written first in Italian by Io: Paul Lomatius painter of Milan and Englished by R.H student in physic*, Oxford 1598

LYLES AND HAMLYN 1997
Lyles, Anne, and Robin Hamlyn. *British Watercolours from the Oppé Collection*, exh. cat., Tate Gallery, 1997

MAAS GALLERY 2005
Dorothy Hawksley, exh. cat., Maas Gallery, 2005

MABBERLEY 2000
Mabberley, David. *Arthur Harry Church: The Anatomy of Flowers*, 2000

MCLEAN 1989
McLean, Ruari. *Edward Bawden: War Artist and his Letters Home 1940-45*, Aldershot 1989

MACLEOD 1988
MacLeod, Michael. *Thomas Hennell: Countryman, Artist and Writer*, Cambridge 1988

MAGEE 2009
Magee, Judith. *Art of Nature: Three Centuries of Natural History Art from Around the World*, 2009

MALLALIEU 1985
Mallalieu, Huon L. *Understanding Watercolours*, Woodbridge 1985

MALLALIEU 1996
Mallalieu, Huon L. 'Watercolour Societies and Sketching Clubs', in Jane Turner (ed.), *The Dictionary of Art*, vol.32, London and New York 1996, pp.902-3

MANCHESTER AND NORWICH 1987
The Art of Watercolour, exh. cat., Manchester City Art Gallery and Norwich Castle Museum 1987

MARKS 1896
Marks, John George. *Life and Letters of Frederick Walker, ARA*, 1896

MARNER 2000
Marner, Dominic. *St Cuthbert: His Life and Cult in Medieval Durham*, 2000

MEYERS AND MCBURNEY 1997
Meyers, Amy, and Henrietta McBurney. *Mark Catesby's Natural History of America: The Watercolours from the Royal Library, Windsor Castle*, 1997

MEYERS AND PRITCHARD 1998
Meyers, Amy, and Margaret Beck Pritchard (eds.). *Empire's Nature: Mark Catesby's New World Vision*, Chapel Hill, NC 1998

MILTON KEYNES GALLERY 2007
David Austen, exh.cat., Milton Keynes Gallery, Milton Keynes 2007

MODERN ART OXFORD 2009
Silke Otto-Knapp: Present Time Exercise, exh. cat., Modern Art Oxford, Oxford 2009

MOORBY AND WARRELL 2010
Moorby, Nicola, and Ian Warrell (eds.). *How to Paint like Turner*, 2010

MORIES 1948
Mories, F.G. 'Artists of Note: Dorothy Hawksley', *Artist*, vol.34, no.5, 1948, pp.107-8

MORRISON 1988
Morrison, Tony. *Margaret Mee: In Search of the Flowers of the Amazon Forests*, Woodbridge 1988

MUNDER ET AL. 2010
Munde, Heike, et al. (eds.). *Karla Black: It's the Proof that Counts*, Zurich 2010

MURRELL 1983
Murrell, Jim. *The Way Howe to Lymne: Tudor Miniatures Observed*, 1983

MYRONE 2010
Myrone, Martin (ed.). *Watercolour in Britain*, 2010

NEWALL 1987
Newall, Christopher. *Victorian Watercolours*, Oxford 1987

PARK 2010
Park, Maureen. *Art in Madness: Dr W.A.F. Browne's Collection of Patient Art at Crichton Royal Institution, Dumfries*, Dumfries 2010

RAY 1955
Ray, G. (ed.). *Contributions to the Morning Chronicle* (W.M. Thackeray, 1846) Urbana 1955

REDGRAVE 1892
Redgrave, Gilbert Richard. *A History of Watercolour Painting in England*, 1892

REYNOLDS 1988
Reynolds, Graham. *English Watercolours* (1950), 1988

REYNOLDS 1988A
Reynolds, Graham. *English Portrait Miniatures*, revised edn., Cambridge 1988

ROBERTSON 1931
Robertson, W. Graham. *Time Was: The Reminiscences of W. Graham Robertson*, 1931

RODARI ET AL. 1998
Rodari, Florian, et al. *Shadows of the Hand: The Drawings of Victor Hugo*, New York and London 1998

ROGET 1972
Roget, J.L. *A History of the 'Old Water-Colour Society', now the Royal Society of Painters in Water-Colours*, 2 vols. (1891), Woodbridge 1972

ROTHENSTEIN 1935
Rothenstein, William. *Men and Memories*, vol.1, 1935

ROYAL ACADEMY 1994
Sandra Blow, exh. cat., Royal Academy of Arts, 1994

ROYALTON-KISCH 1999
Royalton-Kisch, Martin. *The Light of Nature: Landscape Drawings and Watercolours by van Dyck and his contemporaries*, exh. cat., British Museum, London, and Rubenshuis, Antwerp 1999

RUSKIN 1903-12
Ruskin, John. *The Works of John Ruskin*, ed. E.T. Cook and Alexander Wedderburn, 39 vols., 1903-12

SAUNDERS 1995
Saunders, Gill. *Picturing Plants: An Analytical History of Botanical Illustration*, Berkeley and Los Angeles 1995

SLOAN 2000
Sloan, Kim. *'A Noble Art': Amateur Artists and Drawing Masters c.1600-1800*, exh. cat., British Museum, 2000

SLOAN 2007
Sloan, Kim. *A New World: England's First View of America*, British Museum, 2007

SMITH 2002
Smith, Greg. *The Emergence of the Professional Watercolourist: Contentions and Alliances in the Artistic Domain, 1760-1824*, Aldershot 2002

SMITH 2009
Smith, Jonathan. *Charles Darwin and Victorian Visual Culture*, Cambridge 2009

SMITH 2009A
Smith, Lyn. *Voices against War: A Century of Protest*, 2009

SOLKIN 2009
Solkin, David (ed.). *Turner and the Masters*, exh. cat., Tate Britain, 2009

SOLLY 1873
Solly, N. Neal. *Memoir of the Life of David Cox*, 1873

SPENDER 1987
Spender, Michael. *The Glory of Watercolour: the Royal Watercolour Society's Diploma Collection*, 1987

STAINTON 1991
Stainton, Lindsay. *Nature into Art: English Landscape Watercolours*, exh. cat., British Museum, 1991

STAINTON AND WHITE 1987
Stainton, Lindsay, and Christopher White. *Drawing in England from Hilliard to Hogarth*, exh. cat., British Museum, 1987

STEWART AND STEARN 1993
Stewart, Joyce, and William Stearn. *The Orchid Paintings of Franz Bauer*, 1993

STIFF 1996
Stiff, Ruth. *Margaret Mee: Return to the Amazon*, exh. cat., Royal Botanic Gardens, Kew 1996

SUMNER 1989
Sumner, Ann. *Ruskin and the English Watercolour: From Turner to the Pre-Raphaelites*, exh. cat., Whitworth Art Gallery, University of Manchester 1989

TATE ST IVES 2010
Peter Lanyon, exh. cat., Tate St Ives 2010

TOWNSEND 2003
Townsend, Joyce H. (ed.). *William Blake: The Painter at Work*, 2003

TREUHERZ 1984
Treuherz, Julian. 'The Pre-Raphaelite and Medieval Illuminated Manuscripts', in Leslie Parris (ed.). *Pre-Raphaelite Papers*, 1984

TURNER 1983
Turner, D.H. *The Hastings Hours*, 1983

UPSTONE 2005
Upstone, Robert. *William Orpen: Politics, Sex and Death*, 2005

WADDINGTON GALLERIES 2005
Patrick Heron: Gouaches from 1961 to 1996, exh. cat., Waddington Galleries, 2005

WEST 1922
West, W.K. 'The Work of Miss D.W. Hawksley RI', *Studio*, vol.84, July-Dec. 1922, pp.257-62

WILCOX AND NEWALL 1992
Wilcox, Scott, and Christopher Newall. *Victorian Landscape Watercolours*, New York 1992

WILDMAN 1991
Wildman, Stephen. *British Watercolours from Birmingham*, exh. cat., Birmingham Museums and Art Gallery, 1991

WILTON AND LYLES 1993
Wilton, Andrew, and Anne Lyles. *The Great Age of British Watercolours 1750-1880*, exh. cat., Royal Academy, 1993

WOOD 1910
Wood, T. Martin. 'Mr Robert Anning Bell's Work as a Painter', *Studio*, 1910, pp.254-62

WORNUM 1848
Wornum, Ralph N. (ed.). *Lectures on Painting, by the Royal Academicians. Barry, Opie, and Fuseli*, 1848

YEE 1943
Yee, Chiang. *The Silent Traveller in London* (1938), 1943

Index

Supporting Tate

Tate relies on a large number of supporters – individuals, foundations, companies and public sector sources – to enable it to deliver its programme of activities, both on and off its gallery sites. This support is essential in order for Tate to acquire works of art for the Collection, run education, outreach and exhibition programmes, care for the Collection in storage and enable art to be displayed, both digitally and physically, inside and outside Tate. Your donation will make a real difference and enable others to enjoy Tate and its Collection both now and in the future. There are a variety of ways in which you can help support Tate and also benefit as a UK or US taxpayer. Please contact us at:

Development Office
Tate
Millbank
London SW1P 4RG

Tel: 020 7887 4900
Fax: 020 7887 8098

American Patrons of Tate
520 West 27 Street
Unit 404
New York, NY 10001
USA

Tel: 001 212 643 2818
Fax: 001 212 643 1001

Donations, of whatever size, are gratefully received, either to support particular areas of interest, or to contribute to general activity costs.

Gifts of Shares

We can accept gifts of quoted share and securities. All gifts of shares to Tate are exempt from capital gains tax, and higher rate taxpayers enjoy additional tax efficiencies. For further information please contact the Development Office.

Gift Aid

Through Gift Aid you can increase the value of your donation to Tate as we are able to reclaim the tax on your gift. Gift Aid applies to gifts of any size, whether regular or a one-off gift. Higher rate taxpayers are also able to claim additional personal tax relief. Contact us for further information and to make a Gift Aid Declaration.

Legacies

A legacy to Tate may take the form of a residual share of an estate, a specific cash sum or item of property such as a work of art. Legacies to Tate are free of inheritance tax, and help to secure a strong future for the Collection and galleries. For further information please contact the Development Office.

Offers in lieu of tax

Inheritance Tax can be satisfied by transferring to the Government a work of art of outstanding importance. In this case the amount of tax is reduced, and it can be made a condition of the offer that the work of art is allocated to Tate. Please contact us for details.

Tate Members

Tate Members enjoy unlimited free admission throughout the year to all exhibitions at Tate, as well as a number of other benefits such as exclusive use of our Members' Rooms and a free annual subscription to Tate Etc. Whilst enjoying the exclusive privileges of membership, you are also helping secure Tate's position at the very heart of British and modern art. Your support actively contributes to new purchases of important art, ensuring that the Tate's Collection continues to be relevant and comprehensive, as well as funding projects in London, Liverpool and St Ives that increase access and understanding for everyone.

Tate Patrons

Tate Patrons share a strong enthusiasm for art and are committed to giving significant financial support to Tate on an annual basis. The Patrons support the acquisition of works across Tate's broad collecting remit, as well as other areas of Tate activity such as conservation, education and research. The scheme provides a forum for Patrons to share their interest in art and to exchange knowledge and information in an enjoyable environment. United States taxpayers who wish to receive full tax exempt status from the IRS under section 501(c)(3) are able to support the Patrons through the American Patrons of Tate. For more information on the scheme please contact the Patrons office.

Corporate Membership

Corporate Membership at Tate Modern, Tate Britain and Tate Liverpool offers companies opportunities for corporate entertaining and the chance for a wide variety of employee benefits. These include special private views, special access to paying exhibitions, out-of-hours visits and tours, invitations to VIP events and talks at members' offices.

Corporate Investment

Tate has developed a range of imaginative partnerships with the corporate sector, ranging from international interpretation and exhibition programmes to local outreach and staff development programmes. We are particularly known for high-profile business to business marketing initiatives and employee benefit packages. Please contact the Corporate Fundraising team for further details.

Charity Details

The Tate Gallery is an exempt charity; the Museums & Galleries Act 1992 added the Tate Gallery to the list of exempt charities defined in the 1960 Charities Act. Tate Members is a registered charity (number 313021). Tate Foundation is a registered charity (number 1085314).

American Patrons of Tate

American Patrons of Tate is an independent charity based in New York that supports the work of Tate in the United Kingdom. It receives full tax exempt status from the IRS under section 501(c)(3) allowing United States taxpayers to receive tax deductions on gifts towards annual membership programmes, exhibitions, scholarship and capital projects. For more information contact the American Patrons of Tate office.

Tate Trustees

Helen Alexander
Tom Bloxham
Lord Browne of Madingley, FRS, FREng (Chair)
Jeremy Deller
Prof David Ekserdjian
Mala Gaonkar
Maja Hoffman
Patricia Lankester
Elisabeth Murdoch
Franck Petitgas
Monisha Shah
Bob and Roberta Smith
Gareth Thomas
Wolfgang Tillmans

Tate Foundation Trustees

John C Botts, CBE
Carol Galley
Noam Gottesman
Scott Mead
Franck Petitgas (Chair)
Anthony Salz
Sir Nicholas Serota
Lord Stevenson of Coddenham, CBE

Tate Foundation Non-Executive Trustees

Victoria Barnsley, OBE
Mrs James Brice
The Lord Browne of Madingley, FRS, FREng
Susan Burns
Melanie Clore
Sir Harry Djanogly, CBE
Dame Vivien Duffield
Lady Lynn Forester de Rothschild
The Hon Mrs Rita McAulay
Ronald McAulay
Mandy Moross
Paul Myners, CBE
Sir John Ritblat

Lady Ritblat
Lord Sainsbury of Preston Candover
Lady Sainsbury of Preston Candover
The Rt Hon Sir Timothy Sainsbury
Peter Simon
Jon Snow
John J Studzinski, CBE
The Hon Mrs Janet Wolfson de Botton, CBE
Anita Zabludowicz

Tate Members Council

Elkan Abrahamson
David Adjaye
Caroline Blyth
Hannah Collins
Heather Corbett
Shami Chakrabarti
Brendan Finucane, QC
Ryan Gander
Linda Genower
Dominic Harris
Robert McCracken
Miranda Sawyer
Steven Sharp
Francine Stock (Chair)
Simon Wilson

American Patrons of Tate Trustees

Frances Bowes
James Chanos
Henry Christensen III
Ella Fontanals-Cisneros
Jeanne Donovan Fisher
Lady Forester de Rothschild (Chair)
Marguerite Hoffman
Sandra M. Niles
John Studzinski, CBE
Juan Carlos Verme

Tate Britain Donors to the Centenary Development Campaign

The Annenberg Foundation
The Asprey Family Charitable Foundation
Ron Beller and Jennifer Moses
Alex and Angela Bernstein
The Charlotte Bonham-Carter Charitable Trust
Lauren and Mark Booth
Ivor Braka
CHK Charities Limited
The Clore Duffield Foundation
Sadie Coles
Giles and Sonia Coode-Adams
Alan Cristea
Thomas Dane
Sir Harry and Lady Djanogly
The D'Oyly Carte Charitable Trust
The Dulverton Trust
Maurice and Janet Dwek
Bob and Kate Gavron
Sir Paul Getty, KBE
Alan Gibbs

Mr and Mrs Edward Gilhuly
Nicholas and Judith Goodison
Richard and Odile Grogan
Pehr and Christina Gyllenhammar
The Heritage Lottery Fund
Jay Jopling
Mr and Mrs Karpidas
Howard and Lynda Karshan
Peter and Maria Kellner
Madeleine Kleinwort
Brian and Lesley Knox
The Kresge Foundation
Catherine and Pierre Lagrange
Mr and Mrs Ulf G Linden
Ruth and Stuart Lipton
Anders and Ulla Ljungh
Lloyds TSB Foundation for England and Wales
David and Pauline Mann-Vogelpoel
Sir Edwin and Lady Manton
Nick and Annette Mason
Viviane and James Mayor
Sir Peter and Lady Osborne
Maureen Paley
William A Palmer
Mr Frederick Paulsen
The Pet Shop Boys
The P F Charitable Trust
The Polizzi Charitable Trust
Sir John and Lady Ritblat
Barrie and Emmanuel Roman
Lord and Lady Sainsbury of Preston Candover
Mrs Coral Samuel, CBE
David and Sophie Shalit
Mr and Mrs Sven Skarendahl
Pauline Denyer-Smith and Paul Smith
Mr and Mrs Nicholas Stanley
The Jack Steinberg Charitable Trust
Charlotte Stevenson
Tate Gallery Centenary Gala
Tate Members
Carter and Mary Thacher
Mr and Mrs John Thornton
The Trusthouse Charitable Foundation
David and Emma Verey
Dinah Verey
Clodagh and Leslie Waddington
Gordon D Watson
Mr and Mrs Anthony Weldon
The Duke of Westminster, OBE TD DL
Sam Whitbread
Mr and Mrs Stephen Wilberding
Michael S Wilson
The Wolfson Foundation
and those donors who wish to remain
anonymous

Donors to Transforming Tate Britain

The Gatsby Charitable Foundation
The Hiscox Foundation
James and Clare Kirkman
The Manton Foundation
Ronald and Rita McAulay
Simon and Midge Palley
The Garfield Weston Foundation
The Wolfson Foundation
and those donors who wish to remain
anonymous

Tate Britain Benefactors and Major Donors

We would like to acknowledge and thank the
following benefactors who have supported
Tate Britain prior to 31 August 2010.

The Josef and Anni Albers Foundation
American Patrons of Tate
The Annenberg Foundation
Klaus Anschel

John H Armstrong
The Estate of Keith Arnatt
The Art Fund
The Arts and Humanities Research Council
Charles Asprey
The Estate of Frith Banbury
The Estate of Peter and Caroline Barker-Mill
Beecroft Charitable Trust
The Estate of Tom Bendhem
Luis Benshimol
Anne Best
Big Lottery Fund
Billstone Foundation
Ansuya Blom
The Charlotte Bonham-Carter Charitable Trust
Mr Pontus Bonnier
Louise Bourgeois
Brian Boylan
Dr Luther Brady
The Estate of Mrs Marcella Louis Brenner
The Deborah Loeb Brice Foundation
Stuart Brisley, courtesy of England & Co
British Council / DG Education and Culture
The Broad Art Foundation
Mr and Mrs Ben Brown
The Lord Browne of Madingley, FRS, FREng
Calouste Gulbenkian Foundation
Richard Chang
Charities Advisory Trust
Patricia Phelps Cisneros
The Clore Duffield Foundation
The Clothworkers' Foundation
Ron Collins
Michael Craig-Martin
Douglas S Cramer
The Estate of Robin Crozier
The Estate of Mrs Olga Florence Davenport
Manny and Brigitta Davidson and the Family
Tiqui Atencio Demirdjian and Ago Demirdjian
Department for Business, Innovation And Skills
Department for Culture Media and Sport
Christian Dinesen
Anthony d'Offay
Peter Doig
The Drapers' Company
Jytte Dresing
Gill Drey
Anne Faggionato
Teresa Fairchild
The Estate of Mr Angus Fairhurst
The Estate of Maurice Farquharson
First Light
Mrs Wendy Fisher
Lady Lynn Forester de Rothschild
The Estate of Ann Forsdyke
Mildred and Martin Friedman
William Furlong
Galerie Gebr. Lehmann
Henrietta Garnett
Laure Genillard
The Getty Foundation
Millie and Arne Glimcher
Carolyn and Leslie Goldbart
Ralph Goldenberg
Marian Goodman
The Goss-Michael Foundation
Jesse Aron Green
Konstantin Grigorishin
Arthur and Helen Grogan
Paul and Chloë Gunn
The Haberdashers' Company
Viscount and Viscountess Hampden and Family
Eberhard Havekost
Mark Haworth-Booth
Mrs Desiree Hayter
Lynn Hershman-Leeson
Anthony Hill
Damien Hirst
David Hockney

Hazlett Holland-Hibbert
Hollick Family Charitable Trust
Stanley Honeyman
Cristina Iglesias
The Estate of Mr and Mrs Kenneth M Jenkins
Stanley Jones
Elsbeth Juda
Daniel Katz Ltd
Sir Henry and Lady Keswick
Simon Keswick
Keith King
The Estate of RB Kitaj
Elizabeth Knowles, MBE
Leon Kossoff
Mr and Mrs C Richard Kramlich
KwieKulik (Zofia Kulik and Przemyslaw Kwiek)
LCACE (London Centre for Arts and Cultural
 Exchange)
David and Amanda Leathers
Agnès and Edward Lee
Legacy Trust UK
The Leverhulme Trust
Lord Leverhulme's Charitable Trust
The Estate of Barbara Lloyd
Mrs Caro Lloyd-Jacob
Mark and Liza Loveday
John Lyon's Charity
Estate of Sir Edwin Manton
The Andrew W Mellon Foundation
The Paul Mellon Centre for Studies in
 British Art
Marisa Merz
Sir Geoffroy Millais
The Estate of Paul Edwin Millwood
Victoria Miro and Glen Scott Wright
The Monument Trust
Donald Moore
The Henry Moore Foundation
Elisabeth Murdoch
NADFAS
National Heritage Memorial Fund
Elisabeth Nay-Scheibler
New Art Trust
Averill Ogden
Outset Contemporary Art Fund
PF Charitable Trust
PHG Cadbury Charitable Trust
The Stanley Picker Trust
The Pilgrim Trust
Heather and Tony Podesta Collection
Boyana Popova
The Power Family
The Nyda & Oliver Prenn Foundation
The Radcliffe Trust
John Rae
Ally Raftery
Maya and Ramzy Rasamny
The family of Sir Norman Reid
The Estate of Karel and Betsy Reisz
Rootstein Hopkins Foundation
Edward Ruscha
Kathy and Keith Sachs
Said Foundation
Simon Sainsbury
Salander O'Reilly Galleries, LLC
Gerd Sander
Julião Sarmento
Mrs Lee Saunders
John Schaeffer and Nevill Keating Pictures Ltd
Dasha Shenkman
Thomas J Sikorski Charitable Trust
Candida and Rebecca Smith
The Steel Charitable Trust
Jeffrey Steele
Norah and Norman Stone
Tate Asia-Pacific Acquisitions Committee
Tate International Council
Tate Latin American Acquisitions Committee
Tate Members

Tate Middle East and North Africa
 Acquisitions Committee
Tate North American Acquisitions Committee
Tate Patrons
Tate Photography Acquisitions Committee
David Teiger
Terra Foundation for American Art
The Estate of Mr Nicholas Themans
Jannick Thiroux
The Hon Robert H Tuttle and
 Mrs Maria Hummer-Tuttle
Mr and Mrs Petri Vainio
The Keith Vaughan Estate
Marc Vaux
David and Emma Verey
The Andy Warhol Foundation for the
 Visual Arts
Jack Wendler
Sir Samuel Whitbread
Jane and Michael Wilson
Iwan and Manuela Wirth
The Hon Mrs Janet Wolfson de Botton, CBE
Poju and Anita Zabludowicz
and those donors who wish to remain
anonymous

Platinum Patrons

Mr Shane Akeroyd
Ryan Allen and Caleb Kramer
Mehves Ariburnu
Mr and Mrs Edward Atkin
Beecroft Charitable Trust
Pierre Brahm
Broeksmit Family Foundation
Rory and Elizabeth Brooks
Lord Browne of Madingley, FRS, FREng
Mr Dónall Curtin
Ms Sophie Diedrichs-Cox
Mr David Fitzsimons
The Flow Foundation
Hugh Gibson
The Goss-Michael Foundation
Mr and Mrs Charles M Hale
Vicky Hughes (Chair)
Mr and Mrs Yan Huo
Ms Pamela Joyner
Mrs Gabrielle Jungels-Winkler
Mr Phillip Keir
Maria and Peter Kellner
Miss Helene Klausner
Mr and Mrs Eskandar Maleki
Panos and Sandra Marinopoulos
Mr and Mrs Scott Mead
Mrs Megha Mittal
Pierre Tollis and Alexandra Mollof
Mr Donald Moore
Mr and Mrs Paul Phillips
Ms Charlotte Ransom and Mr Tim Dye
Ramzy and Maya Rasamny
Simon and Virginia Robertson
Mr and Mrs Richard Rose
The Rumi Foundation
Mr and Mrs J Shafran
Mrs Andrée Shore
Maria and Malek Sukkar
Mr and Mrs Stanley S. Tollman
Michael and Jane Wilson
Poju and Anita Zabludowicz
and those who wish to remain anonymous

Gold Patrons

Elena Bowes
Melanie Clore
Beth and Michele Colocci
Alastair Cookson
Haro Cumbusyan
Ms Carolyn Dailey

Ms Mala Gaonkar
Mr and Mrs A Ramy Goldstein
Mrs Petra Horvat
Anne-Marie and Geoffrey Isaac
Mrs Heather Kerzner
Mr Eugenio Lopez
Fiona Mactaggart
Maria de Madariaga
Mrs Bona Montagu
Mr Francis Outred
Simon and Midge Palley
Mathew Prichard
Mr David Roberts
Mr Charles Roxburgh
Mrs Rosario Saxe-Coburg
Carol Sellars
Flora Soros
Mrs Celia Forner Venturi
Manuela and Iwan Wirth
Barbara Yerolemou
and those who wish to remain anonymous

Silver Patrons

Agnew's
Helen Alexander
Harriet Anstruther
Toby and Kate Anstruther
Mr and Mrs Zeev Aram
Mr Giorgio Armani
Edgar Astaire
Mr Nicholas Baring
Mrs Jane Barker
Mr Edward Barlow
Victoria Barnsley, OBE
Jim Bartos
Mrs Nada Bayoud
Mr and Mrs Paul Bell
Mr Harold Berg
Ms Anne Berthoud
Madeleine Bessborough
Janice Blackburn
Mr Brian Boylan
Mrs Lena Boyle
Ivor Braka
Viscountess Bridgeman
The Broere Charitable Foundation
Ben and Louisa Brown
Mr and Mrs Charles Brown
Michael Burrell
Mrs Marlene Burston
Timothy and Elizabeth Capon
Mr Francis Carnwath and Ms Caroline Wiseman
Lord and Lady Charles Cecil
Frank Cohen
Dr Judith Collins
Terrence Collis
Mr and Mrs Oliver Colman
Carole and Neville Conrad
Giles and Sonia Coode-Adams
Cynthia Corbett
Mark and Cathy Corbett
Tommaso Corvi-Mora
Mr and Mrs Bertrand Coste
The Cowley Foundation
Kathleen Crook and James Penturn
James Curtis
Loraine da Costa
Mrs Isobel Dalziel
Sir Howard Davies
Mrs Belinda de Gaudemar
Giles de la Mare
The de Laszlo Foundation
Anne Chantal Defay Sheridan
Marco di Cesaria
Simon C Dickinson Ltd
Ms Michelle D'Souza
Joan Edlis
Lord and Lady Egremont

John Erle-Drax
Stuart and Margaret Evans
Eykyn Maclean, LLC
Gerard Faggionato
Mrs Heather Farrar
Mrs Margy Fenwick
Mr Bryan Ferry
The Sylvie Fleming Collection
Mrs Rosamund Fokschaner
Joscelyn Fox
Eric and Louise Franck
Elizabeth Freeman
Stephen Friedman
Julia Fuller
Ms Carol Galley
Gapper Charitable Trust
Mrs Daniela Gareh
Mrs Joanna Gemes
Mr David Gibbons
Mr Mark Glatman
Mr and Mrs Paul Goswell
Penelope Govett
Mrs Sandra Graham
Gavin Graham
Martyn Gregory
Sir Ronald Grierson
Mrs Kate Grimond
Richard and Odile Grogan
Mr Jacques Hakimian
Louise Hallett
Mrs Sue Hammerson, CBE
Jane Hay
Richard Hazlewood
Michael and Morven Heller
Robert Holden
James Holland-Hibbert
Lady Hollick
Mr Michael Hoppen
John Huntingford
Mr Haydn John
Mr Michael Johnson
Mr Chester Jones
Jay Jopling
Mrs Marcelle Joseph and Mr Paolo Cicchiné
Mrs Brenda Josephs
Tracey Josephs
Andrew Kalman
Dr Martin Kenig
Mr David Ker
Mr and Mrs Simon Keswick
Richard and Helen Keys
David Killick
Mr and Mrs Paolo Kind
Mr and Mrs James Kirkman
Brian and Lesley Knox
Kowitz Trust
Mrs H Kretzmer
Rehmet Kassim Lakha
Steven Larcombe
Simon Lee
Zachary R Leonard
Mr Gerald Levin
Leonard Lewis
Anders and Ulla Ljungh
Mr Gilbert Lloyd
George Loudon
Mark and Liza Loveday
Daniella Luxembourg Art
Anthony Mackintosh
The Mactaggart Third Fund
Mr M J Margulies
Mr and Mrs Jonathan Marks
Marsh Christian Trust
Ms Clémence Mauchamp
Mr Klaas Meertens
Mr Martin Mellish
Mrs R W P Mellish
Professor Rob Melville
Mr Michael Meynell

Mr Alfred Mignano
Victoria Miro
Mrs Joyce Misrahi
Jan Mol
Mrs Valerie Gladwin Montgomery
Houston Morris
Mrs William Morrison
Paul and Alison Myners
Mr David Nader
Richard Nagy
Julian Opie
Pilar Ordovás
Sir Richard Osborn
Joesph and Chloe O'Sullivan
Desmond Page
Maureen Paley
Dominic Palfreyman
Michael Palin
Cornelia Pallavicini
Mrs Adelaida Palm
Stephen and Clare Pardy
Eve Pilkington
Ms Michina Ponzone-Pope
Susan Prevezer, QC
Mr and Mrs Ryan Prince
Valerie Rademacher
Mrs Phyllis Rapp
Mr and Mrs James Reed
Mr and Mrs Philip Renaud
The Reuben Foundation
Sir Tim Rice
Lady Ritblat
Tim Ritchie
Rupert and Alexandra Robson
David Rocklin
Frankie Rossi
Mr David V Rouch
Mr James Roundell
Mr Lyon Roussel
Mr and Mrs Paul Ruddock
Naomi Russell
Ms Homera Sahni
Mr Alex Sainsbury and Ms Elinor Jansz
Cherrill and Ian Scheer
Sylvia Scheuer
The Schneer Foundation
Andrew and Belinda Scott
Neville Shulman, CBE
Ms Julia Simmonds
Mrs Cindy Sofer
Mrs Carol Sopher
Louise Spence
Digby Squires, Esq.
Mr and Mrs Nicholas Stanley
Charlotte Stevenson
Mrs Tanya Steyn
The Swan Trust
Mrs Patricia Swannell
Mr James Swartz
The Lady Juliet Tadgell
David and Sayoko Teitelbaum
Sir Anthony and Lady Tennant
Christopher and Sally Tennant
Britt Tidelius
Emily Tsingou and Henry Bond
Melissa Ulfane
Mr and Mrs Petri Vainio
Mrs Cecilia Versteegh
Gisela von Sanden
Audrey Wallrock
Stephen and Linda Waterhouse
Offer Waterman
Terry Watkins
Mr and Mrs Mark Weiss
Jack Wendler
Ms Jil Wensauer
Miss Cheyenne Westphal
Mr Douglas Woolf
and those who wish to remain anonymous

Young Patrons

HRH Princess Alia Al-Senussi
Ms Maria Allen
Sigurdur Arngrimsson
Kirtland Ash
Ms Myrna Ayad
Rachael Barrett
Mr Francisco Borrego
Mr Andrew Bourne
Mr Daniel Bradman
Matt Carey-Williams and Donnie Roark
Mrs Laura Comfort
Thamara Corm
Mrs Suzy Franczak Davis
Ms Suzana Diamond
Mr Alan Djanogly
Miss Roxanna Farboud
Jane and Richard Found
Michael Freund
Ms Alexandra Ghashghai
Mr Nick Hackworth
Alex Haidas
Mr Benji Hall
Dr Lamees Hamdan
Mrs Samantha Heyworth
Mrs Susanna Hong
Miss Eloise Isaac
Ms Melek Huma Kabakci
Mr Efe Kapanci
Helena Christina Knudsen
Ms Marijana Kolak
Miss Constanze Kubern
Mr Jimmy Lahoud
Miss Julie Lawson
Mr Christian Levett
Mrs Siobhan Loughran
Charlotte Lucas
Mr Shahriar Maleki
Mr Kamiar Maleki
Mr Fernando Moncho Lobo
Erin Morris
Miss Annika Murjahn
Mrs Annette Nygren
Alberto and Andrea Olimon
Phyllis Papadavid
Ms Camilla Paul
Mr Mauro Perucchetti
Lauren Prakke
Ivetta Rabinovich
Mrs Karin Reihill
Mr Bruce Ritchie and Mrs Shadi Ritchie
Kimberley and Michael Robson-Ortiz
Mrs Sabine Schmitt
Mr Roopak Shah
Amir Shariat
Andreas B Siegfried
Tammy Smulders
Mr Saadi Soudavar
Ms Brigitta Spinocchia
Miss Malgosia Stepnik
Mr Edward Tang
Soren S K Tholstrup
Mrs Dita Vankova
Mr Mehmet Erdinc Varlibas
Rachel Verghis
Mr Josh Wyatt
Miss Burcu Yuksel
Mr Fabrizio Zappaterra
and those who wish to remain anonymous

Credits